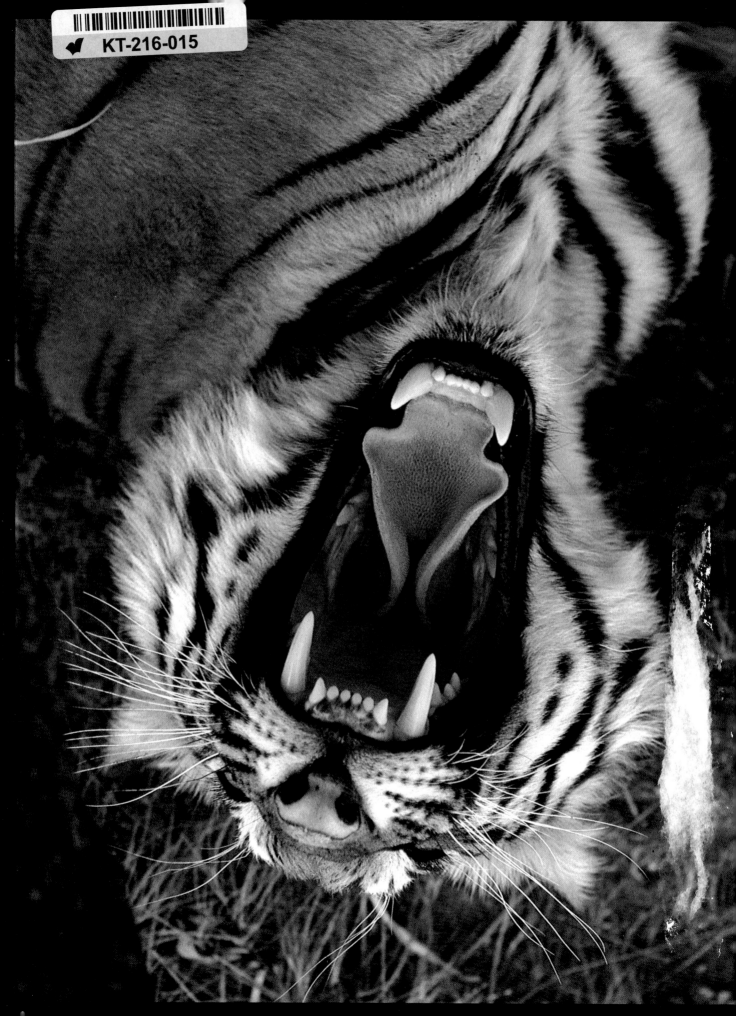

MADHYA PRADESH

Bhopal

Shivpuri

Jhansi

Gwalior

Sawai Madhopur

Ranthambor NP

Keoladeo Ghana

Bharatpur

Jaipur

Agra

Delhi

Moradabad

HARYANA

RAJASTHAN

Contents

Map symbols

Lodges or hotels

⬇

Highways or main roads

Dirt roads (4x4)

National parks and reserves

Key to photo symbols

Wide angle lens: from 20 to 35mm

Medium focal length lens: from 70 to 200mm

Long focus or telephoto lens from 300 to 600mm

rbett NP

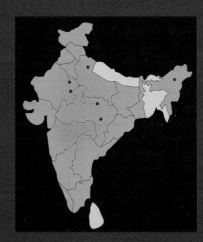

UTTAR PRADESH

● Lucknow

● Kanpur

● Murwara

● Murwara

Bandhavgarh NP

Umaria ●

● Jabalpur

● Mandla

Kanha NP

BHUTAN

ARUNACHAL PRADESH

Dibrugarh

Kaziranga

ASSAM

NAGALAND

Gauhati

MEGHALAYA

MANIPUR

Imphal

Though often overlooked, India is an exceptional destination for those keen to explore another wildlife world. It is a country which possesses a substantial natural heritage whose beauty and variety can rekindle interest and pleasure in safaris. As the national symbol of Indian wildlife, the mythical Bengal tiger constitutes one of its many attractions. In recent years, the authorities have made a considerable effort to manage the country's protected areas more rigorously. In a context of extreme poverty, however, it remains difficult to resist the strong pressure being exerted by the country's changing demographics. Hopefully, India will successfully meet this challenge.

INDIA

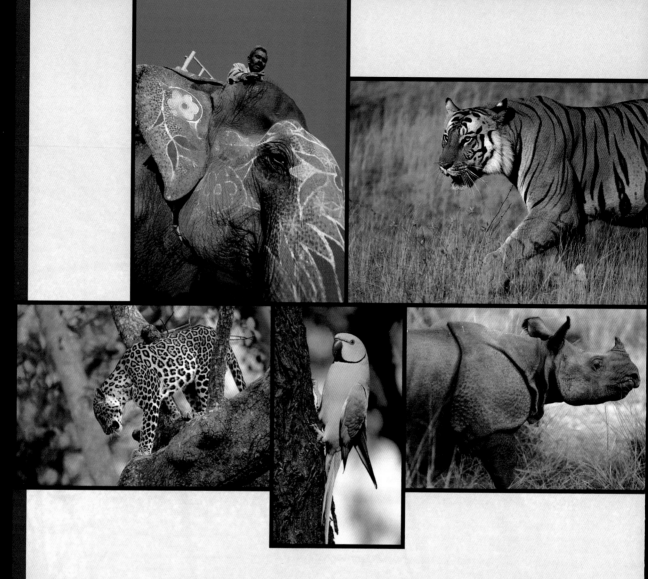

Independent since 1947, India covers an expanse of 3.268 million square kilometres – or six times that of France – and has a population of just over one billion inhabitants, making it the world's second most populated country after China. To the south of continental Asia, India comprises three geographic entities. In the north, the Himalayan Mountains soar to a height of 8,598 metres in the shape of Mount Kachenjunga. In the centre, the Indo-Ganges Plain includes the fluvial basins of the Indus and, notably, the Ganges which, in the east, merges with the Brahmaputra to form the world's largest delta extending over 140,000 square kilometres. To the south, the Deccan Peninsula is dominated by a high, even plateau variously contoured by escarpments and mountain ranges.

Several natural frontiers isolate India from its neighbours. To the northwest, three distinct regions separate it from Pakistan: the Himalayas which at Kashmir define the borders with the Punjab; the Thar Desert where the last landscapes of west Rajasthan disappear; and finally down to Gujarat's enormous Rann of Kutch marshlands. The majestic Himalayan chain delineates the doorsteps of China, Nepal and Bhutan. Further east, its foothills separate India from Myanmar, while a mosaic of marshes, mangrove swamps and tropical forests open out towards Bangladesh. In the south is the Deccan, a triangle formed by Bangalore, Mysore and Coorg, where the coasts are washed by the warm currents of the Indian Ocean.

India's many topographical and climatic variations support a multitude of animal and plant species. Although seriously threatened by demographic pressures, the natural wealth of the country is surprising. Almost 15,000 types of plant-life have been recorded, while species of mammal, reptile, bird, insect and fish run into the thousands, with almost 200 considered to be

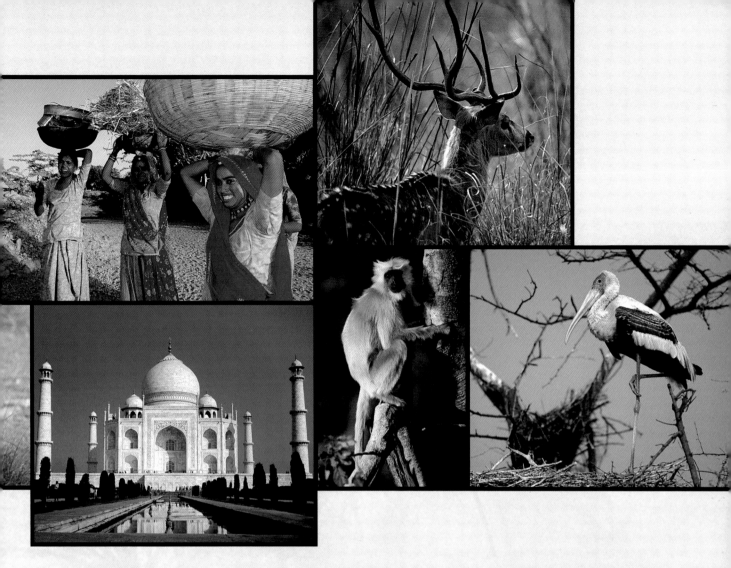

in danger of extinction. Apart from the unicorn rhinoceros and the wild elephant, the tiger is unquestionably the worldwide symbol of the battle to save India's wildlife environment. The sub-continent is so big that climatic conditions vary greatly from one region to the next. In the continental regions explored in this book, March to May is the hottest period with daytime temperatures frequently reaching 45 degrees C. During the monsoon season – from June to September – temperatures also remain pretty high at around 35 degrees C. Meanwhile, destructive, yet life-saving, violent rains flood the fields and villages and trigger landslides, but they leave behind a luxuriant vegetation and humid atmosphere conducive to both man and beast. Then in November, the temperature begins to drop significantly. During the day, temperatures are between 22 and 26 degrees C and do not rise again until February.

This is the weather to expect when roaming in the land of the tiger. Although Panthera tigris is found in numerous other reserves throughout India, we found the best viewing territory for this animal was in the country's northern half. Ranthambore recalls an age of colonial big game hunting amidst the vestiges of ruined temples, the latter often concealing wild animals; while the Bandhavgargh and Kahna national parks will not fail to remind you of Kipling's magical descriptions in his famous Jungle Book. In the mountainous scenery of Corbett, you will be guided by the tiger's trail and that of the wild elephant, whose stardom it challenges. Bharatpur provides a pause in this journey through the land of the striped feline. In fact, the tiger is absent from this up-country bird sanctuary which is home to countless thousands of birds. Finally, the original setting of the Kaziranga National Park ends this journey on the tracks of Asia's big cat.

Ranthambore

East of Rajasthan, where the Aravelli mountain chain meets the Vindhya Plateau, is the site of the legendary Ranthambore National Park. This is located at the heart of what remains of the Sawai Madhopur Forests, named after the little town situated a few kilometres from the park, and is celebrated as the ancient hunting ground of the maharajas of Jaipur. Designated a wildlife sanctuary in 1955, before playing an active part in the 1973 Tiger Project, Ranthambore was elevated to the status of National Park in 1980 and is particularly noted for wildlife observation. It is a small park whose central area covers 400 square kilometres and to which can be added the associated Kela Devi Reserve in the northeast and the Man Singh Reserve in the south. In total this amounts to over 1,300 square kilometres of protected space.

Apart from its many natural treasures, Ranthambore has a precious historical heritage of temples and pavilions throughout the park which provide a picturesque setting where animals have long found protective lairs. Built in the tenth century on an enormous rocky promontory, the eponymous fort is the central feature of this important heritage and the ancient seat

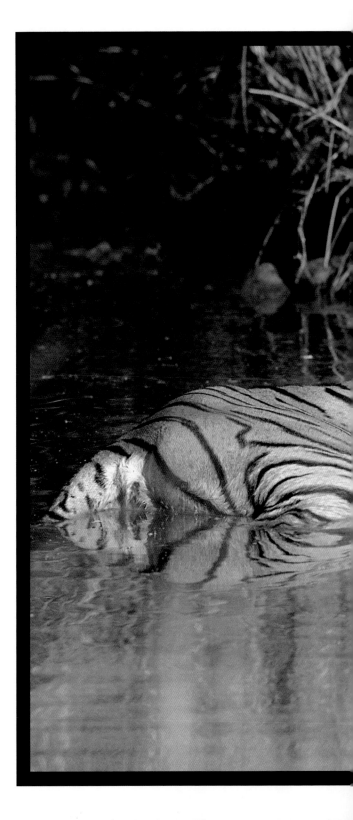

The statistics for tigers in Indian parks are often unreliable. At Ranthambore, it seems the population barely reaches 20 animals. The park provides these large creatures with vital waterholes in which they like to immerse themselves for long periods to cope better with the scorching hot days before the arrival of the monsoon, and they do not hesitate to pursue their prey in these ponds. This shot was taken with a telephoto lens in the warm light of early evening.

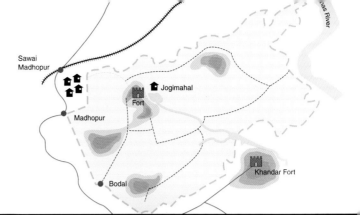

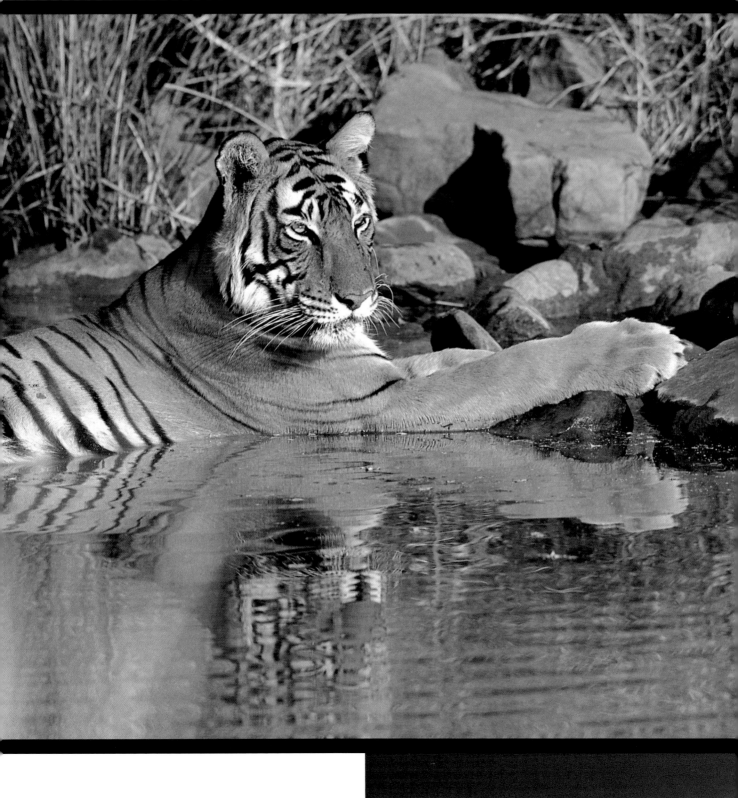

In the heart of Ranthambore forests, this winding water course gives the scenery a certain charm which is sometimes reinforced by the presence of a tiger. For this shot, the use of a medium focal length lens has eliminated the sky and concentrated interest on the river and its over-hanging branches.

The rhesus macaque – this one disturbingly eyeing the photographer – is widespread throughout India. It is most often seen on the ground in open spaces where it forages for the plants, insects and spiders that comprise its diet. This contrasts with the Hanuman langur, however, which prefers wooded areas. Such adaptability encourages it to colonise all types of habitat at altitudes up to 3,600 metres. Familiar with humans, these monkeys can be photographed with a medium focal length lens.

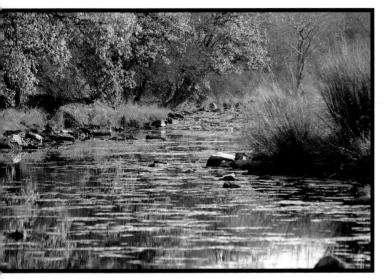

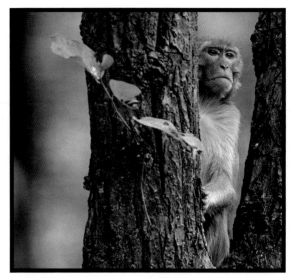

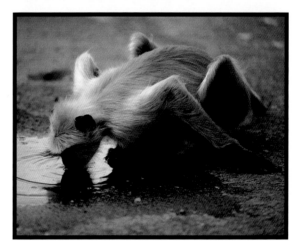

of a Hindu kingdom over which Rajputs and Moguls fought for many years. A huge building with thick, crenulated walls, it still welcomes neighbouring villagers who make the pilgrimage to Ganesh, the very popular elephant headed god, bringer of wisdom and wealth. The Banas River to the north and the Chambal River to the south provide the natural borders to Ranthambore. Between the two, the parkland undulates from massive rocky formations fractured here and there by open escarpments along the wide valleys. The centre of the park features half a dozen lakes and ponds which are a major attraction to wildlife, especially birds. All this results in the distinctive charm of the scenery and confers upon the various sites a fascinating mood of faded splendour. This is a place where the delicate flowering lotus and water-lily contrast brutally with the decaying forest and the bushy grasslands, which are criss-crossed by numerous streams.

On the banks of a small lake, this ancient temple is mirrored between aquatic plants whose flowering seasonally embellishes the setting. To get this type of shot from across the road, a medium or long focus lens is needed. Sometimes small groups of sambar deer feed here and cross the shallow waters.

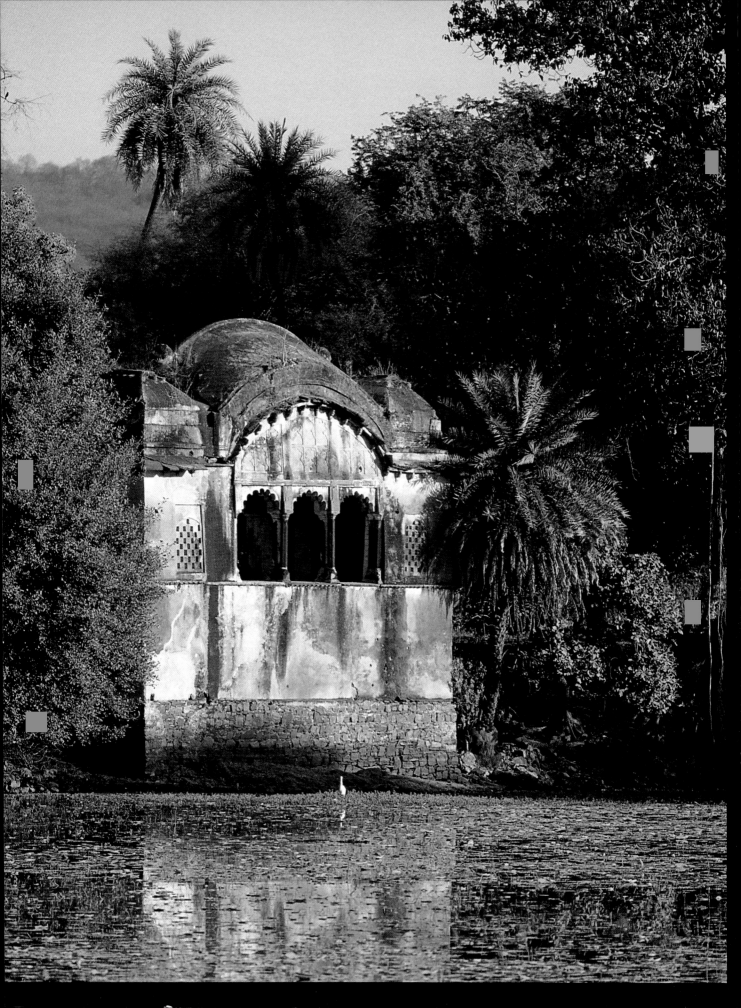

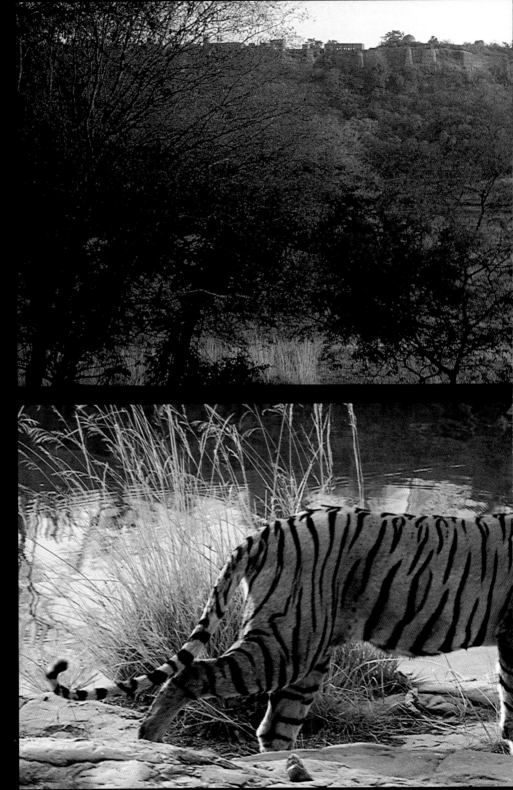

Ranthambore's forest landscape, punctuated by waterholes, is clearly an ideal habitat for the tiger but, as elsewhere, it is a difficult creature to find and observe. It is often better to wait for its appearance, although tigers are not very active in the daytime. Since the roads are often some distance from the ponds, it is best to deploy a long focus lens to photograph this cat. A medium focal length is useful in scenery where a tight framing of the total setting is your aim: in this case, the walls of the fort, rose-tinted by the morning light.

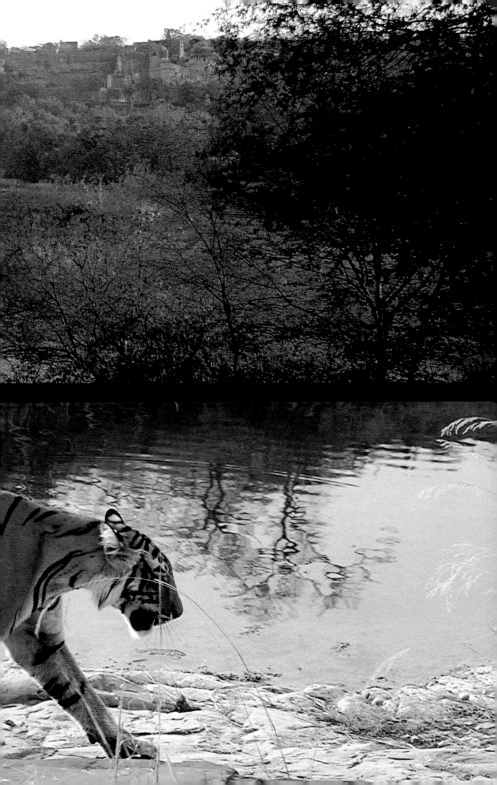

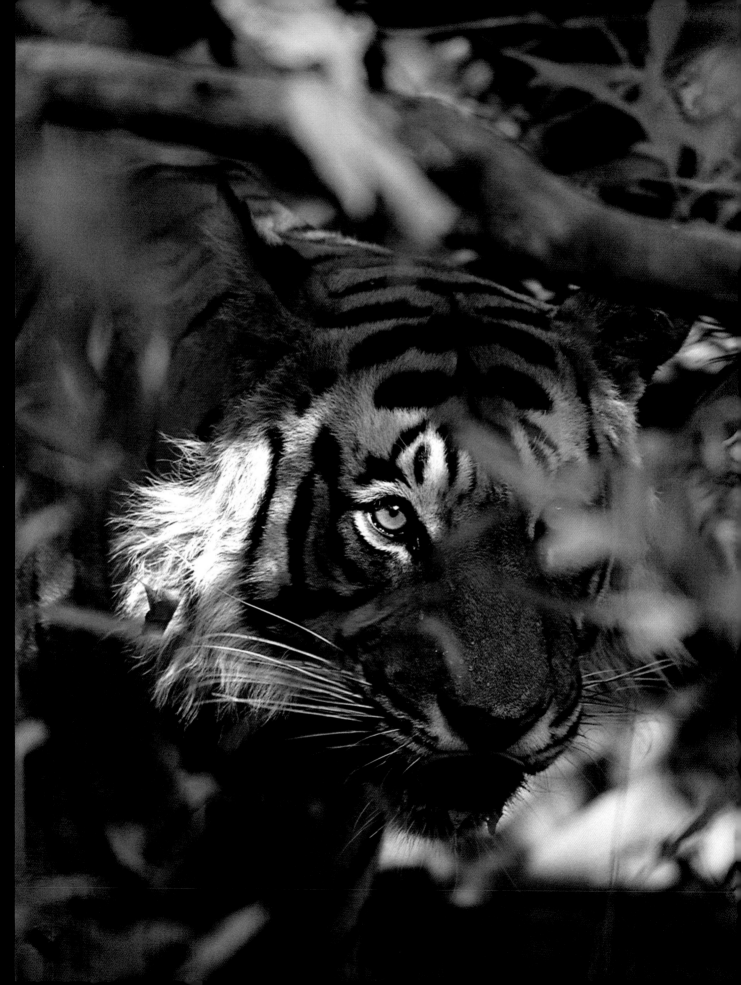

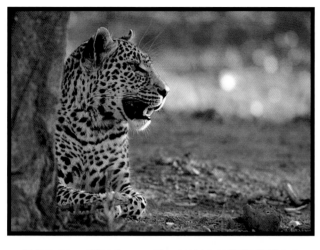

Finding a leopard lying on the ground alongside the road is rare, although that doesn't mean it avoids following the tracks made by vehicles or other animals. But the animal does not like being bothered, so a telephoto lens is needed to get a shot like this. Likewise the same focal length was needed to shoot this sloth bear. This nocturnal animal feeds mainly on fruit and insects and it is exceptional to encounter a sloth bear during the day.

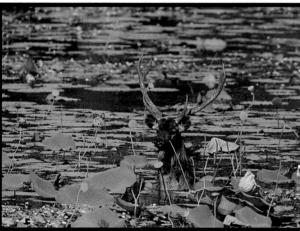

An excellent swimmer, the sambar won't hesitate to cross rivers and lakes, leaving only its head and metre-length antlers above water. Alone or in small groups, this deer eats the aquatic vegetation while an egret sometimes perches on its back removing unwanted parasites. A long focus or telephoto lens is essential for this type of shot because the road does not always follow the water's edge and the animal may keep its distance.

For a tiger, the jungle is always the best cover. Here it roams discreetly out of sight and even when the lush vegetation, fed by recent rains, contrasts with its fiery coat, it remains barely discernible. So use a long lens to shoot the best portrait. In this shot, the face, partly obscured by foliage and the shaft of sunlight illuminating its eye, reinforces the creature's elusive mystery.

Ranthambore protects 30 species of mammal of which the most mythical representative is, of course, the tiger. This creature enjoys total protection which discourages, if not totally eliminates, poaching. Solitary and discreet, the relative tranquillity he enjoys has encouraged the big cat to show himself in daytime. Consequently, the tiger can be seen today near waterholes where it comes to drink and look out for prey. His furtive shadow haunts the undergrowth and triggers the alarm call of Hanuman or grey langurs (monkeys) and chital deer; the latter, elegantly attired in spotted coat, are a popular food source for the big cat.

Deer, such as the sambar, are not scared to enter

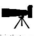

In late afternoon, when the sun sparkles amidst the vegetation, the photographer armed with a long focal length lens has been able to capture the curious but wary look of this axis deer. The same equipment is recommended to avoid scaring these fawns and their mother. The

female axis only gives birth to a single offspring at monsoon time, when the lush vegetation provides good grazing for all herbivores. Some females produce a second baby later in the year, when conditions are less favourable and there is a higher mortality rate.

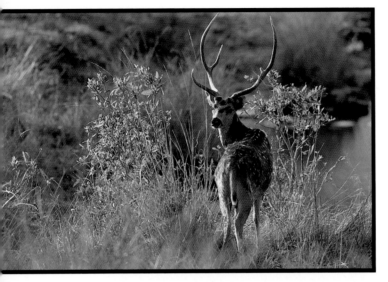

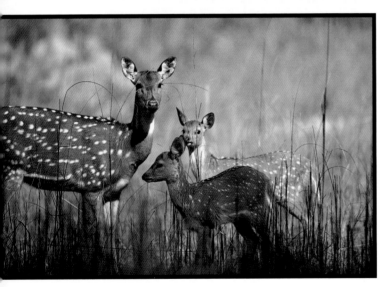

As well as a marked gender difference, the nilgai is an antelope which can go without water for several days, so seeking it at waterholes can be fruitless. A telephoto lens is perfect for seizing a shot of this shy animal. A long focus lens is needed for the langur

monkey seen here (opposite page) feasting on red tree blossom backlit by early morning light. Since the roads don't always allow a close approach, a monopod is useful to give stability in a vehicle when aiming high to avoid intrusive foreground vegetation.

the water and use it as an opportunity to eat aquatic vegetation, while cattle egrets perch on their backs and diligently remove parasites. Not far from here, crocodiles drowse on a wet mud bank unconcerned by the presence of a pair of great thick-knees. The nilgai is the largest antelope in the park; the male has a greyish-blue coat and the female a blond coat. Rarer is the Indian gazelle, known locally as the chinkara, which avoids revealing much of its elegant silhouette through the sun-dappled leaves. Like the chital – or axis deer – the chinkara is one of the leopard's favourite meals. Incidentally, the leopard population in the park is twice that of the tiger, and although difficult to see, all kinds of small cats also populate the forest's shadowy faraway nooks. The jungle cat, leopard cat, fishing cat, wild cat and the caracal are all here, though rarely seen by visitors, they leave only footprints, fur or droppings as proof of their presence. The hyena, honey badger, porcupine, mongoose, small Indian civet, Bengal fox and monitor lizard all have a stealthy presence in Ranthambore which makes them hard to see. The sloth bear, too, leads a semi-clandestine life and is undoubtedly one of the most sought-after species by visitors.

More than 250 types of bird live at Ranthambore. Among them, it is not uncommon to see a crested serpent eagle or even a Bonelli's eagle, warming itself on a branch in the morning sun, while

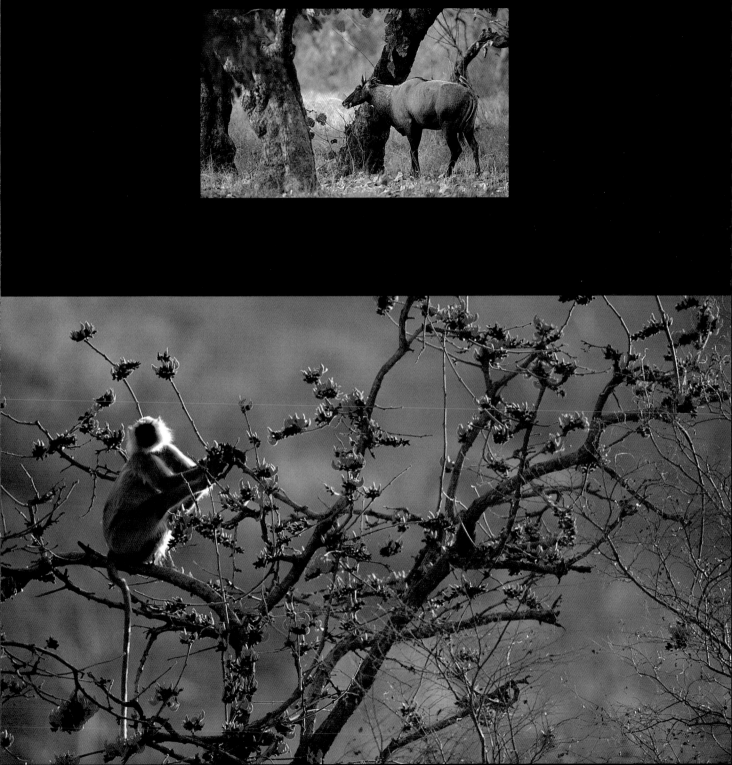

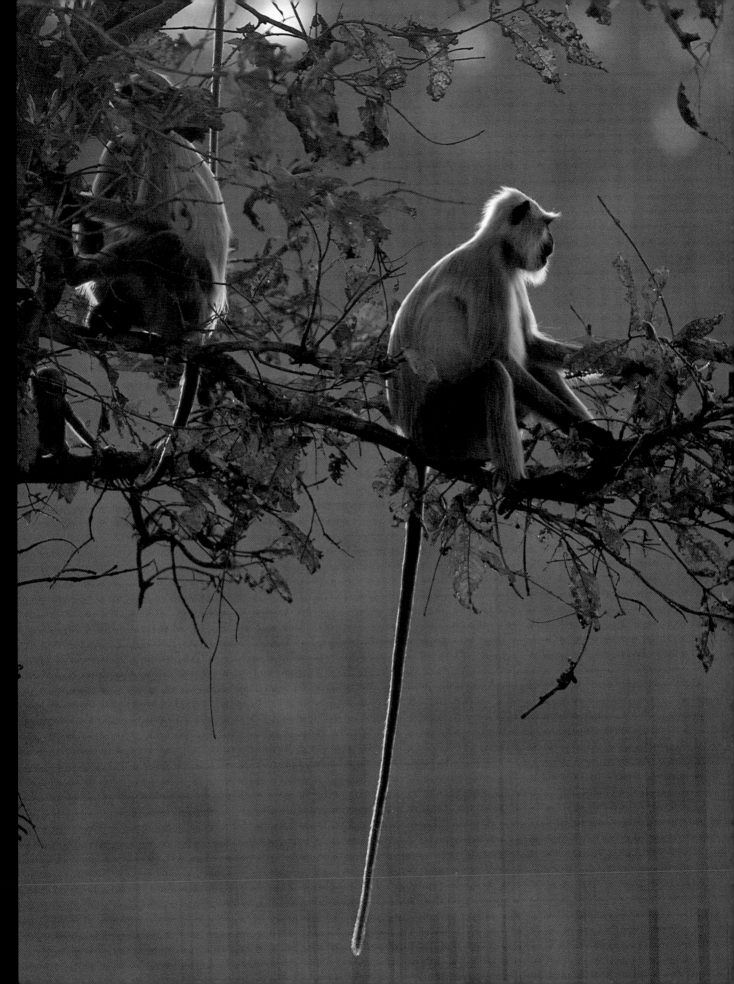

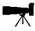

The langur monkey acts as the chital's 'shepherd', by giving an alarm call it warns of approaching predators. To capture the brightly lit contours around this bearded tree-dweller, a long focus lens pointing towards the sun produced the best result.

The crested snake eagle is fairly common and easy to see. This juvenile made loud, piercing cries which caught the photographer's attention. It was possible to take this shot thanks to a 500mm lens balanced on a beanbag, set on the cradle of the vehicle. The same technique was used to photograph these spotted owlets perched on a branch.

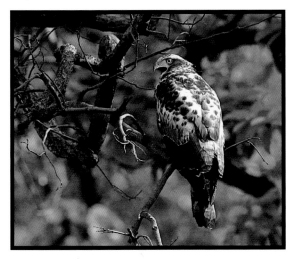

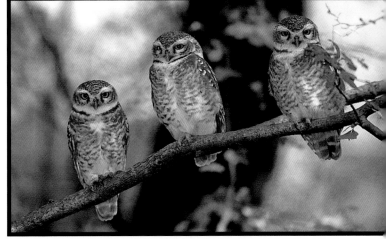

rose-ringed parakeets, in their green plumage, are already very busy tending their nests. Along one of the tracks that cross the park a hollow tree trunk hosts baby collared scops owls whose eyes remain closed as the safari vehicles pass. Close to ponds reflecting colours of bronze and steel, the black-necked storks, spoonbills, egrets, painted storks, cormorants and darter, as well as multitudes of ducks all seek subsistence. Numerous birds abandon their nesting grounds north of the Himalayan barrier to winter under the clement skies of Ranthambore. Other residents of the park include the colourful Indian roller, yellow-footed green pigeon, black drongo and the small minivet. Ranthambore's enigmatic and penetrating mood offers a wonderful initiation into the secrets of Indian wildlife.

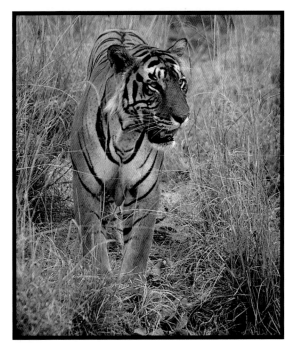

The disruptive markings on the tiger's coat, makes it difficult to detect in long grass. But sometimes it approaches safari vehicles and rewards the patient photographer. In these circumstances, a medium focal length lens is generally sufficient to take a portrait shot of the big cat, but be sure to work silently, without sudden movement, to avoid an unexpected reaction from the animal.

In Bandhavgarh, the hilly terrain can make it difficult to approach a tiger unless you ride on the back of an elephant. The mahout will adroitly lead the elephant towards the tiger without disturbing it. In this way it is possible to take such shots with a medium focal length lens, which is ideal for this type of picture. A longer lens would not only be too heavy and difficult to handle but also impossible to keep steady on the back of an elephant.

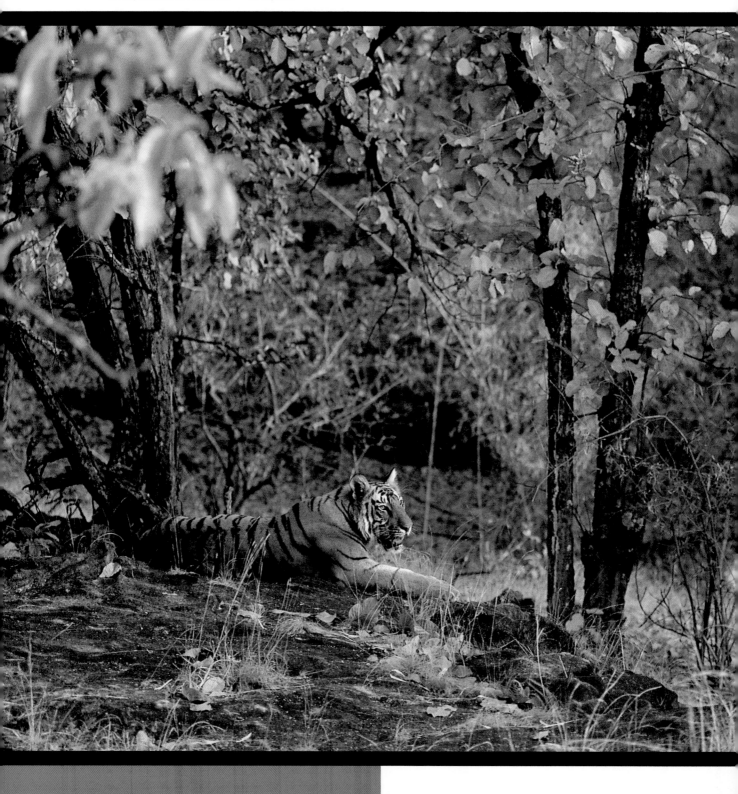

Bandhavgarh

Nestling within the Vindhya Hills in the northeast of Madhya Pradesh State, Bandhavgarh is an old hunting reserve that once belonged to the maharajahs of Rewa. It was here that the famous white Rewa tigers were first observed, the last specimen of which was captured in 1951. Some years later, in 1968, part of the reserve was converted into a wildlife sanctuary. However, it was only in 1980 that it was designated a National Park. In 1986, steps were taken to expand the park through the addition of adjoining forestlands to the north and south which effectively increased the area to 450 square kilometres. Although not part of the Tiger Project, Bandhavgarh is one of the best places to observe the big feline either in a 4x4 vehicle or on an elephant's back. Bandhavgarh harbours the vestiges of an important historic heritage, notably an imposing fort whose ruins are today only assailed by exuberant vegetation. Built on the highest of 32 hills that punctuate the park, its 1,000-year-old ramparts overlook the surrounding landscape from hundreds of metres above.

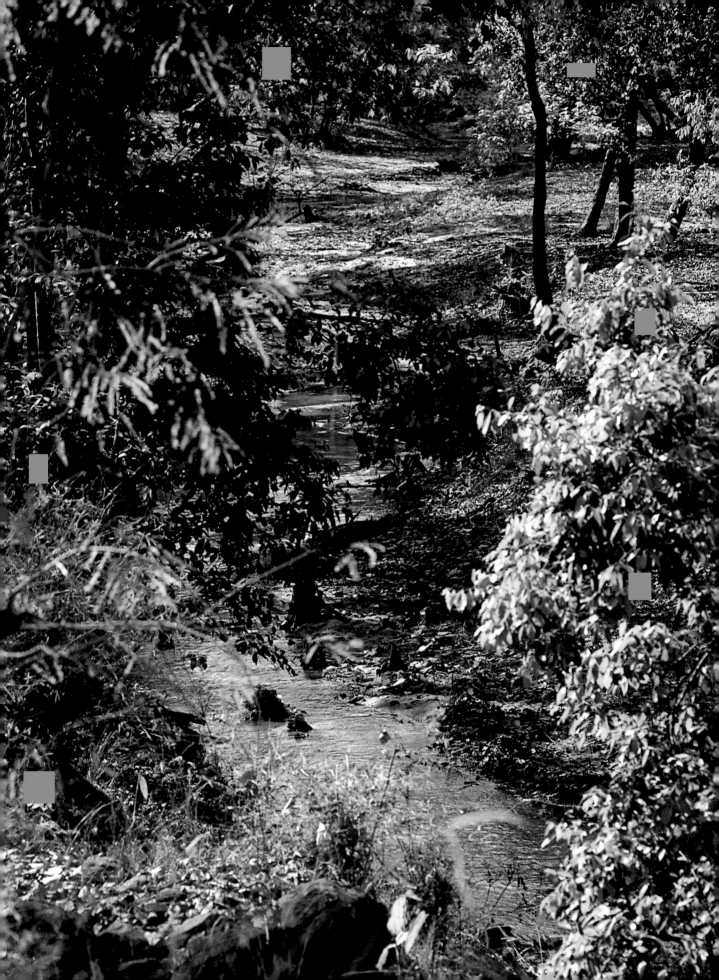

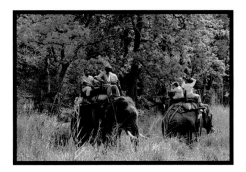 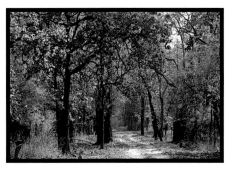

Most of the time, wooded locations have no grand outstanding features. Bandhavgarh is no exception here, so apart from details of foliage or flowers, photographs can document the environment in which the tiger and other jungle animals exist. In forests, whether or not there is a real subject in the shot, and if one only has a medium focal length lens it is best to search for a sunny clearing where the foliage filters the light to create dappled patches.

North of the fort, the presence of various grottos testify to ancestral habitation; others, decorated with religious inscriptions thought to date back 2,000 years confirm the existence of places of worship. Lower down the citadel is the reclining statue of the divine protector Vishnu who guards the source of the Charanganga River. Dating from about 1,000 years ago, this 11-metre statue is still an object of ritual veneration today. The site called Shesh Saya marks the beginning of the main access path to the fort which is lined with temples and statues. A beautiful walk on a somewhat steep path reaches the fort where the effort is rewarded by a spectacular panorama and, occasionally, an encounter with animals sheltering inside the fort.

From here, one can see the rocky but wooded hills that dominate the northern landscape. They are slashed by wide valleys, often with escarpments, sometimes forested and sometimes carpeted by meadows and marshes where most of the animals

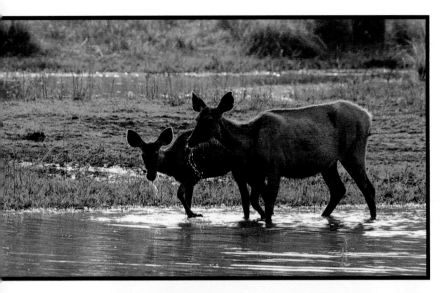

After a gestation period of eight to nine months, sambar calves are usually born in May or June just before the monsoon season. To photograph this mother and its offspring of the previous year against the light, it was necessary to wait until the end of the afternoon. The tight frame was made possible by using a long focus lens which made the most of the light – the sun's reflection on the water highlights the rimlit animals.

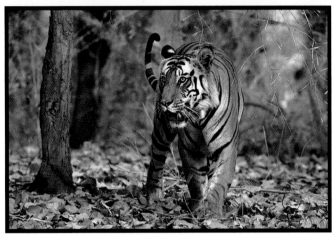

The amorous male tiger poses a mortal danger to a female's offspring. Like the lion, he kills her young before mating with their mother and thus perpetuates his genes. Once again, a long focal length lens was necessary to shoot this portrait, but a medium focal length lens can also be useful because the animals sometimes approach so closely to a safari vehicle, they will brush alongside it.

come to drink and graze. Further south, the contours soften as the hills and ridges give way to ancient farmlands abandoned by the villagers and overgrown by wild grasses. The Bandhavgarh area is mainly covered by light woodland dotted with clumps of bamboo. The undergrowth is calm and bright and inspires an almost magical, even bewitching, mood when the sun's rays dapple the foliage, dry or shiny depending on the season. When approaching the summit of the hills, the jungle gives way to a mixture of plant-life typical of the regions of central India.

Within this domain, 22 types of mammal and 150 species of birdlife coexist. The tiger is, of course, the star

The chitals generally prefer the big clearings and open spaces that intersect the jungle, the haunt of their constant enemies the tiger and the leopard. One meets those most frequently in groups of ten to 30, but sometimes an individual isolates itself from the rest as here. By chance, a ray of sunlight pierces the forest to illuminate this superb male and palm fronds thrusting from the ground. This luminous portrait was achieved with the help of a long focus lens.

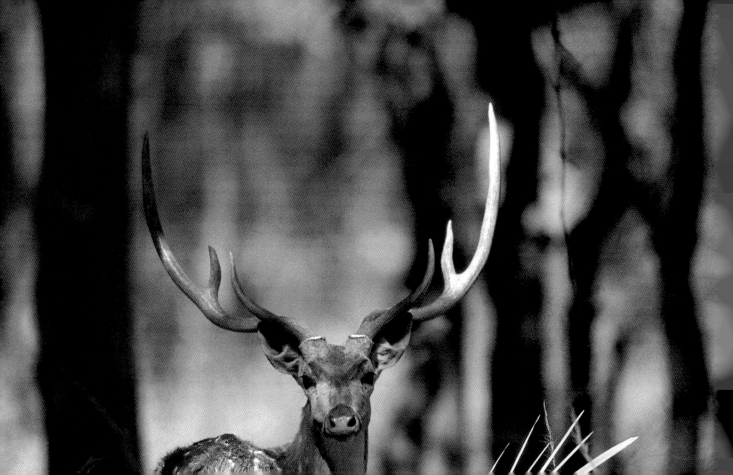

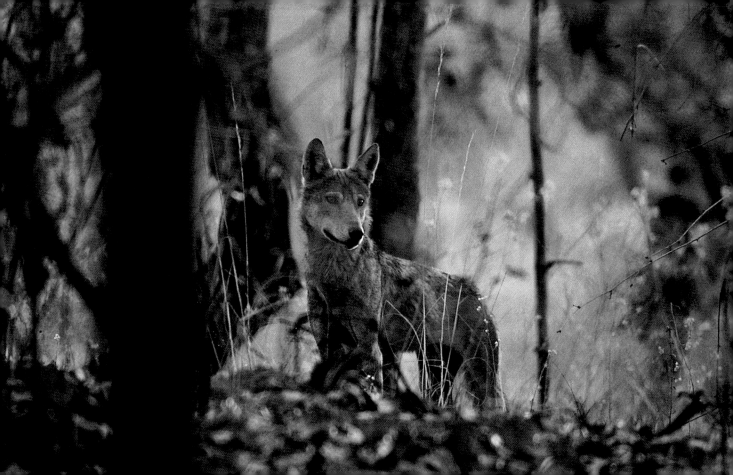

attraction. Its beauty and power, as elsewhere, have made it king of the jungle.

Bandhavgarh's jungle remains equally fascinating with its ragged contours and vegetation, bathed in sunlight, eclipsing and enveloping such a range of wildlife within its shadows. Apart from the herds of deer – notably axis deer (chital) and sambar – which provide the tiger and leopard with their favourite food, it is not uncommon to see wild boar foraging by the roadside under the mocking eye of langur monkeys safely ensconced in the trees. Less common is the rhesus macaque, whose pink face can turn bright red depending on the mood. Elsewhere, there are three types of canines in the park. These are the nocturnal golden jackal which can often be heard in the dark evenings; the dhole, a wild dog with a flaming coat and hooked muzzle and the wolf with its slender profile – unlike its cousins elsewhere in the world – lives in pairs, not packs. The muntjac, a small red gazelle, is addicted to dense forests but occasionally ventures to the edge of the woods to savour young plants. The very rare four-horned antelope, on the other hand, prefers open spaces close to vital water sources. On the heights near the fort, the blackbuck, whose males have long wavy horns, find a place to distance themselves from the tiger. But sometimes they encounter the gaur, an enormous Indian bison, which occasionally descends from the hills to graze on the central grasslands. Out-of-sight to visitors, unless they are very fortunate, are the pangolin, the ruddy mongoose, honey-badger, jungle cat, Bengal fox and small Indian civet, to name just a few which survive here but are rarely seen. They exist alongside reptiles like the cobra and the python, as well as the tortoise and a variety of lizards.

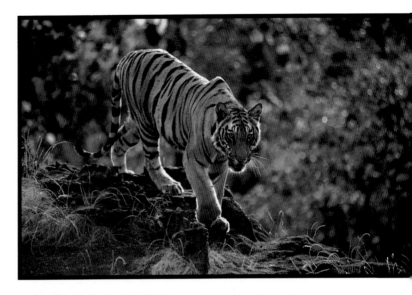

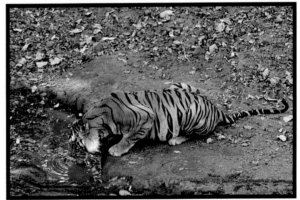

Thanks to an experienced and efficient driver predicting a tiger would follow the rocky hillock and come face to face with the vehicle, the photographer equipped with a medium focal length lens only had to seize the moment with this powerful predator enveloped in its shining halo of light. The same lens, light and handy, was used to take this shot of the tiger drinking. As the waterholes are frequently situated off-road, reaching them sometimes calls for the services of , a tame elephant and its mahout who leads it with his voice and by pressing his bare feet on the animal's neck. So it is just bad luck if the angle is not quite right for the best picture.

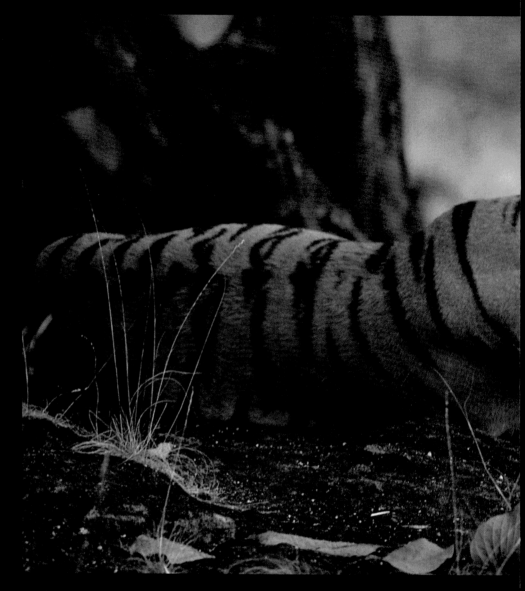

Here is the kind of photo that it is possible to take either with a telephoto lens if in a vehicle, or with a medium focal length lens from the back of an elephant. Like many felines, the tiger spends a lot of time sleeping or drowsing, which gives the visitor ample time to take its photograph.

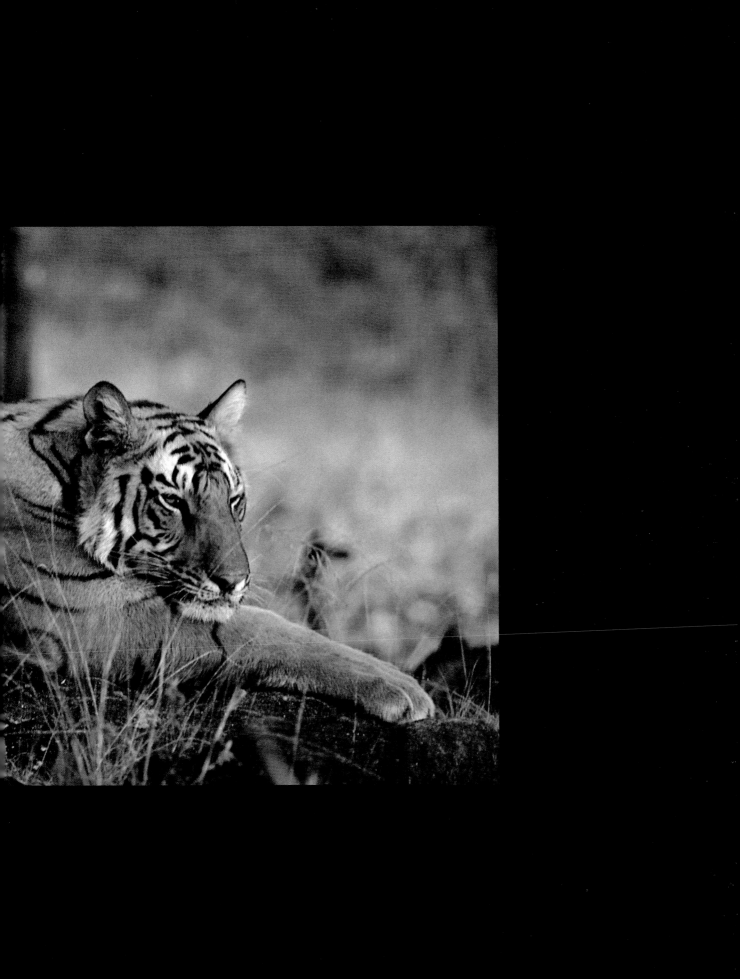

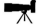

Whether photographing the
white-throated kingfisher (left) or
the Indian roller – two birds with
dazzling plumage – a long
telephoto lens is most suitable.
Such birds are often very mobile,
nervous and tiny, so it is essential
to use a 300 to 600mm
telephoto lens, sometimes even
with a multiplier or teleconverter,
to capture all the detail in the
feathers. Despite its more
imposing stature, the cattle egret
is no exception to this rule.

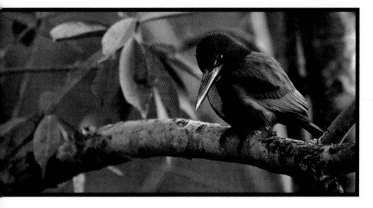

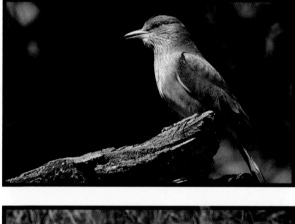

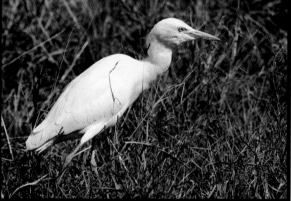

The birdlife includes bee-eaters, white-bellied
drongos and the white-browed fantail, not
counting a multitude of other fowl with equally
exotic names. In the branches of fruit trees, the
yellow-footed green pigeon and the blossom-
headed parakeet along with the distinctive
outline of the Indian grey hornbill can be seen.
But all are far removed from the vultures circling
above the sinister fortress whose ramparts they
have colonised. At the end of autumn, the park is
visited by the majestic steppe eagle which arrives
here to take up its winter residence. Overall,
however, the number of visiting migratory water
birds remains relatively low because Bandhavgarh
has too few waterholes to support large
populations of birds, even if they are only
seasonal. The vigilant protection of Bandhavgarh
sustains a wilderness where the palpable but
capricious presence of the tiger makes this park a
unique place for wildlife observation.

With the approach of the monsoon,
when temperatures touch 45
degrees C, tigers appreciate the cool
wetness of the swamps where the
high grass conceals them perfectly.
Here they are difficult to locate and
can be approached only from an
elephant's back. A medium focal
length zoom or a 300mm telephoto
lens is indispensable to shoot this
type of portrait.

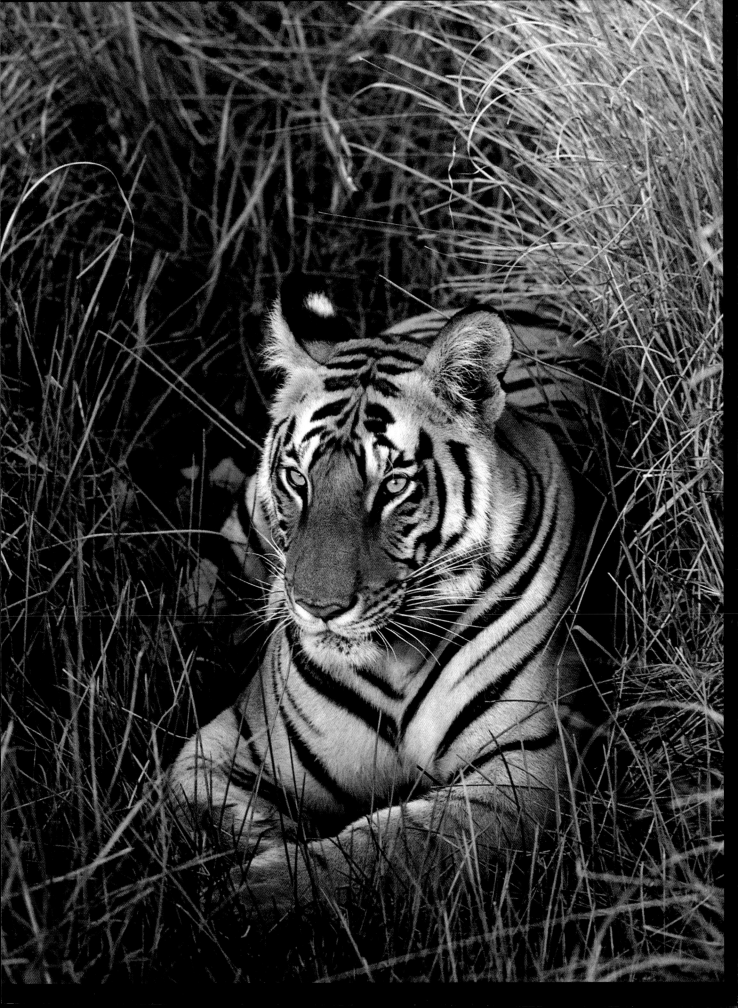

India shelters a significant population of leopards which are every bit as discreet as their African counterparts. Opportunistic, this is an animal which adapts to any environment provided that there is food. The tiger is its only foe. Although it's spotted cousin is more agile when climbing trees for protection or to stache its prey, the big striped cat is nearly four times heavier with unrivalled power that guarantees supremacy in most situations.

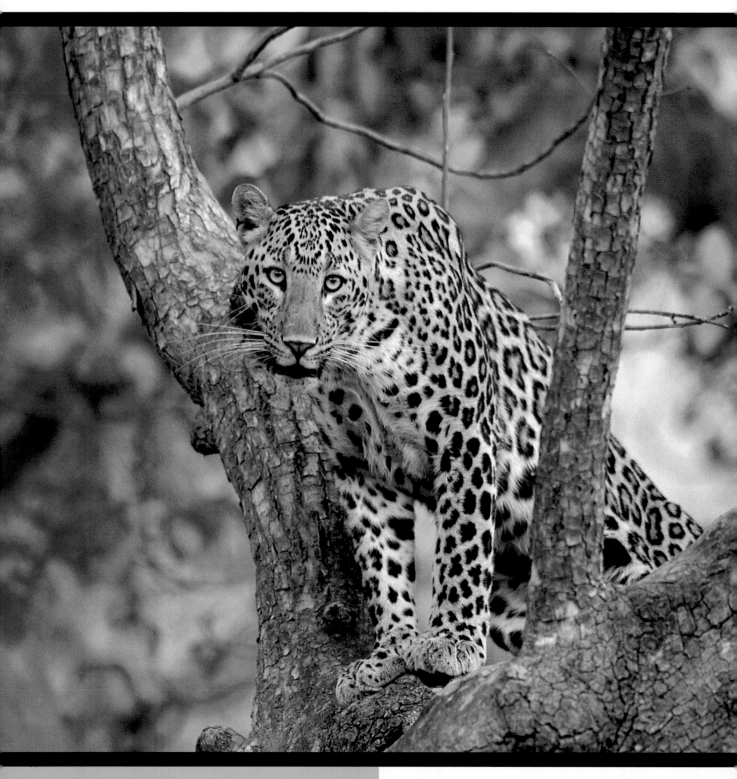

Kanha

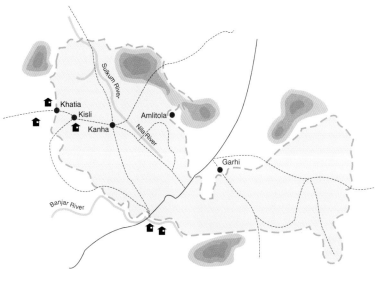

Situated in Madhya Pradesh State about 160 kilometres southwest of Bandhavgarh, the Kanha territories were initially, as so often in India, a privileged up-country hunting ground for the British from the beginning of the 20th century. However, its wildlife enjoyed protection from 1933 when it was decided to convert 250 square kilometres into a sanctuary. But the National Park did not see the light of day until 1955 after long negotiations and reversals had dogged its history. None of which stopped it becoming the first Tiger Project reserve ear-marked by the Indian government in 1974 to safeguard populations which had been dramatically reduced by hunting. The area embraced by Kanha has been increased several times by the addition or extension of land. Today it covers 1,945 square kilometres of which 940 square kilometres form the park's central precinct. This makes Kanha amongst the biggest national parks in India and is the main tiger sanctuary.

The topography of Kanha is distinguished by the presence of two key valleys forming a semi-circle: Banjar Valley to the west and

31

The chinkara, or Indian gazelle, is hunted for its meat in certain regions. Despite protection within the national parks and reserves, it is by nature cautious. Its escape route is important and a long focus lens is usually needed when photographing.

The same thing applies when taking a shot of the peacock as its colourful fan-tail opens. Often quick to run or take flight, you have to be in the right place, at the right time to photograph this bird displaying.

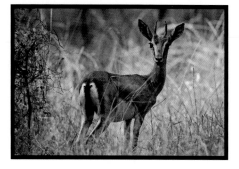

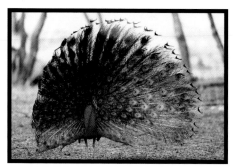

Halon Valley to the east. Covered by vast forested clumps, they are set into a maze of hills whose steep slopes sometimes break their cover of thick vegetation to accommodate large boulders. The park's northwest zone is closed by rocky projections that leave just enough space for the winding river to pass, while the final summits of the Mekal Mountains delineate the southern border. A multitude of water courses and gorges pattern Kanha's territory, liberally contributing to its blooming vegetation and the presence of an indigenous wildlife within its sumptuous scenery. It is no accident, therefore, that this Garden of Eden inspired Rudyard Kipling to write his wonderful *Jungle Book*. At the heart of this wild kingdom, the clearings – often ancient farmlands – bring sunlight to its bountiful vegetation. They are also frequently the meeting place for important gatherings of animals that come here to savour the tender grasses and bask in the sun after the night chill. Amongst the numerous herbivores, the most abundant are the axis deer which sometimes share their pastures with the blackbuck, the

A wide angle lens was used to capture soft and oblique backlight enhancing sparkling sunlight on the vegetation. The only problem with this type of picture – usually taken from a vehicle – is finding a good viewpoint from where to shoot.

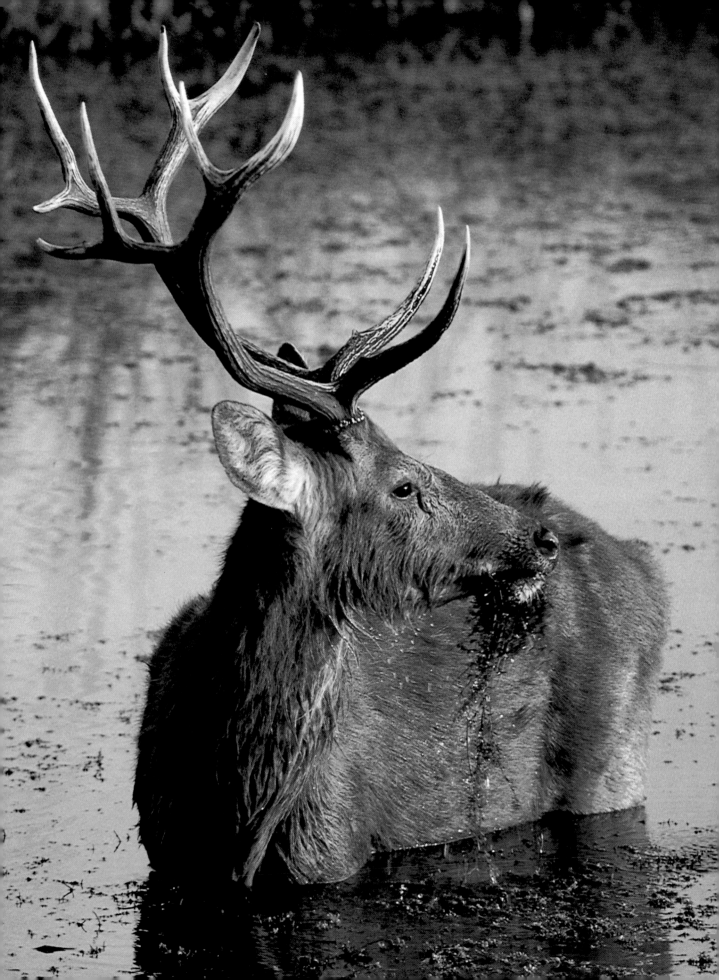

In the 1960's about 97 per cent of the barasingha population was eradicated from Kanha. Now protected, this elegant deer continues to multiply. As it spends a lot of time in the water, the photographer has ample opportunity to take original shots, preferably with a telephoto lens.

The nilgai exhibits some unexpected qualities. Little affected by the heat, it is capable of incredible speeds when chased and has highly developed eyesight as well as sense of smell. Rather than dense forests, it favours open environments and hilly terrain where trees are sparse.

Sometimes niglai venture into fields cultivated by villagers and damage their crops. This cautious antelope keeps a good distance, so a long focal length lens is essential.

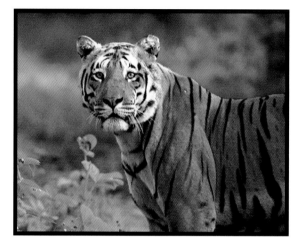

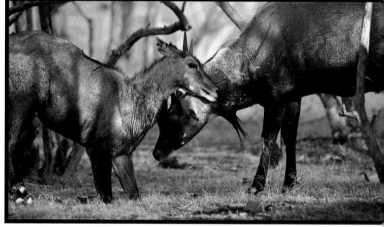

males of which have spirally twisted horns. The deer, known locally as the chital, are closely allied to langur monkeys whose alarm calls warn them of impending danger, usually approaching predators such as the tiger or leopard. As usual, the feline duo is dominated by the tiger whose presence here is more marked than its spotted and furtive counterpart. The leopard's semi-nocturnal habits protect it from the prying gaze of photographers and observers, unlike Shere Khan which is on full display. Kanha has the distinction amongst the parks of supporting similar populations of the two big cats. Elsewhere, panthers are usually more numerous, and although the park is renowned for tiger sightings, the swamp deer (called locally barasingha) challenges this animal's stardom. This elegant deer, native to India's heartlands, has come close to extinction but a protection programme has increased the Kanha herds by several hundred. It currently cohabits with the sambar, largest of all deer in India, and the shy nilgai, a solidly-built

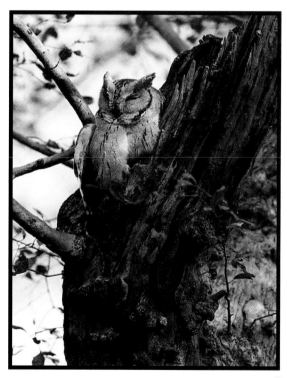

The little collared scops owl does not seem perturbed by the presence of visitors. He hasn't even opened one eye, and awaits the evening to resume his activities. Impossible to photograph at night, the photographer must be satisfied with existing conditions. A long focus lens is indispensable for this type of picture.

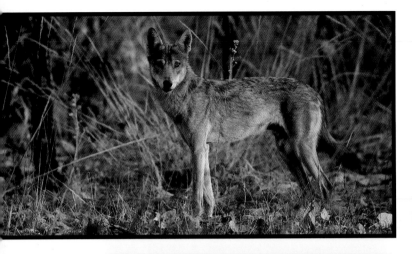

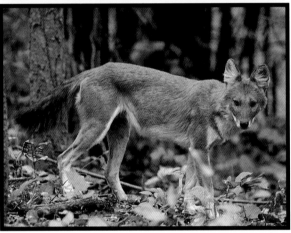

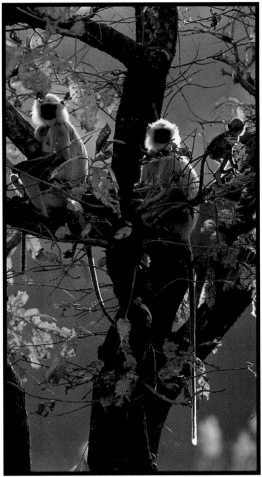

antelope to be seen in its preferred habitat of light undergrowth.

During the day, the thick vegetation on the hillsides conceals the big silhouette of the gaur. Gregarious (but timid) and the world's largest bovid, the gaur vanishes from sight after grazing on the grassy clearings in the mild morning. It is not unusual to come upon a pack of dhole or Indian wild dogs returning to their forest retreat in the south of the park. Perhaps they will pass close to the sloth bear den, a rocky cavity to which this plantigrade withdraws until resuming activity after nightfall. Calls and chirping in the woods and meadows also indicate the presence of a remarkable birdlife which, according to studies, numbers 200 to 300

Be careful not to confuse the wolf (above left) with the dhole dog (below left). Other than their physical distinctions, the two canines can be differentiated by their lifestyle. Unlike the Indian wolf, for example, the dhole lives and hunts in packs. This permits it to attack large prey and even, in exceptional circumstances, to attack bears, tigers and leopards. Both daytime operators, the wolf and the dhole are quite shy and not easily observed or approached. A long focus lens is therefore the photographer's best friend.

Contrary to its imposing stature, the gaur is not aggressive, its size discouraging its enemies. It is happiest in hilly and wooded terrain to which it retreats during the hot daytime temperatures and rarely shows itself. The huge dimensions of the gaur allow for good pictures with a medium focal length lens.

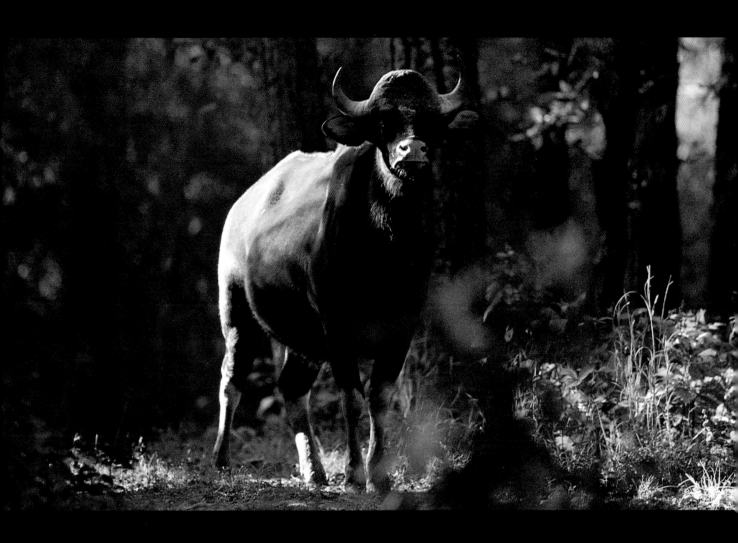

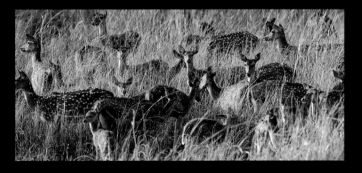

The solution for concentrating
light – as on this group of axis
deer – is to wait for oblique rays
at the end of day. Use a long focus
lens to crop out the bright sky
which would spoil the quality of
the picture.

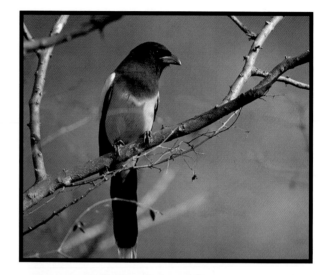

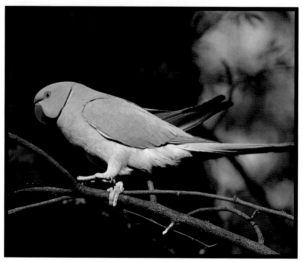

species. The fanned plumage of the majestic peacock is always a captivating spectacle. But the air also hums from the flutter of greater racket tailed drongos, green bee-eaters, paradise flycatchers, and other birds chancing to cross the sullen flight of the lesser adjutant. Birds of prey are represented by the delicate black-shouldered kite, the laggar falcon, which frequents arid landscapes; the shikra sparrowhawk, which, like the crested serpent eagle, prefers light woodlands; and, finally, the opportunistic long-billed vulture, circling over the jungle's casualties. An old reservoir located at the centre of the Kanha prairies in winter attracts numerous water birds, including a multitude of teal of all types. Almost a twin of Bandhavgarh, Kanha National Park is the living and intact embodiment of Kipling's *Jungle Book* to which it lent colour, light and atmosphere.

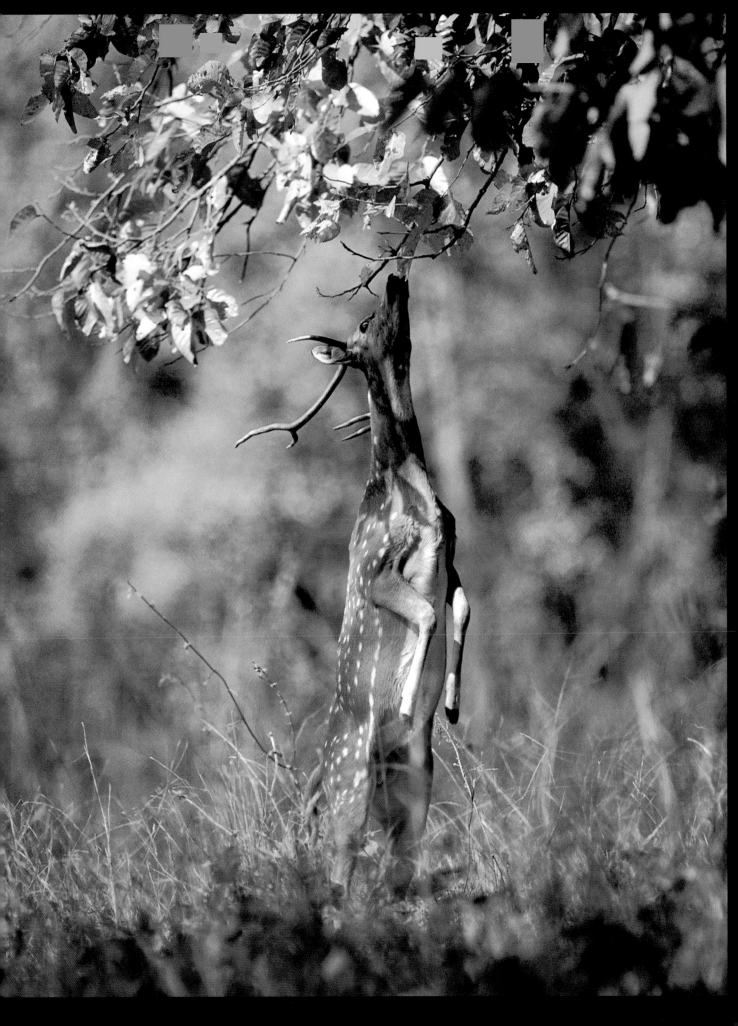

Corbett

In the mid-19th century, deforestation ravaged Corbett, not only to supply the timber industry of the British colonials but also to help the local inhabitants dependent on agriculture and cattle for their livelihood. This degrading of a site which had already revealed enormous natural wealth, attracted the attention of a certain Major Ramsey who decided that protective measures were called for before it was too late. Consequently, controls were introduced over agriculture and cattle activities and the felling of trees to gradually restore the wilderness areas. Early in the 20th century this led to the idea of transforming Corbett into a wildlife sanctuary. However, this suggestion was promptly rejected because tiger hunting was still a popular pastime of Indian high society and the British Raj. But 30 years later, under the initiative of the governor of United Provinces, Sir Malcolm Hailey – an environmentalist ahead of his time – India's first National Park was created and named after its creator. It was rechristened Ramganga National Park in 1952 following Indian independence, but renamed again in 1957 in memory of Jim Corbett. Initially a hunter, a naturalist and then a photographer, Corbett contributed greatly to the park's preservation and was among the first to participate in the Tiger Project in 1973.

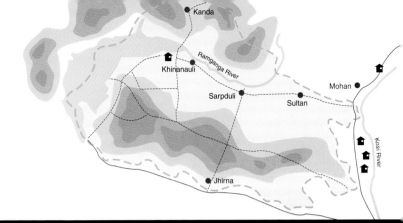

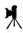

At sunrise, Corbett's rolling landscape is blanketed in an orange mist that wraps this silent wilderness in a mood of enchantment ripe for creative work. A wide angle lens will faithfully capture the scale of this tableau and its colour shades.

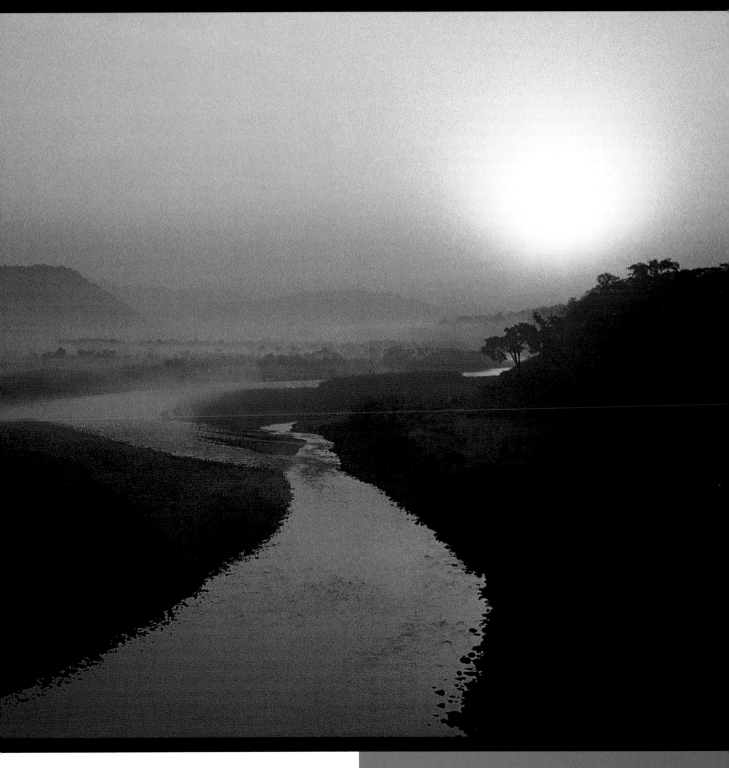

Herds of axis deer, or chital, generally make up the park's largest population of herbivores. In spring, the rutting period sees the males engage in violent combat in order to win breeding rights with the available hinds. Although aggressive amongst themselves, the stags seem curiously timid when confronted by humans. So it is best to photograph the scene with a telephoto lens to avoid upsetting their behaviour or interrupting the unfolding picture.

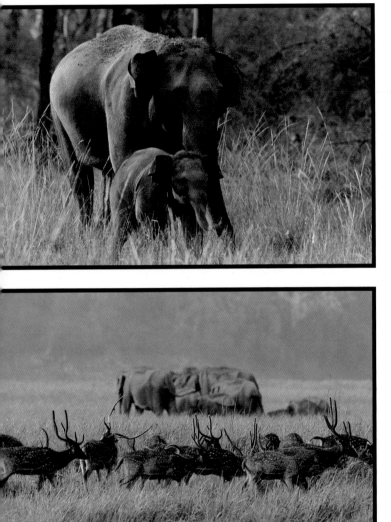

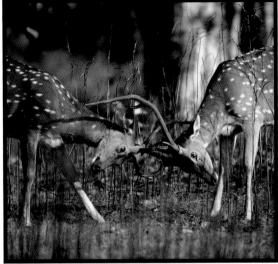

Although it is easily scared, the untamed Indian elephant occasionally appears aggressive. It then pays to have a long focus lens to hand. This helped to avoid upsetting a mother and her offspring and also to capture a full frame shot as on the right. While the Indian elephant has certain features that distinguish it from its African cousin, its social life in family groups is very similar.

Today, Corbett's protected area covers 521 square kilometres.

The park extends to the foothills of the Himalayas in the South Patlidun region of Uttaranchal, with the altitude ranging from 400 to 1,200 metres above sea level. Three mountain chains cross the park, each east-west, while numerous hills and swampy depressions furrow the landscape. North of the long central chain, stretches a wide steep-sided valley through which winds the Ramganga River. This enters the park from the northeast and flows into a lake of the same name that designates the park's western border. The lake was formed in 1970 by the construction of the Kalagarh Dam, one of the largest in Asia which, when full, immerses about ten per cent of Corbett's surface. Apart from the lake, the Ramganga River is the park's only permanent source of water. Bisecting the countryside, its numerous streams dry out in summer – from March to June –

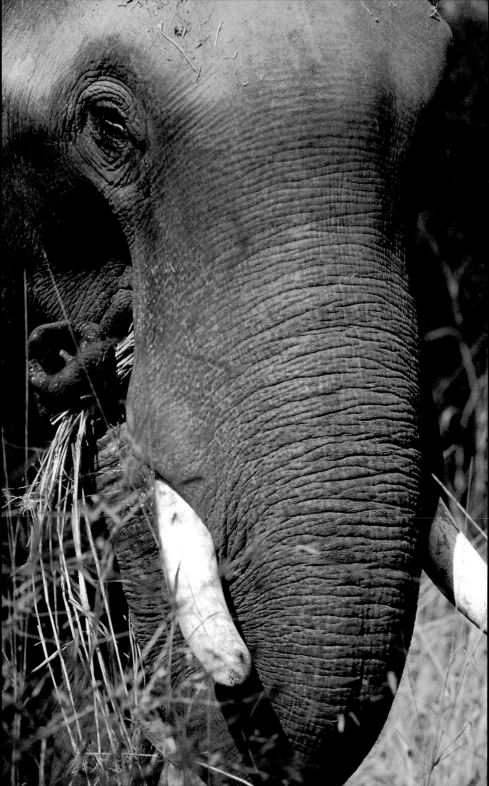

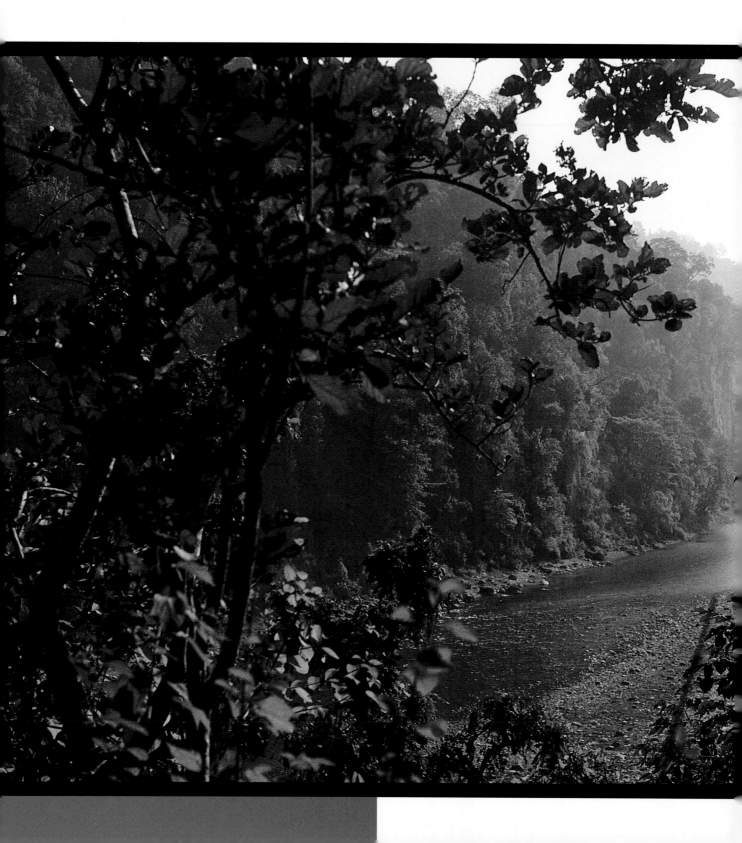

The course of the Ramganga River slices through Corbett's scenic grandeur, producing spectacular escarpments worth photographing. When a hazy atmosphere softens the vegetation, just take out the wide angle lens and shoot. On the other hand, it is pointless trying to picture a gavial crocodile at the foot of cliffs. A telephoto lens is needed to distinguish the embossed armour-plating of this endangered reptile which is sometimes more than six metres long.

leaving behind a dusty terrain dotted with stagnant waterholes around which animals eagerly congregate.

Densely wooded, Corbett's contours harbour a considerable variety of plant species, dominated by the tall and straight trunks of the sal trees. On the former cultivated lands that mainly occupy the park's central area, wild grasses nourish all types of animal life but also conceal their approaching predators. Wild elephant and gray mongoose are the attraction at these spots,` where the hog deer can also be seen; the latter is solitary by nature but not too solitary when it comes to sharing good pastures. He completes the big cats' inventory of preferred prey which also includes the chital deer, sambar and muntjac. These predators are unrivalled big beasts coexisting within the confines of Corbett.

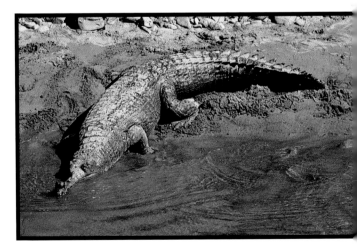

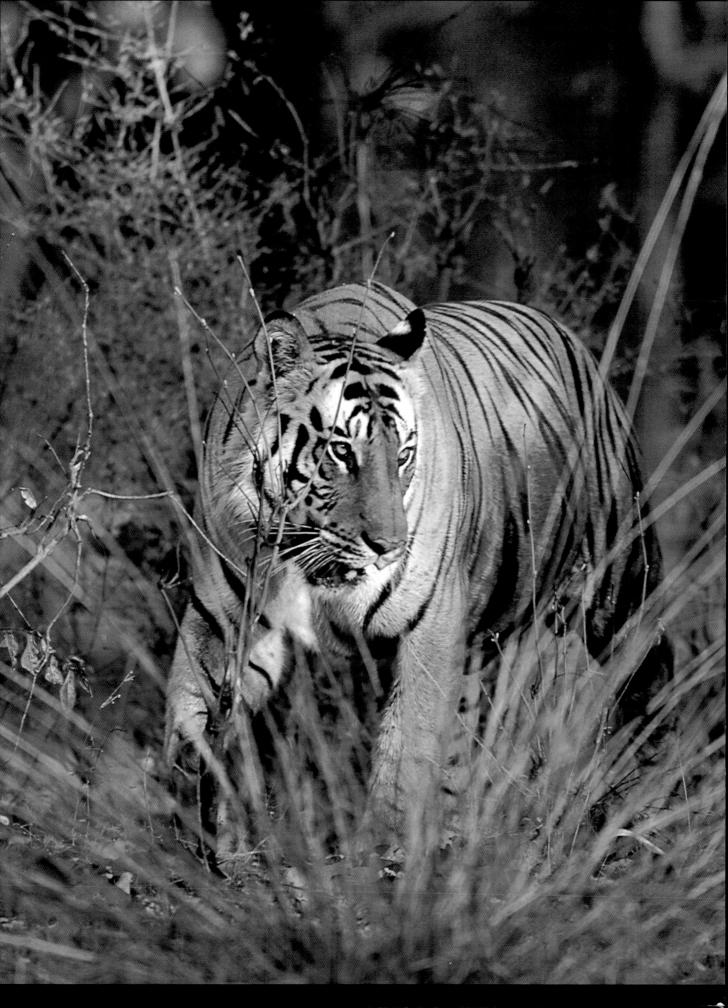

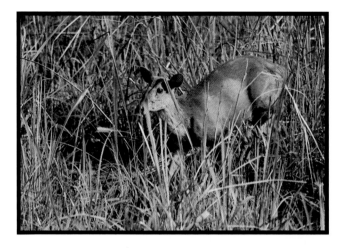

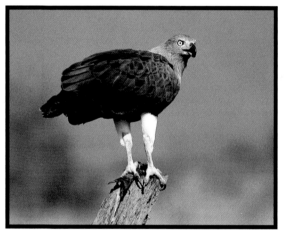

The long grass provides useful protection for herbivores like the muntjac and the sambar (respectively, above and below left) where they can hide away to avoid the piercing gaze of predators. They keep a good distance from both visitors and predators, so a long focus lens is essential here. It is also handy when tight-framing a shot with subtle light bathing blond grass. There is no point switching lenses to capture the hypnotic gaze of this grey-headed fish eagle posing on a stump near the river.

Renowned for its tigers, Corbett is a park where they are regularly observed. The complete protection now bestowed on tigers has even induced individuals from outside the park to take up residence. For this shot, opposite, taken with a telephoto lens, the best angle was the lowest possible frontal shot of the animal to illustrate its absolute power. This angle also included an untidy foreground of out of focus grass and twigs from which the tiger seems to emerge.

In fact, leopards prefer the hilly uplands, leaving the lowland jungles to the tigers.

With a greyish-gold coat and short horns, the rare goral is a type of goat that has adopted the steeper terrain where it forages and feeds at dusk and dawn. The fauna that populates the park is considerable, although not always easy to spot. A meeting with the leopard cat, jungle cat or the fishing cat is not too likely. Similarly, the sloth bear is rarely seen far from his hideaways in the north of the park. As for the pangolin and the palm civet, their nocturnal habits keep them away from visitors. Seeing a red fox or a rhesus macaque is, therefore, much more likely. But the river offers more hope. Here it is possible to see the Eurasian otter and spot the gavial, a curious

Along with the langur, the macaque is, without any doubt, the most common of the north Indian jungle monkeys. Yet it rarely penetrates deeply into undergrowth preferring instead the well-lit edges where it forages for the insects and plants essential to its survival. It prefers moving on the ground than in trees and is not fearful of humans who sometimes provide easy food pickings. So a medium focal length lens was used to take a picture as the macaque alights on a low branch.

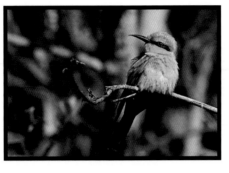

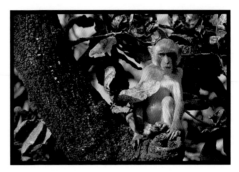

Comfortable in open spaces and relatively widespread, the green bee-eater is one of those small coloured birds whose portrait necessitates a long focal length lens. Lively and unpredictable, like most birds, it has to be confident or very busy before allowing itself to be photographed.

crocodile species equipped with a long, narrow snout for catching fish and crustaceans on which it normally feeds. Located on the main migration routes, Corbett – already renowned for some 500 species of birds – has been greatly enriched by new species attracted by an increased expanded water area created by the dam. Amongst the transient birds, large numbers of web-footed waterfowl and limicoles enliven the banks of waterholes under the stern gaze of the osprey. Residents include numerous water birds such as the darter, the cormorant and crowds of herons, black-necked storks, egrets and spoonbills. The shikra sparrow-hawk, black eagle, white-rumped vulture and many others dwell here permanently. Elsewhere, the huge woodland copses on the hills and the banks of the Ramganga shelter peacocks and various types of parakeet, hornbill and cuckoo as well as woodpecker, minivet, fantail and drongo. Corbett's exceptional natural wealth undoubtedly makes it one of India's foremost locations for observing wildlife. It also accounts for some of the country's most documented wildlife.

On the ground, tigers and leopards avoid one another. Attacks are always to the disadvantage of the leopard, with a weight of 60 kilos presenting little protection against a 300 kilo tiger. Depending on distance, medium or long lenses allow for beautiful shots. For tigers, it is fundamental that the angle of the shot be as low as possible so that the look is straight into camera and expresses the full danger of this animal. As for the threat inspired by the leopard, this is best captured by its furtive shadow and with just a hint of light in the fixed stare.

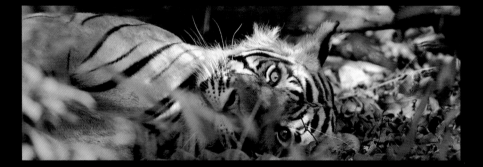

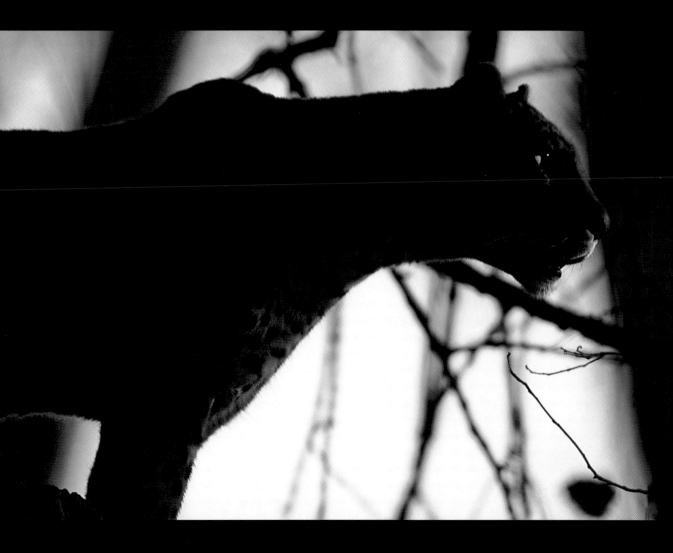

A flight of hundreds of egrets and spoonbills, their plumage immaculate, always presents a magnificent sight. It is, therefore, critically important to take the shot at the very moment when the wings flap in the backlight.

The dense vegetation creates a dark backdrop that highlights the luminosity of the birds. Depending on where the photographer finds himself, a long or medium focal length lens is recommended.

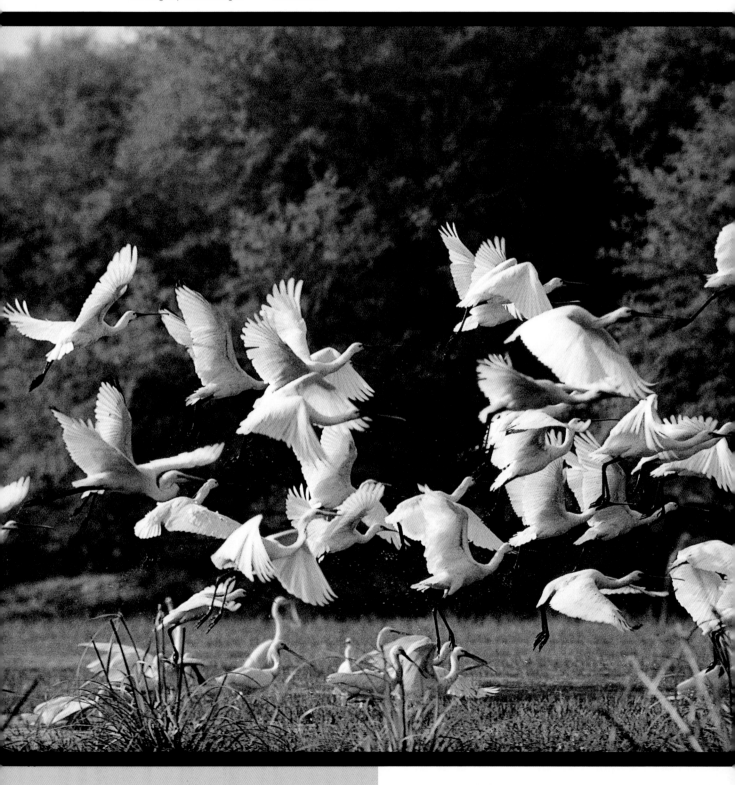

Bharatpur

The map shows locations including Bharaptur, Jatoli, Keoladeo Temple, Chowki, Ghana Canal, and Chiksana Canal.

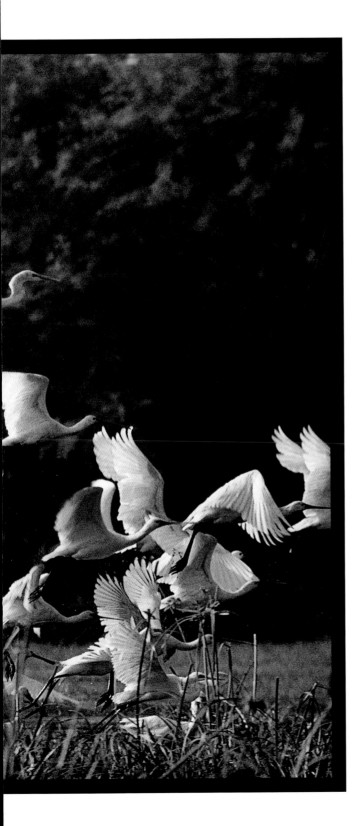

Located in Rajasthan, Bharatpur was once little more than an arid savannah scattered with trees and bushes. The perspicacious Maharajah of Bharatpur noted, however, that the terrain presented a natural depression with the capacity to retain great quantities of monsoon water and, in the process, to attract abundant birdlife. Sensing the site's potential, he had a number of small dams created in a matter of years, at the end of the 19th century, the new eco-system soon attracted thousands of birds. The Maharajah had created for himself one of India's most important hunting reserves. To this remarkable venue he invited his intimate friends and political connections to participate in legendary hunting parties where thousands of birds would be bagged in a single day! And although the game park was converted to a sanctuary in 1956, the use of shotguns continued until 1972 as tourists and villagers were also free to enter the area without restriction.

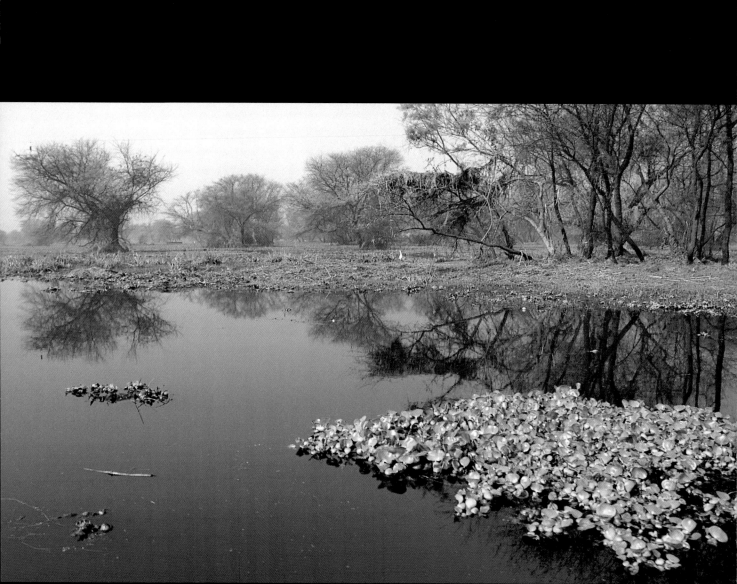

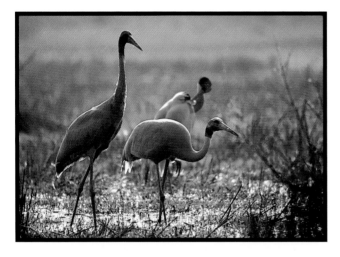

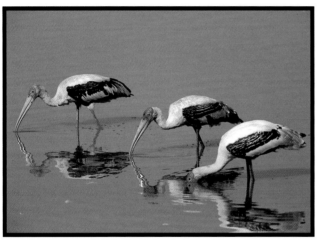

To bring an end to these anarchistic practices, not to mention their impact on the environment, Bharatpur was transformed into the Keoladeo Ghana National Park in 1981 which brought 29 square kilometres under its protection. About two-thirds of the park is made up of three lakes with levels that vary according to the amount of rainfall. The largest, occupying the northeast half of the park, is fed entirely by rainwater from the Ghana Canal which crosses its centre. Second largest is Lake Koladahar, which extends to the extreme southeast. The smallest, Lake Mrig Tal, fills the park's northwest quarter.

Elsewhere, numerous shallow swamps adjoin dense forests dominated by a variety of acacia trees which provide valuable nesting sites. Bharatpur's humid environment also encourages a particularly rich flora that is more than adequate to meet the nutritional needs of this abundant wildlife. The coexistence of all these birds in such a small area is facilitated by the particular diets evolved by each species. Without this, how else could these ponds, even rich as they are in micro-organisms and fish, possibly produce the tons of daily nourishment needed by all the park's residents?

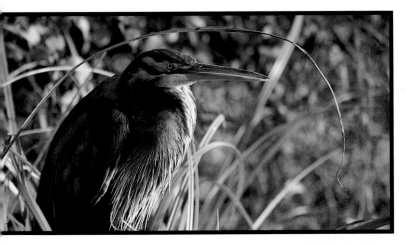

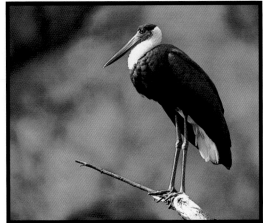

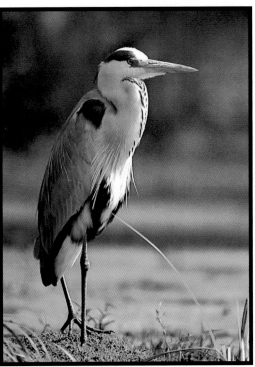

Some 400 species of birds are attracted to the park, one-third of which are migratory birds arriving from the four corners of the globe. The latter come to overwinter in Bharatpur's agreeable climes before returning to distant breeding grounds - some as far away as Siberia, China or Central Asia. In total, there are nearly 120 species that actually nest together within the park. Some branches host up to nine different bird species, while the trees close to the water teem with noisy colonies of waders whose enormous concentrations have mainly contributed to the fame of the Keoladeo Ghana marshes. The renowned heronries number in their midst the grey heron, the purple heron and the black-crowned night heron, not to mention the little egret, intermediate egret and the great egret. It makes up an endless inventory of birdlife to which can be added the cormorant, darter, painted

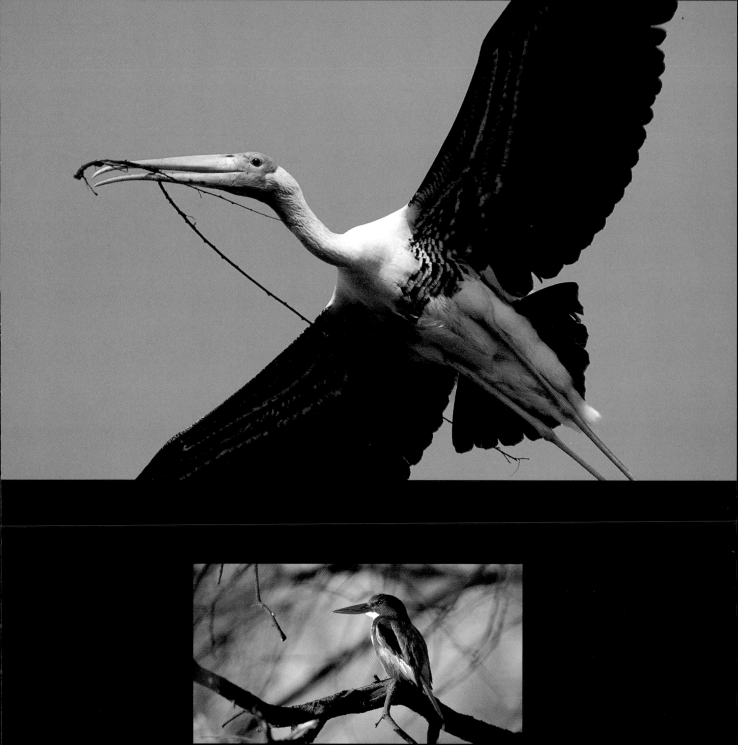

To photograph a bird in flight like this black-necked stork it is advisable to set the shutter on high speed priority. The same advice applies when attempting to capture the sarus crane's mating ritual which, incidentally, can also occur outside its normal reproduction period. A telephoto lens allows the photographer to keep a safe distance without disturbing the birds' activity. A telephoto lens is also required to shoot the darter whose serpentine neck acts like a spear when its beak harpoons a prey. Again, the same gear is appropriate when photographing the angry looking lesser adjutant, which tends to enjoy the dry period before the monsoon because it reduces the waterholes to small puddles and concentrates the fish which makes them easy to catch.

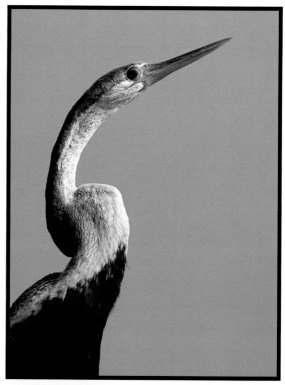

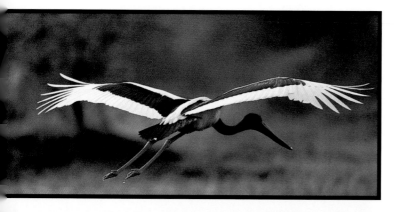

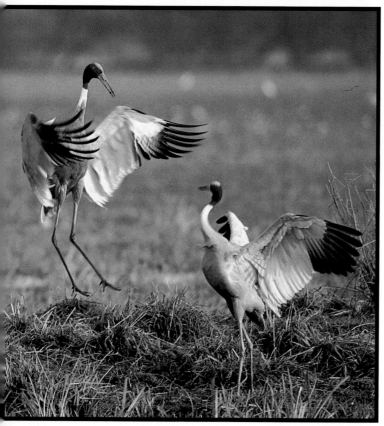

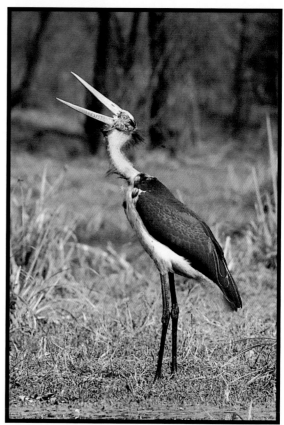

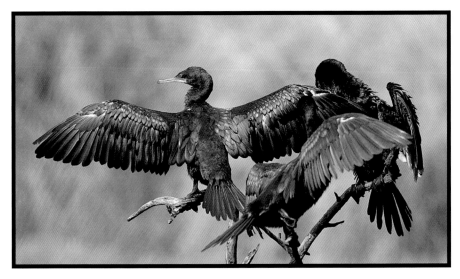

Cormorant feathers are not waterproof. After diving into ponds in search of food they therefore have to spread out their wings to dry them. The posture of these birds then offers some creative originality as the sun sinks and highlights the detail of their plumage. A telephoto lens facilitates a tight framing of the subject.

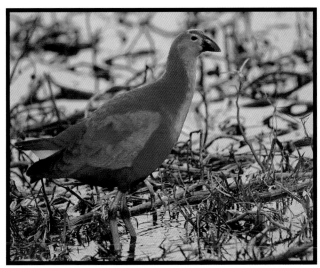

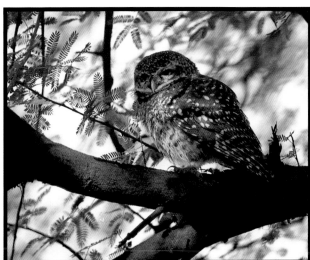

It would seem somewhat difficult for the purple swamphen to pass unnoticed with such an intensely blue plumage, but she succeeds in doing so, particularly when covering her floating nest. As for the spotted owlet, even though it can be observed during daylight more easily than any other nocturnal bird of prey, it can be difficult to find amongst the foliage, although a ray of sunshine can help. A long focus lens was essential for both shots.

stork, Indian openbill, Eurasian spoonbill, black-necked stork, lesser adjutant and black-headed ibis.

In the tangle of relatively less populated water rushes, strolls the cosmopolitan common moorhen, while a jacana picks its way over the broad leaves of a water-lily, anxious to get back to its nest hidden in a clump of floating vegetation. In October the first ducks, geese and teals (of all kinds) begin to arrive, along with plovers, sandpipers and snipes which settle

The bronze-winged jacana is one of eight jacana species in the world. It feeds on aquatic weeds and small invertebrates and, like its cousins in other continents, scampers better over floating plants than it flies over a long distance. Pond herons, are widespread throughout India and the mimetic plumage of this solitary bird makes this it difficult to detect except when out in the open. Because birds are rarely approachable, a better shot will be gained by using a long focus lens.

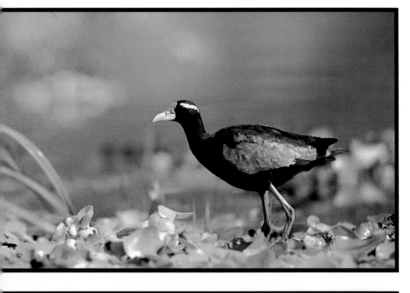

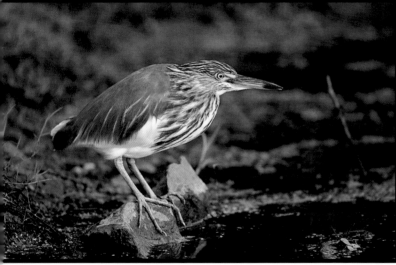

Spoonbills live in colonies, which often present opportunities to take beautiful shots of them by using a telephoto lens or, depending on the situation, a zoom lens set at a medium focal length. Spoonbills gather in wetlands where they feed on fish, insects and other small aquatic animals. They then return to their tree nests, typically made from twigs and lined with waterweeds.

alongside pelicans. But the star of all these migrants is undoubtedly the Siberian crane. After a long and complicated journey of more than 6,000 kilometres, these cranes arrive in December and take up quarters until March. Although a loyal visitor for centuries, the crane population in Bharatpur continues to decline, but despite its rareness, the national park owes its classification as a world heritage site to the presence of the crane. Birds drawn to humid sites are, however, not the sanctuary's only seasonal visitors. Wagtails, pipits and buntings travel long distances to spend the winter months under beautiful Indian skies. Many other birds spend the whole year in Bharatpur. Therefore, it is also possible to admire the flashing dive of the pied kingfisher, the nuptial parade of the sarus crane, the acrobatic flight of the red-wattled lapwing and many other sights as well. Among Bharatpur's 32 birds of prey, the steppe eagle, osprey, Eurasian marsh harrier and the pallid harrier constitute the main migrants, while the crested serpent eagle, tawny eagle, and the brahminy kite remain in the park throughout the year.

Although the park's main consideration is bird watching, the ground fauna is no less interesting to observe – especially during the summer months when it is common to see wild

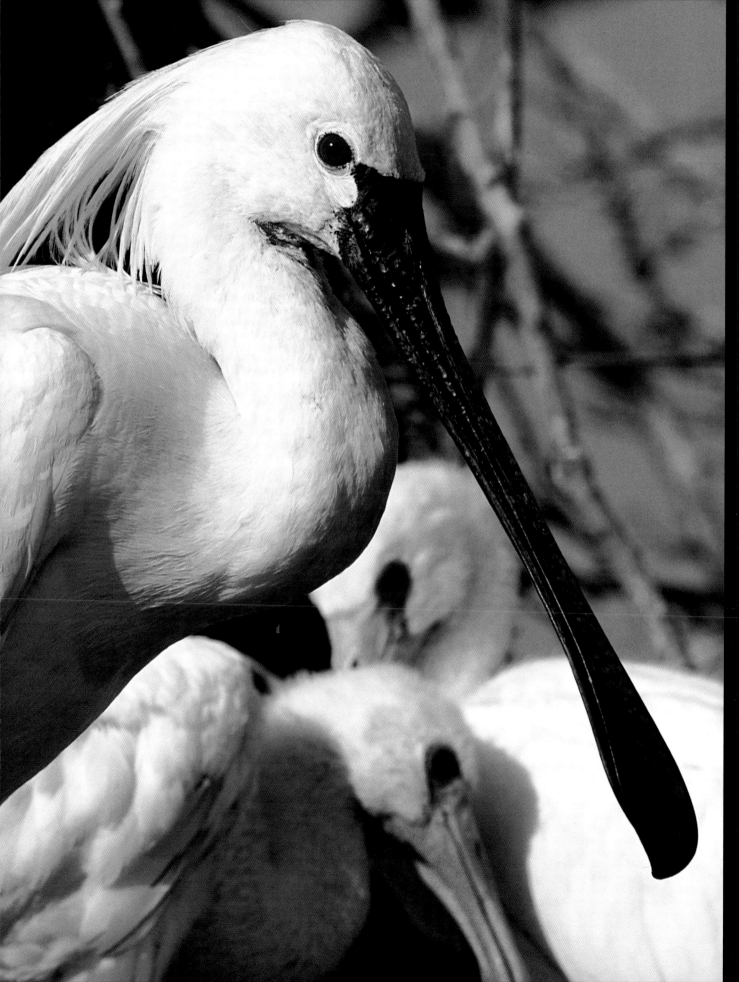

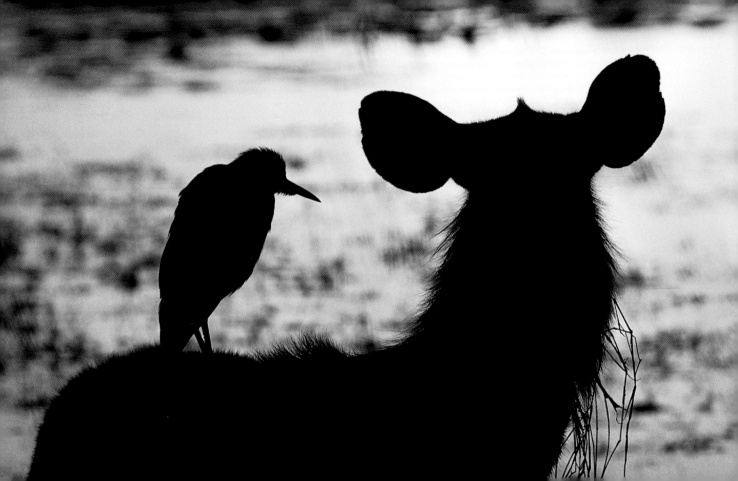

The golden jackal adapts to just about any environment. In India, it is found in humid forests, savannahs, deserts and, exceptionally, even at altitudes of over 3,500 metres. Being nocturnal animals seeing them in daytime is a bit of luck for the photographer. This may occur either in intense heat, which forces the animal to look for water, or in overcast conditions that darken the sky. In all cases, a long focus lens is best used for this subject.

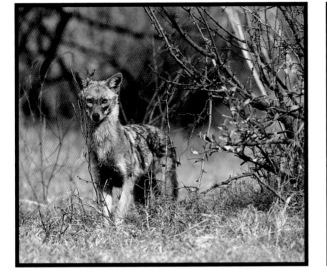

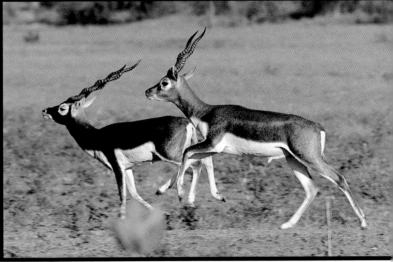

boar in the undergrowth. The nilgai antelope and the sambar frequent the humid prairies, unlike the chital deer which prefer drier areas in the south and west of the park where one can meet the elegant blackbuck. The tapering shadow of the grey mongoose is, on the other hand, a familiar sight along the reserve's trails; while the otter plays hide-and-seek in the brackish water. When night falls, it's the turn of the golden jackal, the jungle cat, the fishing cat and the hyena to go hunting. The list of small mammals is even longer, but unfortunately few of them are visible because their activities are mainly nocturnal, which allows them to escape the pressures of tourism.

Bharatpur is a genuine ornithological paradise, a privileged location at which to study avian fauna, where the remarkable variety of bird concentrations even compensates for the absence of the tiger.

Like much of India's wildlife, the blackbuck is quite shy. When it makes off, its running is characterised by a gallop interrupted by little jumps. Shutter priority and a fast speed setting with the use of a telephoto lens are the keys to catching them in mid-jump.

The sambar deer spends much of its time in the water which this shot on the opposite page illustrates well. To achieve this lighting effect, a long focus lens is absolutely essential. It alone can concentrate light in this way. The sun's violent reflection on the surface of the lake provides a flamboyant backdrop against the simple silhouette.

61

Kaziranga

To the northeast of Assam, wedged between the mountainous Mikkir massif and the mighty Brahmaputra, Kaziranga's wilderness unfolds upon the southern bank of the sacred river. As is often the case in India, the park was initially a big game reserve and then became a protected area in 1926. However, tourist access was denied until the end of the 1930s. Then the reserve was transformed into a wildlife sanctuary in 1940 and eventually accorded the status of National Park in 1974. Today, it extends over 430 square kilometres and shelters the world's foremost population of unicorn rhinoceros – currently estimated at more than 1,000 animals – or about ten times the number recorded early in the 20th century. Situated near a wide flood valley by the wooded hills of Karbi Anglong, Kaziranga provides a very different environment to other Indian parks. Here are neither jungles nor steep mountains but wide open spaces dotted with thickets and carpeted with abundant grassland nourished by the annual monsoon floods of the Brahmaputra.

The violent overflowing of the river each year kills many animals and forces the survivors to seek refuge on higher ground. Rather like a migration, one sees the beasts

India's unicorn rhinoceros grows to more than 1.70 metres at its shoulders which classes it, in terms of size, just behind the African white rhinoceros. Its horn, however, is smaller, rarely exceeding 24 centimetres. This, unfortunately, does not prevent poachers hunting it even in the protected areas, a practice which is made that much easier because rhinos adhere to the same tracks and defaecation sites. Although the animal seems peaceful, it is best to photograph it with a long focus lens.

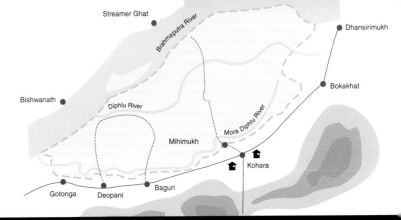

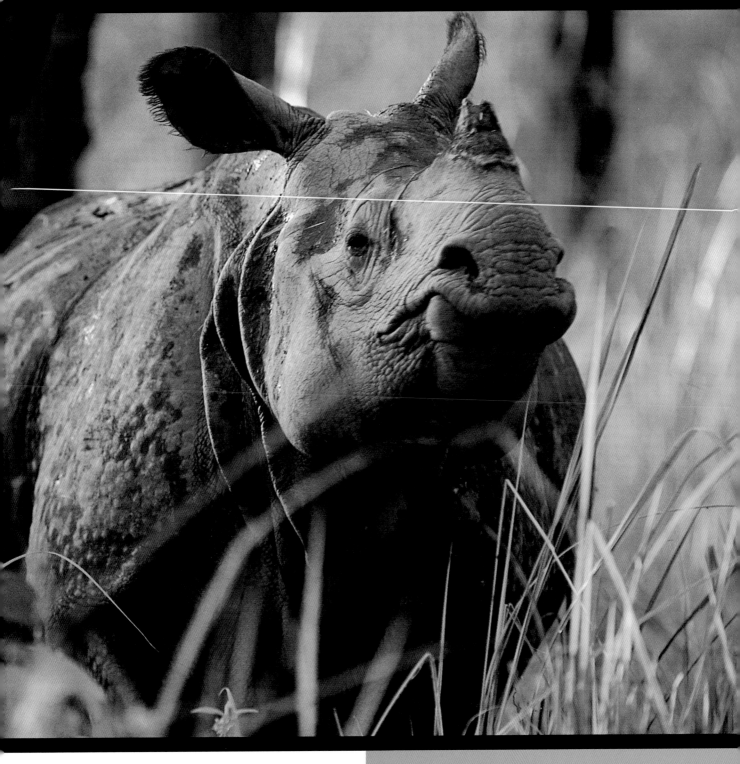

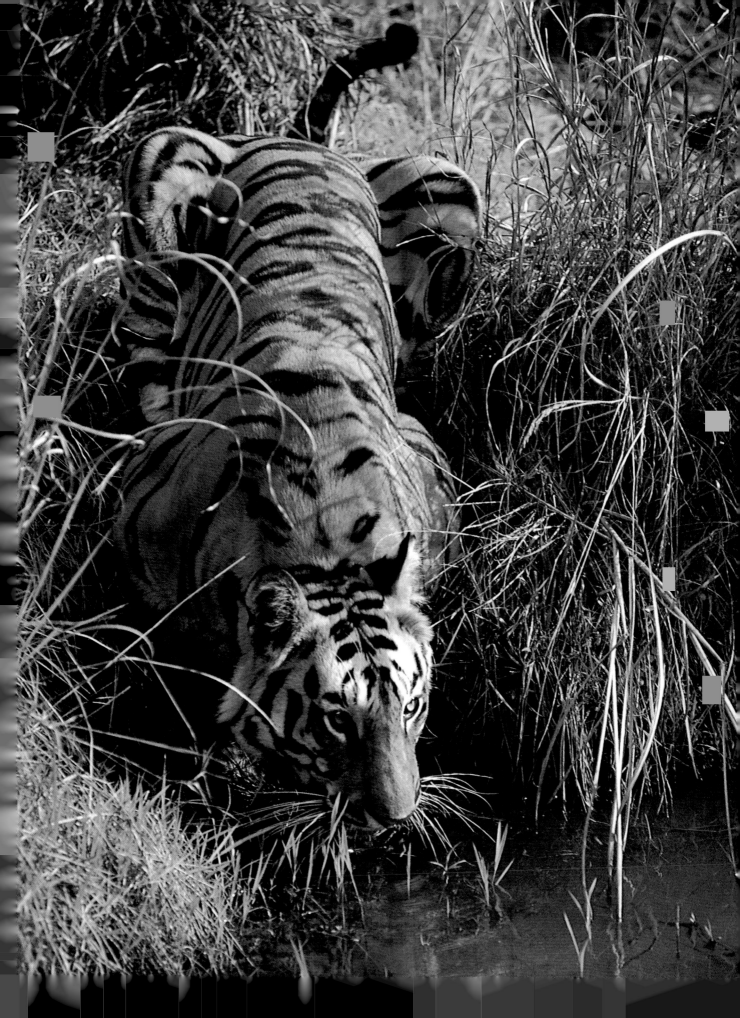

The water buffalo weighs more than a tonne, is a little less than two metres high at his shoulders, has ridged horns spanning 2.5 metres and the wherewithal to command the tiger's respect, though not always successfully. For the shot below, a long focal length lens was essential due to the presence of offspring which made adult behaviour unpredictable.

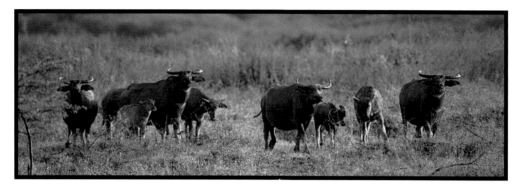

According to Indian scientists, Kaziranga's tiger population is the country's most abundant, although it remains the most difficult creature to spot. They estimate that an average 17 tigers populate each 100 square kilometres. The park's rivers and marshes constitute a major attraction for all the animals. The tiger is no exception and it is often possible to take a shot like the one opposite from an elephant's back. A medium focal length lens, therefore, is perfect for the job.

– alone, in small groups or in herds – regrouping in their temporary abode. But the river in spate, devastating as it can be, also feeds enormous shallow swamps, bristling with reeds and water hyacinths, punctuated with small wooded islands where the foothills meet the water. The early morning atmosphere – misty but sparkling – makes Kaziranga a wonderful setting, an almost perfect retreat for all kinds of India's majestic wildlife to whom it provides a little bit of paradise.

Close to marshes one often sees the prehistoric unicorn rhinoceros with leathery folds of armour-plated exterior. A tranquil herbivore, it is only offensive towards those who cause it annoyance and has only two enemies. First, the tiger: the intrepid feline will not hesitate to attack the rhino's offspring which the mother does not always succeed in protecting. Secondly, man: poaching, although banned, has not yet been totally eradicated and the demand for rhino horn is still considerable in some

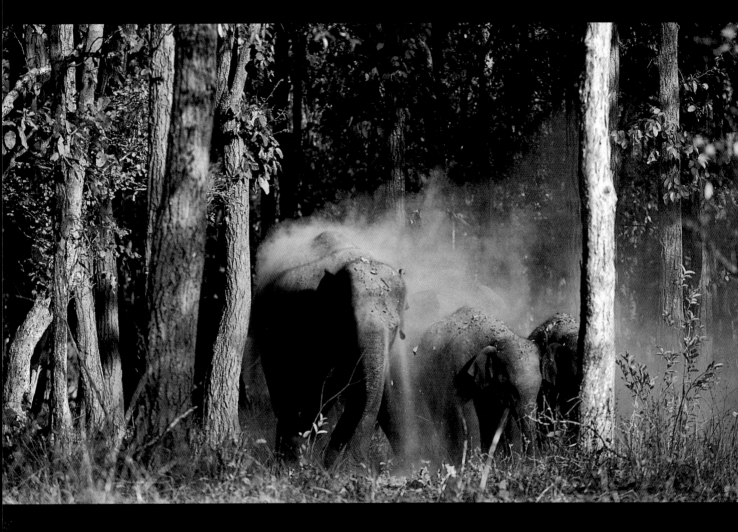
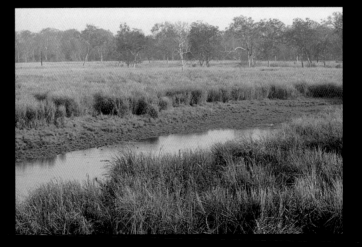

east Asian countries. Fortunately, only a few rhinos are shot each year by poachers. However, the relative increase of the reproduction rate of the species does not guarantee that it will be saved from extinction.

The marshes are also the refuge of the water buffalo. Of a somewhat bellicose nature, this giant knows how to keep its adversaries at a distance. There is also an important elephant population among Kaziranga's heavyweights which are grouped in herds ranging from a few animals to about 60. A favourite gathering for all species, the swamplands are frequented by the gregarious barasingha deer. The latter, endemic to India, has almost disappeared. It prefers damp areas and only survives in a few rare parts of the sub-continent. The grassy plains close to the water also host the hog deer, a cousin of the chital deer with its broad-back silhouette. Similarly indistinct in the foliage – the leopard and its little cousin the leopard-cat are quite common. The small-clawed otter is a nocturnal hunter which builds its home in root entanglements washed bare by the flood waters. A brackish soup appears which sometimes indicates the slick shape of the Ganges river dolphin. Less often seen are the gaur, with its heavy stooped gait, and the long-coated sloth bear, which also frequent the Kaziranga sanctuary along with the langur and macaque monkeys. The Hoolock gibbon, meanwhile, has invaded the adjacent Panbari forest in the southeast of the park. Naturally, all kinds of small carnivores, such as the civet and the mongoose, have established their shelters in the park's protective precinct.

Kaziranga's aquatic environment has become a major attraction for numerous migratory birds which, in the winter months, gather here in great numbers. Among them, the web-foots are the stars – particularly the

Male swamp deer which have not yet acquired a harem of females, gather in small groups. At the rutting season in early winter, however, they will challenge the incumbent stag to lure the females away. So a long focus lens is ideal for photographing the beautiful lighting on these animals in the late afternoon. The gaur, below, usually feeds in grassy plains but generally inhabits hilly woodlands. On hot days, it shelters in the shade of forest areas. And even if the animal's outline is imposing, a long focus lens is still needed to get a full shot of its enormous head.

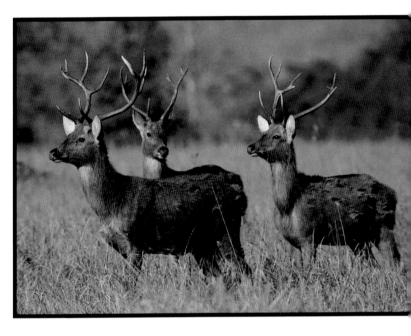

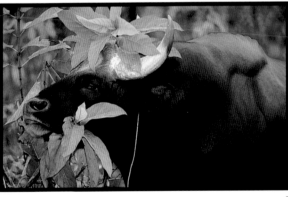

Around 25,000 wild elephants populate the forests of India. Like the African elephant, it conforms to a matriarchal structure. At puberty, the males leave the group while the parent females stay together. To get this photograph (opposite), it was important to shoot when the dust thrown up by their trunks offered the most beautiful lighting effect on the animals. The photo was taken with a telephoto lens. A wide angle lens is a useful way to portray both the wetland habitat and the more distant forest.

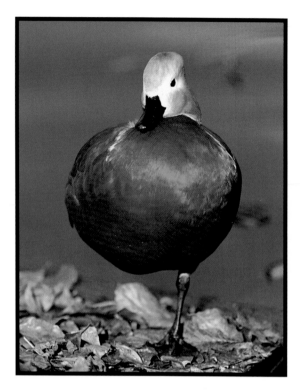

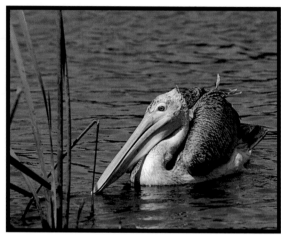

bar-headed goose, ruddy shelduck, gadwall, falcated duck and the northern shoveler. Egrets, herons and storks abound in the wetlands as do spot-billed pelicans The park also constitutes a veritable paradise for raptors. The brahminy kite, Pallas's fish eagle, white-tailed eagle and the grey headed fish eagle all particularly appreciate the abundance of the waterholes around which they feed. The black-shouldered kite with its delicate grey plumage prefers large, fallow spaces which it scrutinises with its bright orange eyes. While around the immediate copse the oriental honey buzzard and crested serpent eagle let themselves be observed. So Kaziranga is a virtual Noah's Ark, whose ecosystem favours animal life in all its forms and affords the visitor one of India's largest wildlife concentrations. Of course, the visibility of the animals depends on the season, because sometimes one can drive for half an hour without seeing wildlife at all.

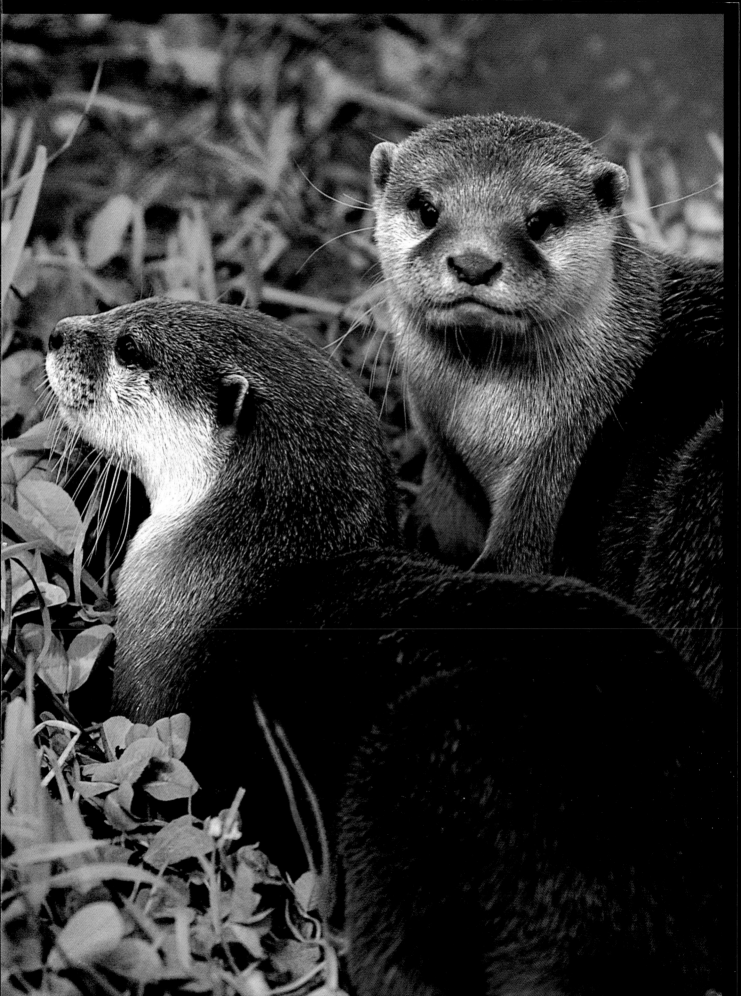

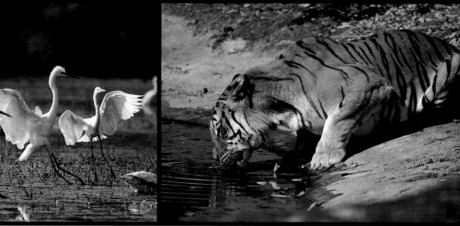

Practical tips

LANGUAGE

Although not spoken by all the population, English is the first official language of India along with 15 others. English is the language of the elite and the language often used by Indians amongst themselves. On the other hand, more than 700 lesser languages and local dialects are in common use.

CURRENCY

The Indian Rupee. There is little opportunity to use bank cards. The U.S. Dollar and the Euro are the most widely accepted foreign currencies.

ELECTRICITY

230/240 volts round pin.

CLIMATE

The climate is tropical, hot and dry from November to May before the arrival of the monsoon. From April, the summer temperatures often exceed 40 degrees C and the nights are warm. During the heavy summer rains, the thermometer drops appreciably, but the level of humidity is so high that it is hardly more bearable. From October to March, the days are hot but not excessive and the nights are cool.

LUGGAGE

Clothing: light for day wear – shirts, T-shirts, trousers, Bermuda shorts; warmer for morning and evening (according to season) – pullover, polar jacket, wind-breaker, gloves. Footwear: good walking boots as well as a pair of light shoes. Plus: hat (essential), sunglasses, sun cream (high index), anti-mosquito lotion (depending on season), electric torch, suitcase padlocks, personal first aid kit, vaccination book, passport and visa, air ticket, credit card and currency.

PHOTO EQUIPMENT

Normal kit: camera, lenses, tripod or monopod, filters, plenty of film or memory cards (for digital cameras), rechargeable batteries, normal batteries, cleaning kit (brush and soft cloth), rice or beanbag (useful in some vehicles but seldom used), dust bag, etc. Digital users will find a small external hard drive useful for downloading digital images. For photographers still using film cameras, be sure to carry all films as hand luggage, to avoid fogging from the X-rays used for screening checked baggage.

LODGING

India offers all kinds of accommodation from the most modest to the most luxurious. Near the parks and reserves, the hotels are sometimes former hunting lodges of Maharajahs and British dignitaries. They have the exotic and faded charm of the colonial era. Others are in the form of reasonably comfortable and charming bungalows. It is, therefore, always possible to stay in good or medium category establishments according to budget. In all cases, though, be prepared for constant breakdowns of air-conditioning and ventilation equipment and power failures. Most of the hotels are close to wildlife sites and visitor transport can be arranged. However, the opportunity to overnight inside the parks or reserves is rare and then depends on purchasing a short-stay permit.

TRAVEL

On long trips, coach travel is uncomfortable for westerners. A private car may be the best solution but remember it is always rented with a driver. A few minutes on the roads and the visitor quickly understands why: cows, donkeys, camels, dogs, rickshaws, trishaws, lorries, tractors, pedestrians… all move like an endless fleet, in perfect disorder. The narrow roads and crossings are places where accidents are numerous. In general, to get from one location to the next, plane or train are more reliable. The Indian railway

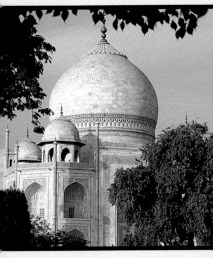

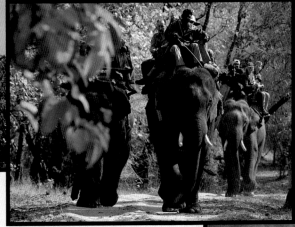

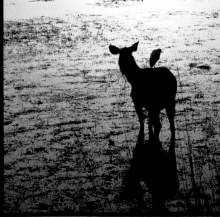

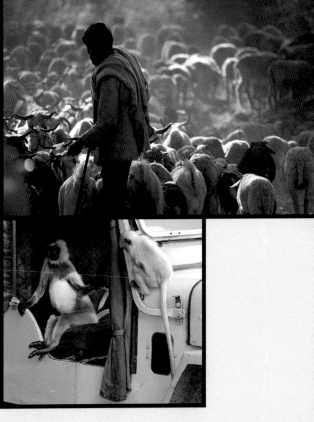

system is well developed – the world's fourth largest – and trains can take you just about everywhere. They generally stop at most stations, staying for seemingly undetermined periods of time. Yet after a complicated journey it is remarkable that the trains usually manage to arrive more or less on time. As an example, plan for a 17.5 hour trip from Delhi to Umaria to reach Bandhavgarh National Park, and another seven hours to travel from Delhi to Sawai Madhopur, a small town close to Ranthambore National Park. What an unforgettable experience this is – a wonderful immersion in the real India and what an opportunity to make contact with Indian travellers.

Inside the parks and reserves, travel is usually in a small 4x4 vehicle without doors and windows and little opportunity for the stable positioning of long focal lenses. In some parks like Bandhavgarh, Kanha, Corbett and Kaziranga, off road, where the tracks are too rough or the terrain too steep, elephants take over. The mobility and self-confidence of the big pachyderms make them the photographer and observer's best friend. In Bharatpur, travel is by boat, bicycle or rickshaw.

PARKS AND RESERVES

More than in any country in the world, animals in India are closely linked to spiritual and cultural life as demonstrated by the pantheon of Hindu gods. In its recent past, a turbulent history has sometimes overlooked these principles and the country was for many decades the favoured territory of aristocratic Indian and British game hunters. Combined with a rapid population increase, the deforestation caused by demand for agricultural land, the poaching of certain species and this intensive hunting has had serious consequences for the nation's wildlife population. Indeed, some representatives, like the cheetah, have disappeared or, as in the case of the tiger, rhinoceros and barasingha, only just been saved from extinction. But the government has taken on board the need to protect these areas and their wildlife. Consequently, India today boasts 80 national parks and 560 protected reserves. Sadly, though, they lack the resources to be truly effective. Often covering small areas, some of these sanctuaries also include zones closed to the public. Elsewhere access for safari visitors may be

limited to the morning and afternoon. Although this rule seems constraining, it provides a welcome pause, especially when the temperature exceeds 40 degrees C. So the creatures of the jungle do get some respite. However, most of the parks are closed during the monsoon season. So it is important to be well briefed on local weather conditions before departing.

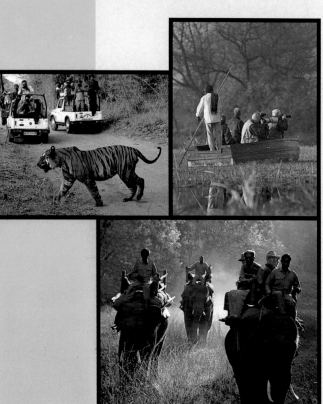

Wildlife Photography

For many, the word safari is synonymous with Africa. In India, although the word has the same meaning, the concept of photo travel sometimes reveals notable differences. This is particularly so with wildlife culture and attendant equipment which is not always the same and means that both amateur and professional photographers should be well informed about the chosen destination. This applies, of course, wherever one goes in the world. But if you want to maximise a trip, it always makes sense to be informed about the geography of the region being visited – its climate, animal species, flora, etc. An obvious benefit is that of choosing the appropriate season and equipment for such a trip.

Where tigers are concerned, it is important to remember that the animal operates mainly in woodlands and that its mimetic coat makes it almost invisible in its environment. Therefore, you might decide that the cool month of February is a good time to make his acquaintance, because the monsoon's beneficial effects on the vegetation gradually dissipate, leaving the trees slowly denuded of leaves but the atmosphere clear and the light sharp. That is no longer the case in April or May. Then the dry, hot air is filled with suspended particles that filter the light, while dried leaves on the trees assume an orange tint which camouflages the big striped cat perfectly. Due to the heat, however, it moves less and can be seen more easily at the waterholes it frequents. Each time of year, therefore, offers its own particular advantages and disadvantages.

The photographic conditions of an Indian safari are not easy most of the time. The safaris occur in small 4x4s that are seldom comfortable and usually carry four people, Western style, but more than double this where Indian tourists are concerned! The same applies where elephant trips are involved. The small platform attached to the animal's back is designed for four people, in addition to the mahout, but sometimes it carries more. It is, therefore, extremely advisable to make appropriate enquiries before booking the tour.

As for photo equipment, at least two cameras and a selection of wide angle to long focus lenses are essential, bearing in mind that the former is not essential because the scenery is not generally that spectacular. A good zoom of the 70-200mm or 80-200mm type as well as an f/4 300mm lens are, on the other hand, essential, especially when the safari is on an elephant's back. In fact, it is not possible to hoist a hefty telephoto lens onto the pachyderm because – unless alone or with one other person – there is little space to sit and no guarantee of stability over what is often rough terrain. Furthermore, the elephant is a living creature. It breathes, sneezes and eats interminably. Without camera stabilisation, therefore, good reflexes and concentration are necessary.

When in a 4 X 4, a long focus lens - 400, 500 or 600mm - will be useful providing it can be held steady on a monopod. Failing this, use a bean bag three-quarters filled with rice or dried legumes, draped on a window frame to cradle a camera with a long lens.

The jungles that comprise the main habitat of Indian wildlife necessitate the use of fast film (ISO 400), bearing in mind that flash is forbidden to avoid disturbing the animals. In addition to dense vegetation, which reduces light sources, the hilly and often mountainous topography of parks like Kahna do not let much light into some of the valleys. The clearings and open spaces, though, permit the use of ISO 100 film stock. The advantage of using digital cameras is that the ISO setting can, if necessary, be changed for each shot.

Even after reading and taking onboard the advice above, it is not easy photographing wildlife in India. For a start, India is not Africa. Everything is very different and even though the biodiversity is as rich and the animals are almost as numerous, they tend to be less visible within more forested landscapes. As always, therefore, it is necessary to be patient at all times. Indian tigers show themselves less often than African lions. Encounters, therefore, are precious and each meeting a privilege. Knowing how to appreciate this fact, not to mention the other wildlife, is what safari life is all about. The variety of deer and birdlife are unequalled. Superb and mythical, India's natural wealth rewards the observer and the photographer who is curious and persevering.

Progressive
ROCK
DRUMMING

by
Andy Griffiths

Visit our Website
www.learntoplaymusic.com

The Progressive Series of Music Instruction Books, CDs, and DVDs

CD TRACK LISTING

1	Ex 1-10	17	Ex 220-228
2	Ex 11-22	18	Ex 229-242
3	Ex 23-36	19	Ex 243-253
4	Ex 37-47	20	Ex 254-261
5	Ex 48-59	21	Ex 262-268
6	Ex 60-75	22	Ex 269-276
7	Ex 76-92	23	Ex 277-288
8	Ex 93-109	24	Ex 289-297
9	Ex 110-123	25	Ex 298-304
10	Ex 124-135	26	Ex 305-307
11	Ex 136-144	27	Ex 308-313
12	Ex 145-154	28	Ex 314-317
13	Ex 155-166	29	Ex 318-327
14	Ex 167-186	30	Ex 328-334
15	Ex 187-209	31	Ex 335-346
16	Ex 210-219	32	Ex 350

PROGRESSIVE ROCK DRUMMING
I.S.B.N. 978 0 947183 35 6
Order Code: CP-18335

Acknowledgments
Photographs: Phil Martin
Instruments supplied by John Reynolds Music City
Thank you to Bruce Matthew (suggestions)

For more information on this series contact;
L.T.P. Publishing Pty Ltd
email: info@learntoplaymusic.com
or visit our website;
www.learntoplaymusic.com

CONTENTS

SECTION THREE

INTRODUCTION

The drummer, together with the bass guitarist, form what is called the 'rhythm section' of a group. They create the backing beat, driving force and 'tightness' necessary for a successful group. **PROGRESSIVE ROCK DRUMMING** will provide you with an essential guide to the rudiments, beats and rhythms used by drummers. Within the three main sections of the book, a lesson by lesson structure has been used to give a clear and carefully graded method of study. No previous musical knowledge is assumed.

Aside from the specific aim of teaching drums to enable you to play in a group, music theory is gradually introduced. This will help you to understand the material being presented and enable you to improvise and create your own rhythms and beats.

From the beginning you should set yourself a goal. Many people learn drums because of a desire to play like their favourite artist (e.g. Stewart Copeland of the 'Police'), or to play a certain style of music (e.g. rock, 'funk', reggae, etc.). Motivations such as these will help you to persevere through the more difficult sections of work. As you develop it will be important to adjust and update your goals.

It is important to have a correct approach to practice. You will benefit more from several short practices (e.g. 45 - 60 minutes per day) than one or two long sessions per week. This is especially so in the early stages, because of the basic nature of the material being studied. In a practice session you should divide your time evenly between the study of new material and the revision of past work. It is a common mistake for semi-advanced students to practise only the pieces they can already play well. Although this is more enjoyable, it is not a very satisfactory method of practice. You should endeavour to correct mistakes and experiment with new ideas. You should combine the study of this book with constant experimentation and listening to other players. It is the author's belief that the guidance of an experienced teacher will be an invaluable aid in your progress.

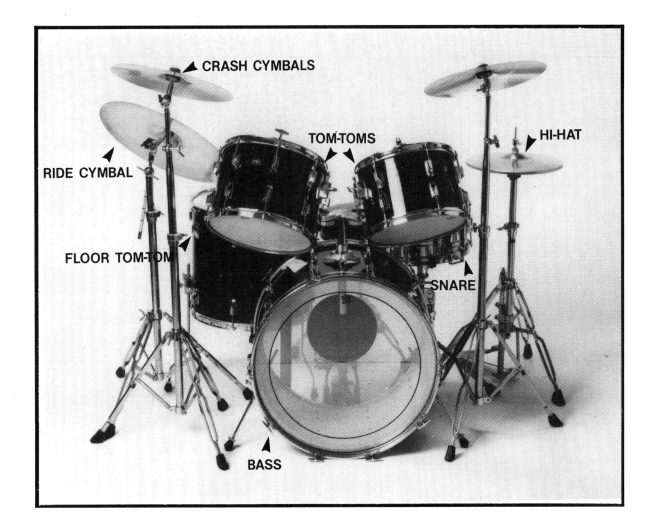

The standard drum kit consists of:
1. **1 BASS DRUM**. Sizes vary from 18"(45 cm.), 20"(50 cm.), 22"(55 cm.), 24"(60 cm.) and 26"(65 cm.) with 22"(55 cm.) being the average.
2. **1 SNARE DRUM**, 14",(35cm.), either wooden or metal, with varying depths, e.g. 5"(13cm.), 6½"(16cm.), 8"(20 cm.).
3. **1 FLOOR TOM-TOM**, 16"(40 Cm.), 18"(45 cm.).
4. **2 TOM TOMS** on the bass drum, varying in sizes from 12"(30 cm.) through to 16"(40 cm.), with 12" and 13"(30 cm. and 33 cm.) or 13" and 14"(33 cm. and 35 cm.) being the most popular combination.
5. **1 PAIR OF HI-HATS**, 14"(35 cm.) top and bottom.
6. **1 RIDE CYMBAL**, 18"(45 cm.) through to 22"(55 cm.), with 20"(50 cm.) being the most popular.
7. **2 CRASH CYMBALS,** sizes from 12"(30 cm.) through to 18"(45 cm.), with 16"(40 cm.) being the most popular.

These are only standard sizes and you will gradually develop your own preferences. Most major drum manufacturers make a variety of sizes and some will make them to your specification.

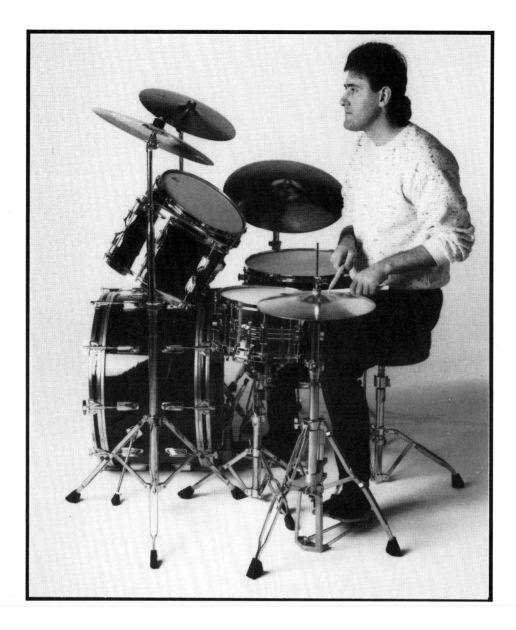

SEATING

Before you commence playing, a comfortable seating position is required. Your drum kit set-up is your own personal choice, but you should be able to reach the tom-toms and cymbals with ease and comfort. The main aim is for comfort and easy playing of the drum kit **(See Photo.)**.

CHOOSING THE DRUM STICKS

There are two types of sticks, nylon tip and wooden tip. Nylon tip sticks sound brighter and cleaner, which is most noticeable when playing on the cymbals.

When choosing a pair of sticks they should be of the same length, weight and straightness (test for straightness by rolling the sticks over a flat surface, if they don't wobble they are straight). A good starting stick would be a size 7A (marked on the side of the stick). As you progress you will be able to try different sizes and see what feels best to you. Try both nylon tip and wooden tip.

PRACTICE PADS

PRACTICE PADS are often used by drummers of all levels because:
1. They are quiet (to avoid complaints).
2. They are portable (e.g. lessons and holidays).
3. They have a similar bounce to a real drumskin.

HOLDING THE DRUM STICKS

There are two accepted ways of holding the sticks, they are:

1. **THE TRADITIONAL GRIP (Photo. 1).**
2. **THE MATCHED GRIP (Photo. 2).**

TRADITIONAL GRIP

PHOTO. 1

MATCHED GRIP

PHOTO. 2

1. THE TRADITIONAL GRIP

The right hand stick is held between the inside of the thumb and first joint of the index finger (about ⅓ of the way down from the butt of the stick). The remaining fingers are wrapped lightly around the stick **(Photo. 1)**.

To make a clean tap with the right hand you must move your wrist in a downward motion allowing the tip of the stick to strike the snare drum cleanly and then bring it back up to its original position **(Photos 1a, b, c)**. By repeating this you will soon develop a smooth right hand action.

PHOTO. 1a

PHOTO. 1b

PHOTO. 1c

The left hand stick is held deep in the crotch of the thumb and first finger. It rests between the second and third finger, between the first and second joints (about ⅓ of the way down from the butt of the stick) **(Photo. 1)**.

To make a clean tap with the left hand you must move your wrist and forearm in an inward and downward motion, allowing the tip of the stick to strike the drum cleanly and then bring it back to its original position **(Photos. 1d, 1e, 1f)**. By repeating this you will soon develop a smooth left hand action and be ready to proceed to more snare drum work.

PHOTO. 1d PHOTO. 1e PHOTO. 1f

2. THE MATCHED GRIP.

The right and left hand hold the sticks in exactly the same way as the right hand in the traditional grip **(Photo. 2)**.

To make a clean tap with either hand you can repeat the stick movements in **(Photos. 1a, 1b, 1c)**.

The matched grip is the style commonly used by rock drummers as it feels natural and more comfortable to play. The traditional grip is widely used by jazz, military band and orchestral drummers.

RUDIMENTS OF MUSIC

Music is written on a **STAFF**, which consists of 5 parallel lines between which there are 4 spaces.

Music Staff.

All drum music begins with the **BASS CLEF** sign. This sign is also used for low pitched instruments such as the bass guitar and the bass line of a piano part.

BASS CLEF.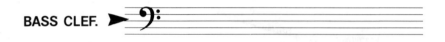

BAR LINES are drawn across the staff, which divide the music into sections called **BARS** or **MEASURES**.

A **DOUBLE BAR LINE** signifies either the end of the music, or the end of an important section of it.

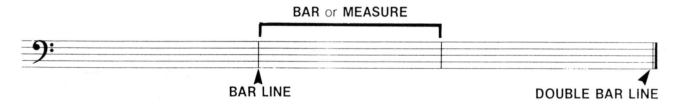

Two dots placed before a double bar line indicate that the music is to be repeated, from the beginning of the piece of music or from a previous set of repeat signs.

REPEAT SIGN

TIME SIGNATURES

At the beginning of each piece of music, after the bass clef, is the time signature. The time signature indicates the 'feel' of the music e.g. rock ($\frac{4}{4}$), waltz ($\frac{3}{4}$), etc.

TIME SIGNATURE

The time signature indicates the number of beats per bar (the top number) and the type of note receiving one beat (the bottom number). For example:

4 - this indicates 4 beats per bar.
4 - this indicates that each beat is worth a quarter note (crotchet).

$\frac{4}{4}$ is the most common time signature used in rock music and is sometimes represented by this symbol **C** called **COMMON TIME**.

Other time signatures used in this book are $\frac{3}{4}$, $\frac{6}{8}$ and $\frac{12}{8}$ time.

SECTION ONE
EXPLANATION OF DRUM NOTATION

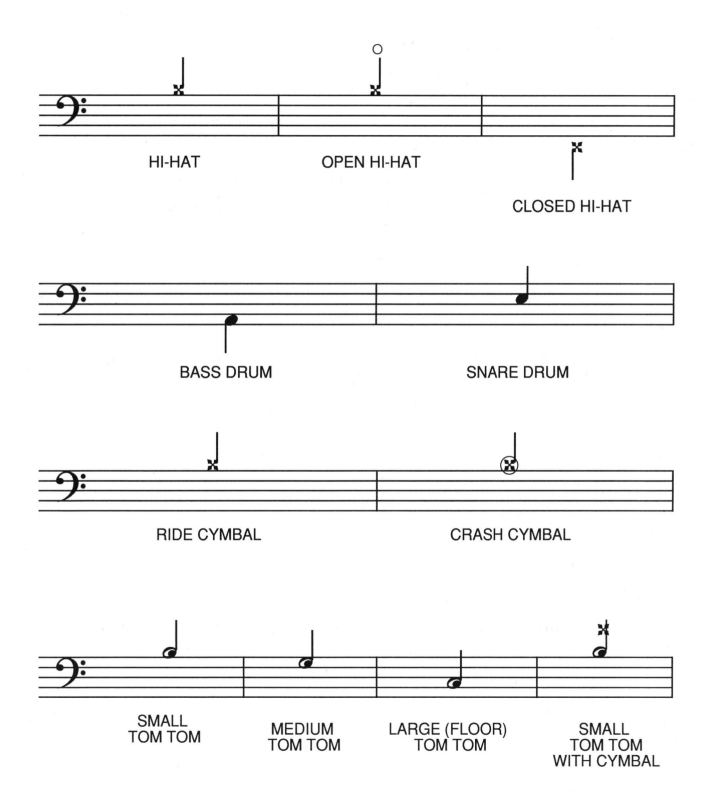

HI-HAT OPEN HI-HAT

CLOSED HI-HAT

BASS DRUM SNARE DRUM

RIDE CYMBAL CRASH CYMBAL

SMALL TOM TOM MEDIUM TOM TOM LARGE (FLOOR) TOM TOM SMALL TOM TOM WITH CYMBAL

LESSON ONE

RIGHT AND LEFT HAND EXERCISES

The first exercises are played using the snare drum and involve right and left hand alternation.

First make a clean tap with your right hand **(Photo. 3a)** and as your right hand is returned to its original position make a clean tap with your left hand **(Photo. 3b)**. Repeat the procedure. The important thing to remember in every exercise is to relax and don't let your wrists and forearms tense up as this will make your taps sound uneven and jerky, thus preventing you from increasing your speed steadily.

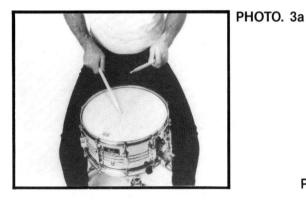
PHOTO. 3a

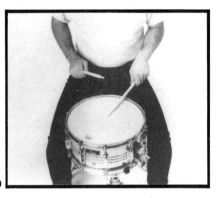
PHOTO. 3b

A **QUARTER NOTE** (sometimes called a **CROTCHET**) ♩ has the value of 1 beat and 4 quarter notes are needed for 1 bar in ⁴⁄₄ time, i.e. a quarter note is played on each beat.

Ex. 1 will be played on the snare drum (S/D), written in the second space from the top of the staff. The L - left hand and the R - right hand will alternate **(Refer To Photos. 3a and 3b)** in ⁴⁄₄ time.

EXERCISE 1

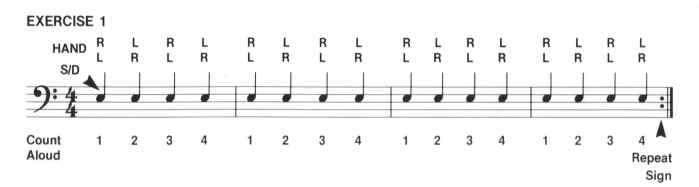

NOTE - Start each exercise with the right hand and then try starting each exercise with the left hand.
By approaching every exercise in this manner you will not be dependant on one hand starting all the time.

This next exercise shall be played using double strokes of the right and left hand. Play the exercise through first **RRLL**, then play it through **LLRR**.

EXERCISE 2

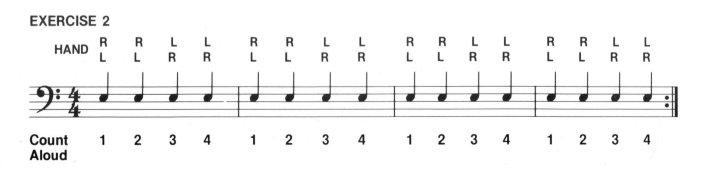

Ex. 3 combines the bass drum (B/D) with the snare drum. The bass drum is played using the right foot and is written in the bottom space of the staff.

EXERCISE 3

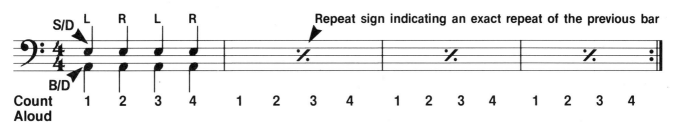

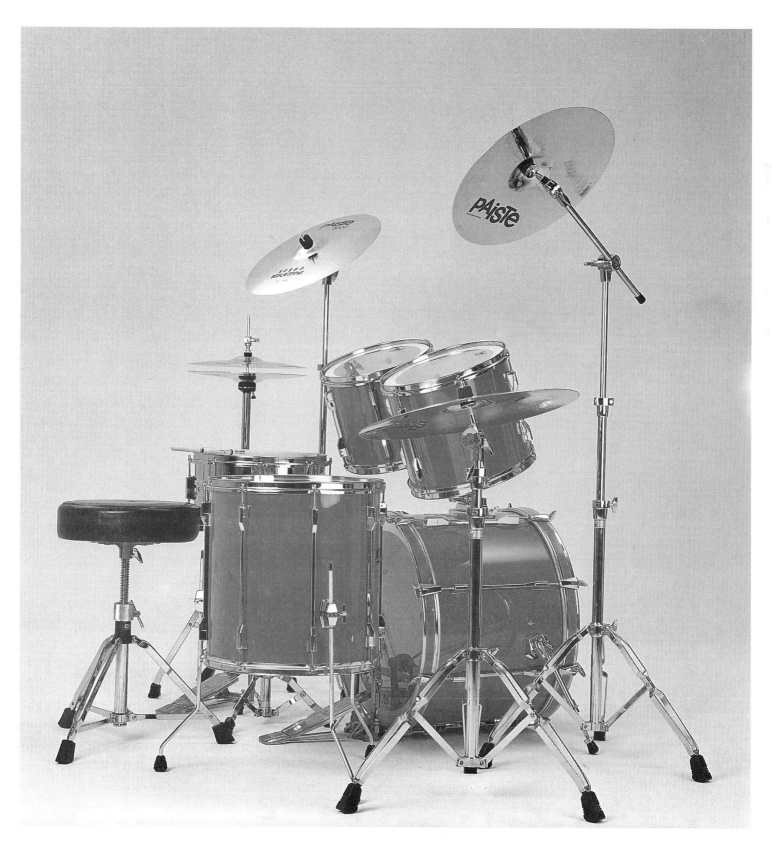

LESSON TWO

Ex. 4 introduces the **QUARTER NOTE REST** ♩ This means silence for the count of 1 beat. It can be found anywhere in the music and is counted in exactly the same way as a quarter note.

QUARTER NOTES AND RESTS

EXERCISE 4

EXERCISE 5

EXERCISE 6

EXERCISE 7

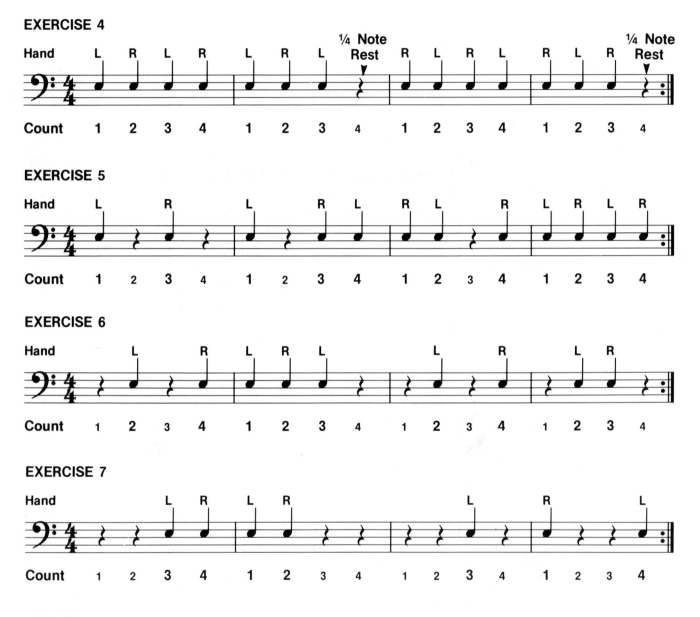

EXERCISE 8

Use the left hand on the 2 and 4 counts, and rest on the 1 and 3 counts, while the bass drum plays on all counts.

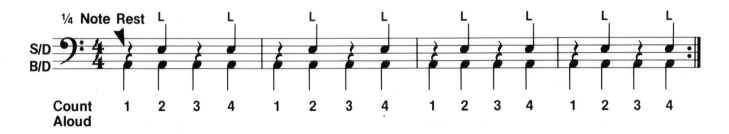

The Cymbals [Ride (R/C) and closed Hi-Hats (H/H)] are indicated thus ✕, and are written on the top line of the staff.

Ex. 9 introduces the **CYMBAL PATTERN** which will enable you to play a complete drum pattern. Use the ride cymbal (R/C) tapping it on every beat (1,2,3,4) with your right hand, while the bass drum (B/D) taps on every beat (1,2,3,4), and the snare drum (S/D) is tapped on every 2 and 4 beat (with the left hand).

EXERCISE 9

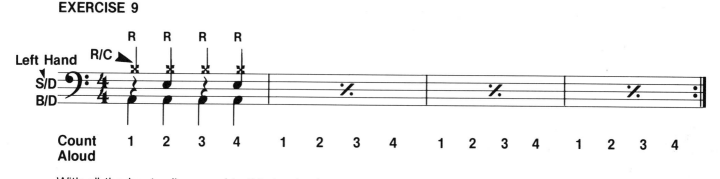

With all the beats discussed in this book, do not restrict yourself to playing them just on the ride cymbal or hi-hats (H/H). Try experimenting playing the cymbal pattern on other parts of the drum kit e.g. cowbell (C/B), tom-toms (small, medium, large), the rim of the snare and tom-toms. If you listen to records very carefully, you can pick out the sections of music where the cymbal pattern is played on the ride cymbal and then moved to the hi-hat or crash cymbal (C/C). Here is typical example of how a song may be structured and where the cymbal pattern could be played.

| H/H | CYM | H/H | CYM | H/H or CYM | H/H | CYM |
| VERSE — | CHORUS — | VERSE — | CHORUS — | INSTRUMENTAL — | VERSE — | CHORUS — | FINISH. |

The hi-hat can be added to **Ex. 9**. Use the left foot to push down the pedal so that the two cymbals click together. Whenever you see the hi-hat in this position it must be closed together on the beat.

**Closed H/H
with foot
on the beat**

Play the H/H with the L. foot on the 2 & 4 count (with the snare) while the B/D and R/C are played on all counts (1,2,3,4).

EXERCISE 10

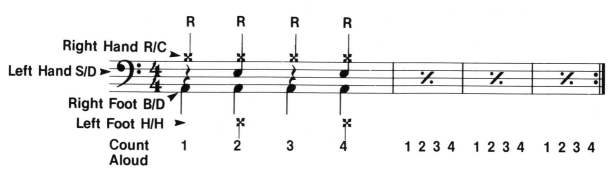

TROUBLESHOOTING

Remember:
1. To hold sticks correctly.
2. To relax and not to tense up your forearms and wrists.
3. To read slowly at first until you can play the exercise smoothly and then attempt to increase your speed.
4. To watch for repeat and rest signs and other relevant information as you play each exercise.

LESSON THREE

EIGHTH NOTES
An **EIGHTH NOTE** (or **QUAVER**) ♪ is worth half a beat in 𝄴 time. Two eighth notes, which are usually joined by a line across the top of the two notes. ♫ have the same value as a quarter note. Eighth notes are counted as such:

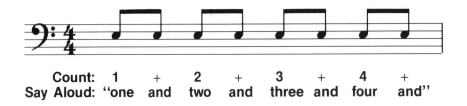

Count: 1 + 2 + 3 + 4 +
Say Aloud: "one and two and three and four and"

Ex. 11 uses a combination of quarter notes and eighth notes, played on the snare drum.

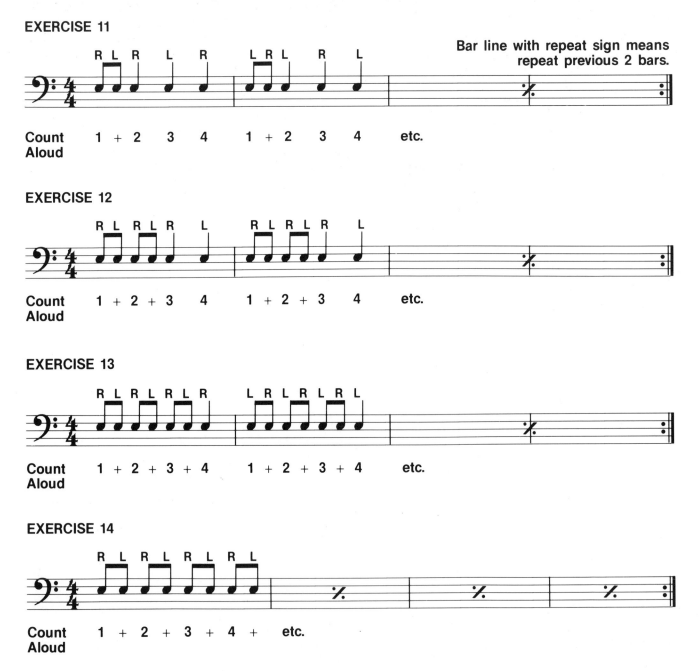

EXERCISE 11

Bar line with repeat sign means repeat previous 2 bars.

Count Aloud 1 + 2 3 4 1 + 2 3 4 etc.

EXERCISE 12

Count Aloud 1 + 2 + 3 4 1 + 2 + 3 4 etc.

EXERCISE 13

Count Aloud 1 + 2 + 3 + 4 1 + 2 + 3 + 4 etc.

EXERCISE 14

Count Aloud 1 + 2 + 3 + 4 + etc.

Now you have learnt some basic eighth note exercises you can move onto rock beats using a basic eighth note cymbal pattern to each bar. Use either the ride cymbal or the hi-hats (closed), playing with the right hand. The cymbal pattern will be played 1+2+3+4+; the bass drum will be played on the 1,2,3,4 and the snare drum will be played on the 2 and 4 counts.

EXERCISE 15

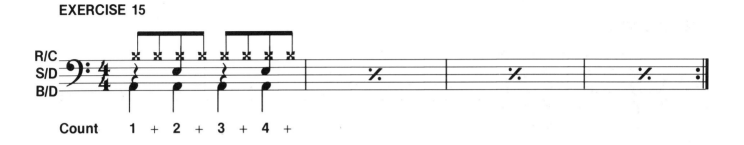

Play this beat in exactly the same manner as **Ex. 15** except the bass drum is played only on the 1 and 3, resting on the 2 and 4.

EXERCISE 16

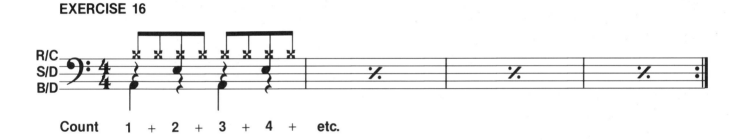

LESSON FOUR

In this lesson eighth note beats on the bass drum are introduced.

EXERCISE 17

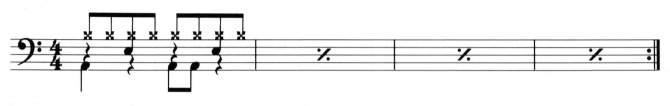

EXERCISE 18

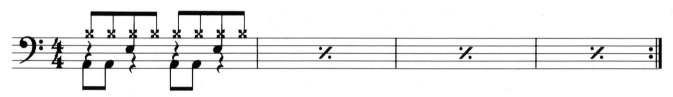

EXERCISE 19

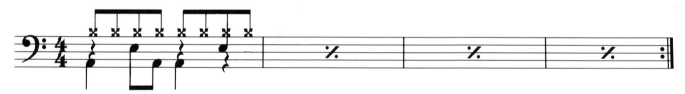

EXERCISE 20

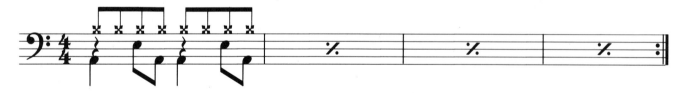

EXERCISE 21

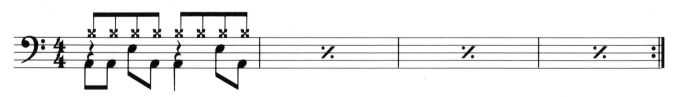

*After playing each exercise individually try playing non-stop from **Ex. 17-21.**

DRUM SOLO 1

EXERCISE 22

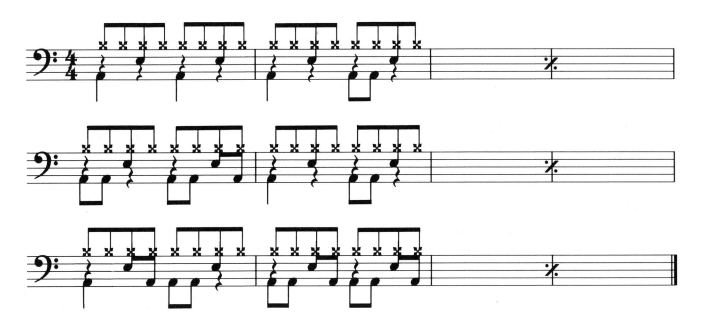

LESSON FIVE

SNARE DRUM STUDIES

The following exercises, using eighth notes, will increase your reading ability and wrist control. These eighth note wrist exercises must be done before every practice as a warm up. Start **VERY SLOWLY** and gradually increase the speed until you cannot go any faster then **GRADUALLY** slow down again. These exercises are designed to build up strength and stamina in your wrists and increase control of your rolls.

EXERCISE 23

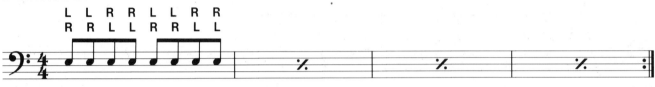

EXERCISE 24

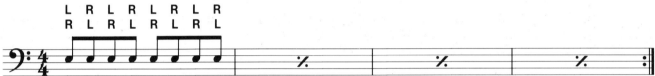

EXERCISE 25

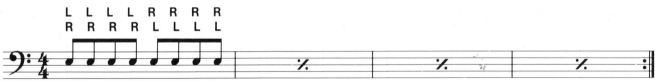

EXERCISE 26

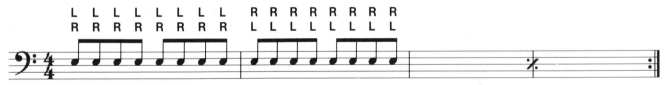

EXERCISE 27

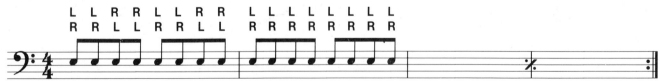

EXERCISE 28

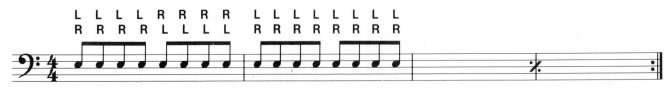

EXERCISE 29

LESSON SIX

SYNCOPATION

SYNCOPATION is the accenting of a normally unaccented beat e.g. in $\frac{4}{4}$ time the normal accent is on the first and third beats:

$$\frac{4}{4} \quad \overset{>}{1} \quad 2 \quad \overset{>}{3} \quad 4 \qquad > = \textbf{ACCENT (Play louder)}$$

so an example of syncopation could be:

$$\frac{4}{4} \quad 1 \overset{>}{+} 2 \overset{>}{+} 3 \overset{>}{+} 4 \overset{>}{+}$$

Syncopation is used in all forms of music e.g. rock, jazz, orchestral, Latin American, etc. Its main advantage is that it can make an otherwise plain beat sound interesting because of the 'off beat' rhythm.

An **EIGHTH NOTE REST** ⅞ means silence for the count of half a beat. It can be found anywhere in music and is counted in exactly the same way as an eighth note.

EXERCISE 30

EXERCISE 31

EXERCISE 32

EXERCISE 33

EXERCISE 34

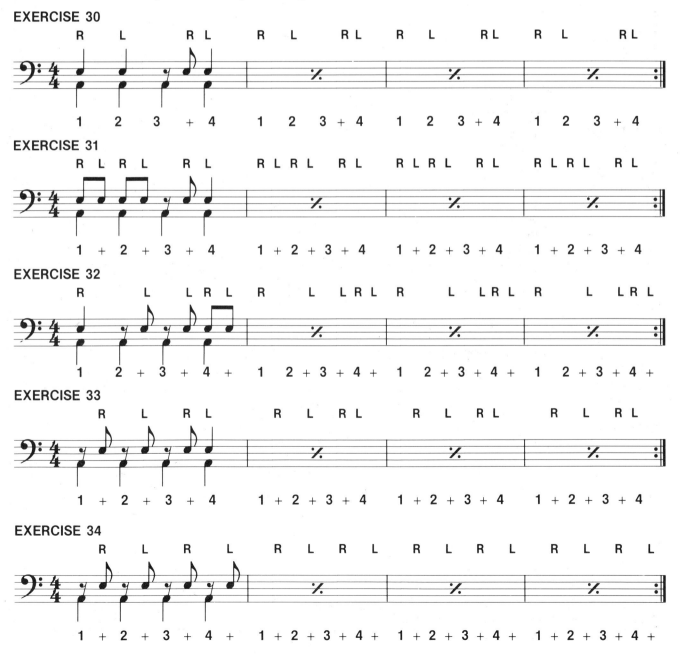

LESSON SEVEN

¾ TIME

Many popular songs are written in ¾ **TIME**. This is often called **WALTZ TIME** and indicates three quarter note beats per bar. In ¾ time the first beat of each bar is emphasized, as such:

To give this feeling (called **LILT**) place the bass drum on the first beat and the hi-hat (closing with the foot) on the following two beats.

EXERCISE 35

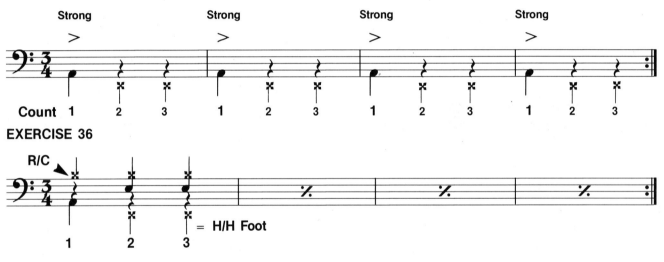

EXERCISE 36

LESSON EIGHT

SIXTEENTH NOTES (OR SEMI QUAVERS)

A **SIXTEENTH NOTE** ♪ has the value of half an eighth note. Thus two sixteenth notes equal an eighth note, and four sixteenth notes equal a quarter note.

Count 1 e + a

In the following exercises the bass drum keeps the beat.

EXERCISE 37

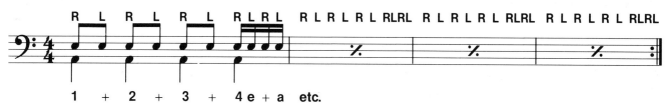

EXERCISE 38

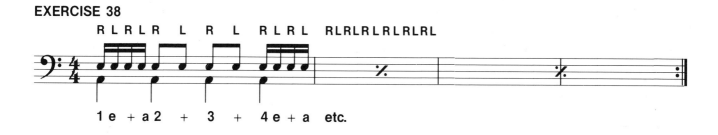

EXERCISE 39

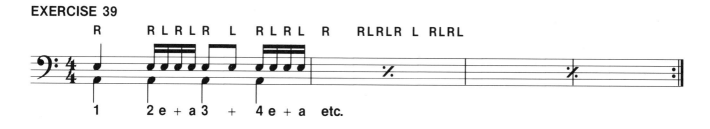

EXERCISE 40

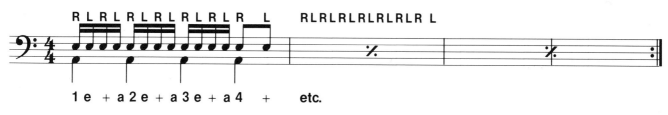

EXERCISE 41

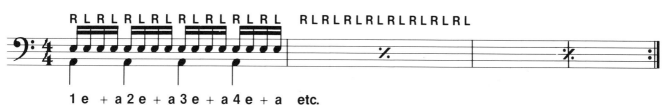

EXERCISE 42

Here is a 16 bar exercise using quarter, eighth and sixteenth notes and rests.

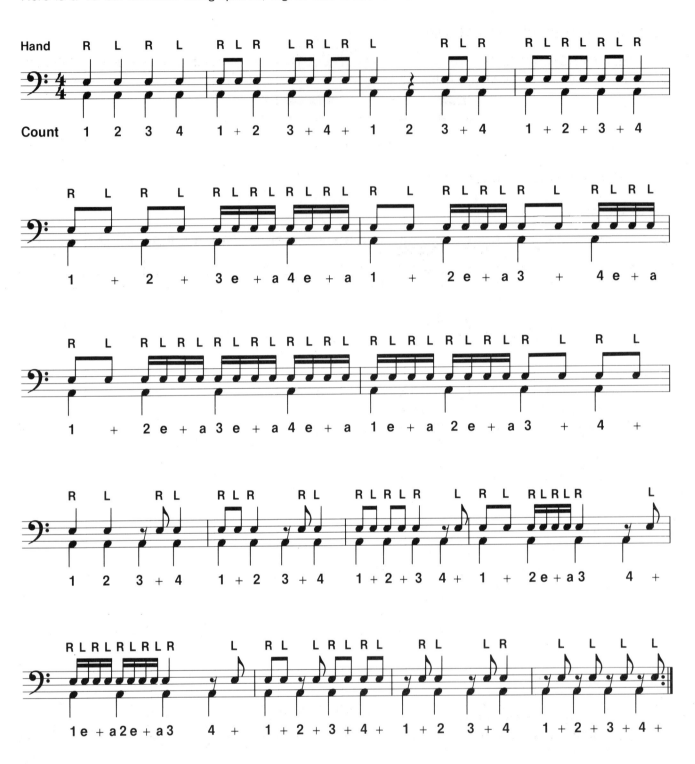

LESSON NINE

EXERCISES AROUND THE DRUMS

This lesson introduces the **SMALL, MEDIUM AND LARGE TOM-TOMS.**
The **SMALL TOM - TOM** is written on the top of the staff.

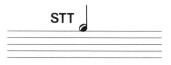

The **MEDIUM TOM-TOM** is written in the first space from the top of the staff.

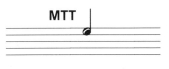

The **LARGE** (or **FLOOR**) **TOM-TOM** is written in the third space from the top of the staff.

The cymbal pattern and small tom-tom are written in the same position on the staff. If they are to be played together, generally the right hand will play the cymbal while the left hand will play the small tom-tom and will be written thus:

In the following exercises the bass drum will be played on every beat (i.e. 1,2,3,4), the right and left hand will be moving around, the snare drum and tom-toms.

EXERCISE 43

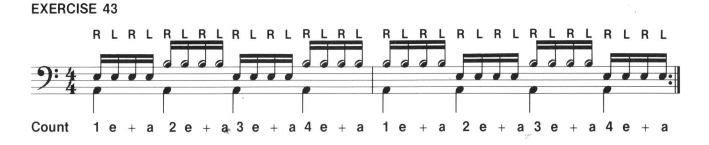

EXERCISE 44

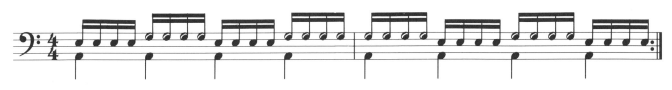

EXERCISE 45

EXERCISE 46

EXERCISE 47

LESSON TEN

FILLS

A **FILL** is any variation of stick movements from the basic beat used to fill out or color the music.

Fills are usually found at the beginning and ending of songs, at the end of certain bars (i.e. when the song changes from verse to chorus and vice-versa), or when leading into an instrumental. There are no set rules for fills, but they must be in time with the piece of music you are playing and tastefully played. Any part of the drum kit can be used, with rolls around the tom-toms and crashing cymbals being very common.

DYNAMICS (the varying degrees of softness and loudness in music) play an important role in music as they add color and feeling.

It is important to note that you don't need to put every fill you know into one break as some of the best sounding fills are the ones with the least amount of playing in them. You will find that most fills come at the end of every 4, 8, 12 or 16 bars, with the fill taking up the last 1 or 2 beats of the bar or the whole last bar, e.g. in a 12 bar progression you might play the standard beat for 11 bars and use a fill in the last bar to lead back into a repeat of the progression.

In these exercises we will combine a beat with a fill, with the fill taking up 1 or 2 beats of the bar.

EXERCISE 48

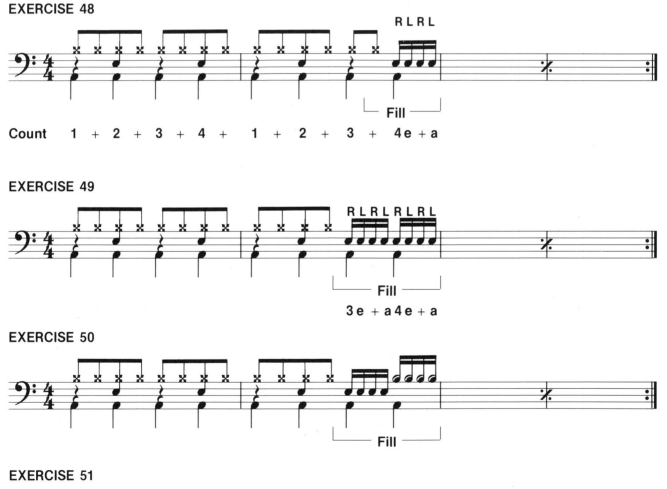

EXERCISE 51

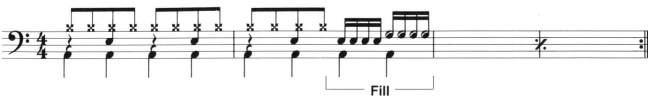

EXERCISE 52

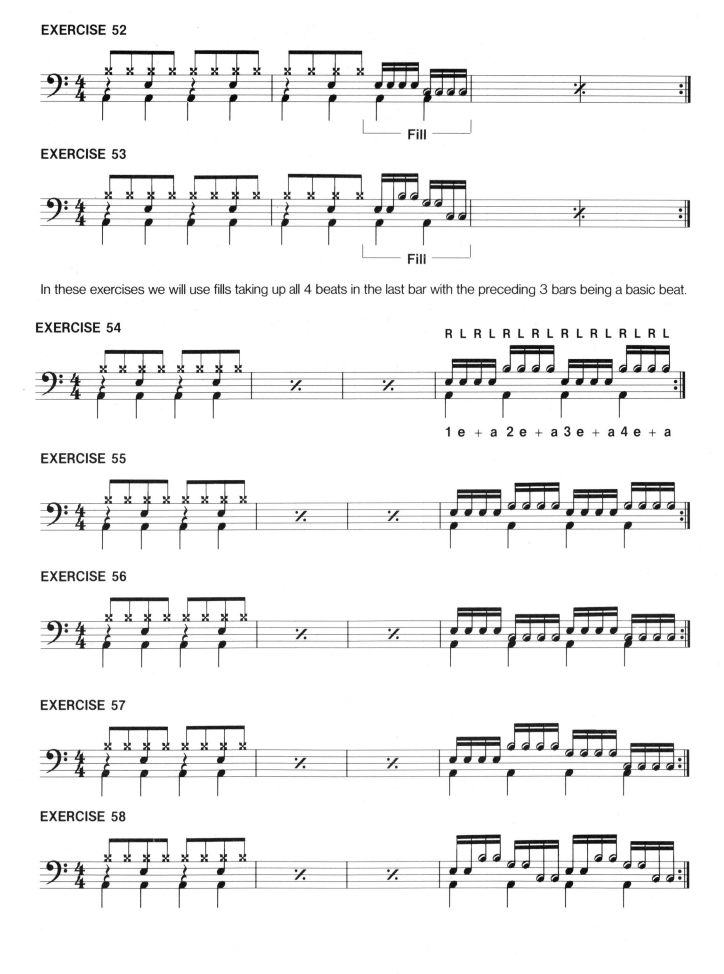

EXERCISE 53

In these exercises we will use fills taking up all 4 beats in the last bar with the preceding 3 bars being a basic beat.

EXERCISE 54

EXERCISE 55

EXERCISE 56

EXERCISE 57

EXERCISE 58

SOLO 2

EXERCISE 59

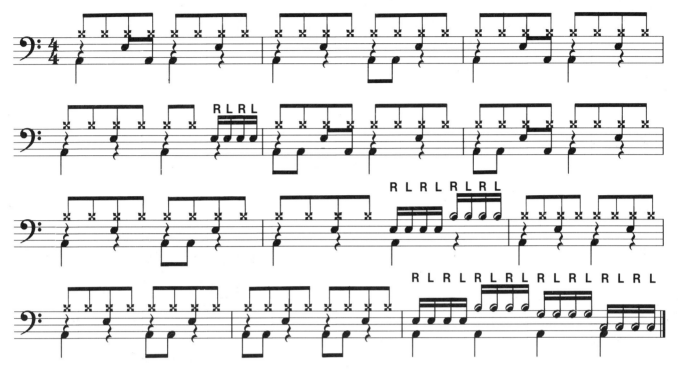

LESSON ELEVEN

EIGHTH AND SIXTEENTH NOTE COMBINATIONS

Interesting beats can be created by joining sixteenth notes and eighth notes. They are written and counted as such:

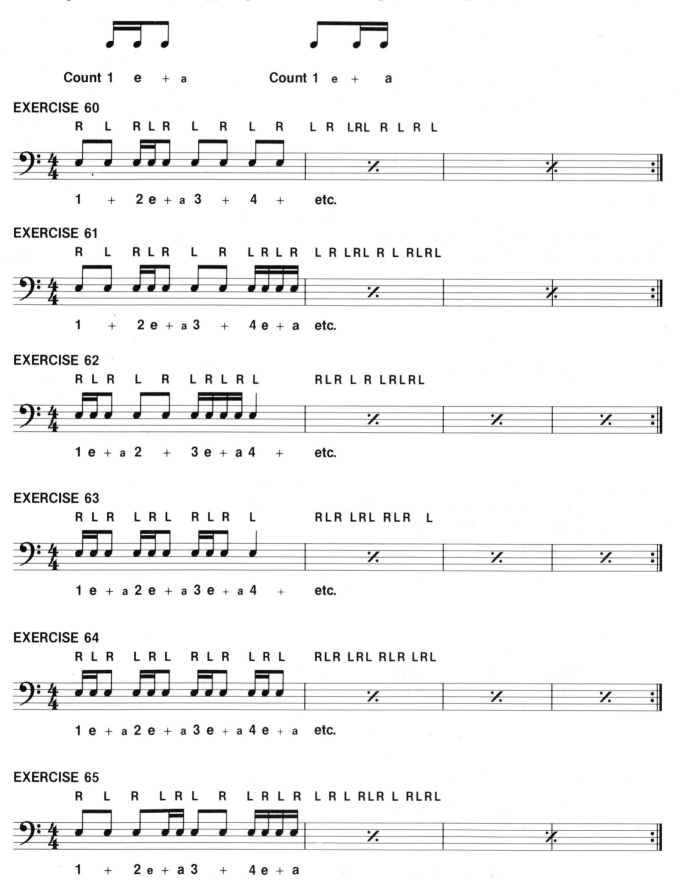

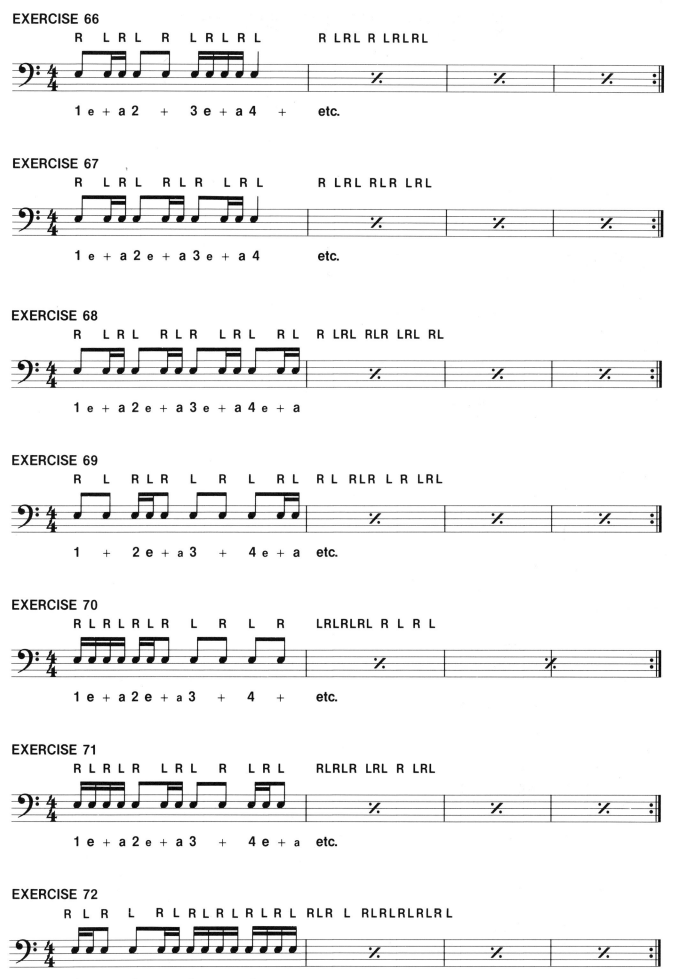

EXERCISE 73

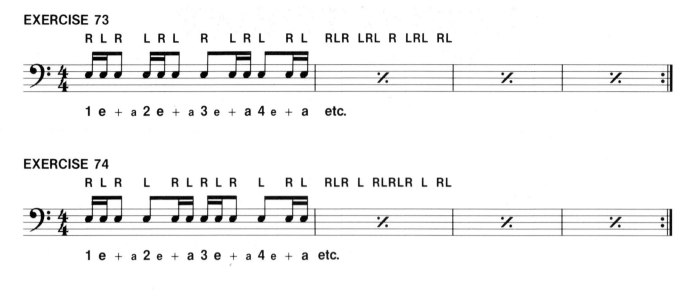

1 e + a 2 e + a 3 e + a 4 e + a **etc.**

EXERCISE 74

1 e + a 2 e + a 3 e + a 4 e + a **etc.**

This sixteen bar exercise combines quarter, eighth and sixteenth notes.

EXERCISE 75

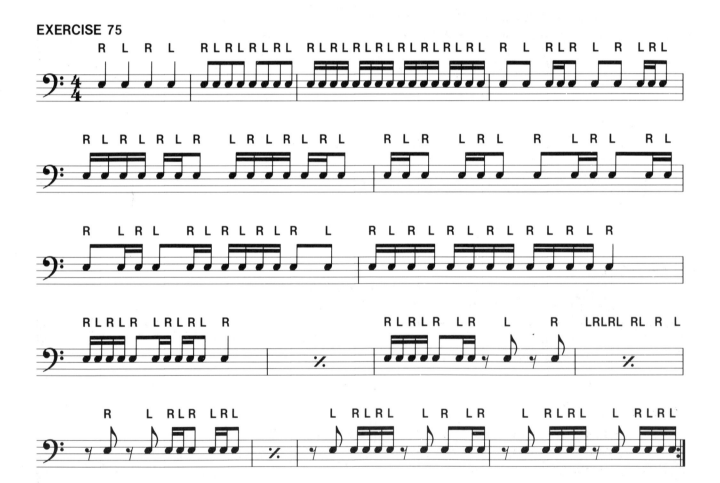

LESSON TWELVE

ADVANCED FILLS

In **LESSON NINE** you were introduced to fills using straight sixteenth note timing.

Here are some more fills, this time using more advanced variations of sixteenth note timing.

EXERCISE 76

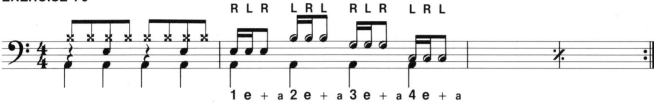

EXERCISE 77

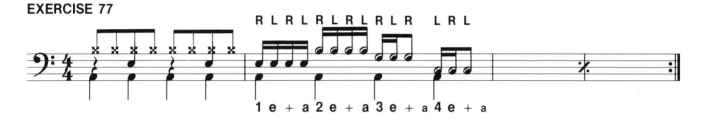

EXERCISE 78

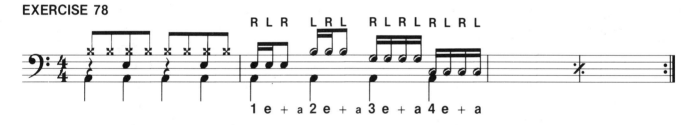

EXERCISE 79

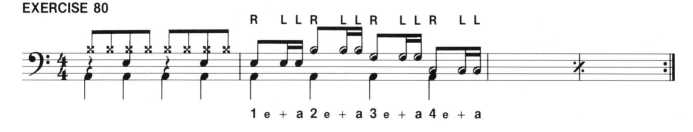

EXERCISE 80

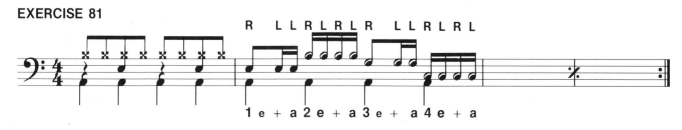

EXERCISE 81

EXERCISE 82

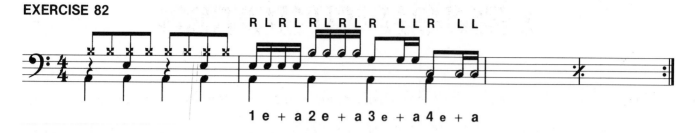

1 e + a 2 e + a 3 e + a 4 e + a

EXERCISE 83

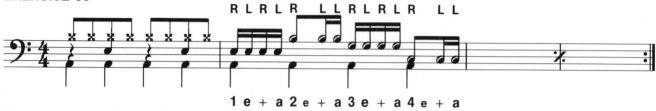

1 e + a 2 e + a 3 e + a 4 e + a

EXERCISE 84

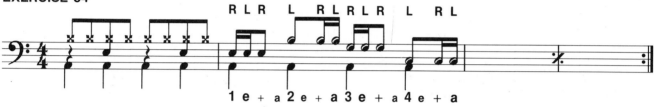

1 e + a 2 e + a 3 e + a 4 e + a

EXERCISE 85

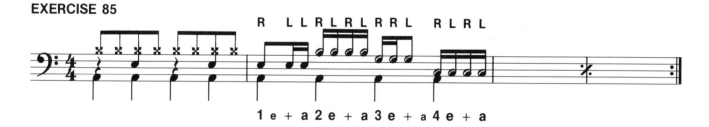

1 e + a 2 e + a 3 e + a 4 e + a

LESSON THIRTEEN

DOTTED NOTES

A small dot after any note makes it last half as long again (one and a half times its normal length).

A quarter note ♩ which lasts for one beat in 4/4 time, lasts for one and a half beats when a dot is placed after it (♩.). Dotted quarter notes are best counted with 'and' between each beat. You will often find them mixed with eighth notes (♪).

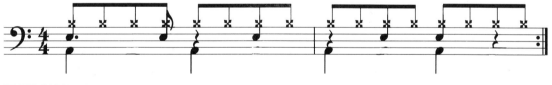

EXERCISE 86

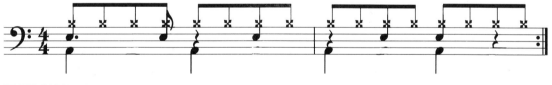

Count 1 2 + 3 4

EXERCISE 87

1 2 + 3 4 +

EXERCISE 88

1 2 + 3 4 +

In the following exercises dotted quarter notes are used in a rock beat.

EXERCISE 89

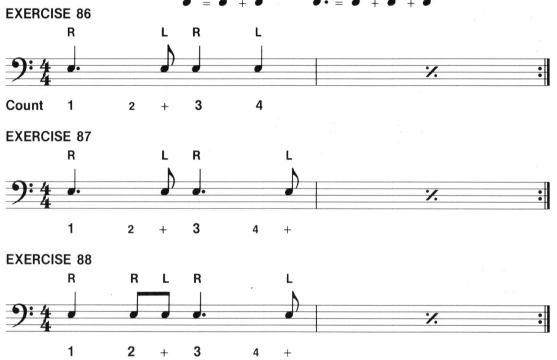

EXERCISE 90

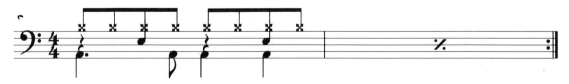

EXERCISE 91

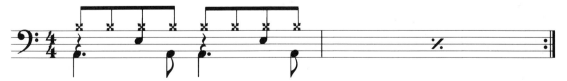

EXERCISE 92

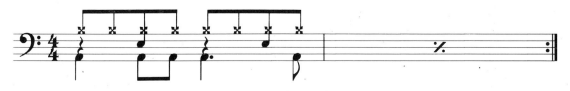

LESSON FOURTEEN

DOTTED EIGHTH AND SIXTEENTH NOTES

The dot increases the value of the preceding note by one half. Since an eighth note equals two sixteenth notes, a dotted eighth note equals three sixteenth notes.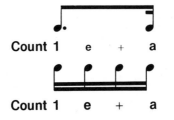

A dotted eighth note and sixteenth note add up to one beat.

Count like this:

Count 1 e + a

Count 1 e + a

This combination is called a **DOTTED EIGHTH AND SIXTEENTH**.

EXERCISES USING DOTTED NOTES

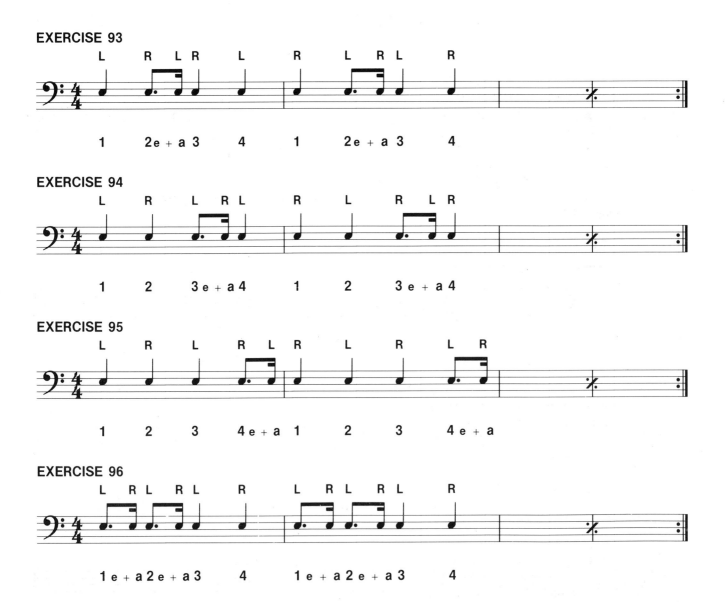

EXERCISE 93

EXERCISE 94

EXERCISE 95

EXERCISE 96

EXERCISE 97

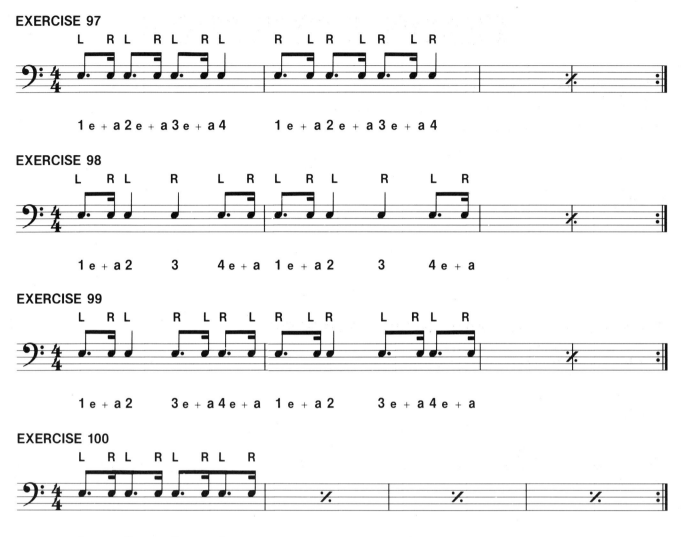

EXERCISE 98

EXERCISE 99

EXERCISE 100

The following drum beats use dotted eighth and sixteenth notes between the bass drum and the snare. The hi-hat plays straight eighth notes throughout.

EXERCISE 101

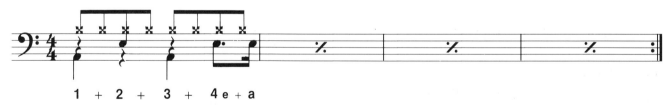

1 + 2 + 3 + 4 e + a

EXERCISE 102

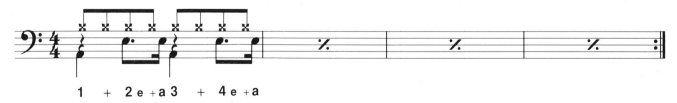

1 + 2 e + a 3 + 4 e + a

EXERCISE 103

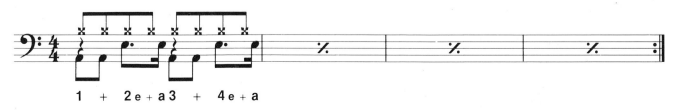

1 + 2 e + a 3 + 4 e + a

LESSON FIFTEEN

SIXTEENTH NOTE RESTS

A **SIXTEENTH NOTE REST** 𝄿 means silence for the count of a quarter of a beat. It can be found anywhere in music and is counted in exactly the same way as a sixteenth note. Here are some examples of sixteenth note rests:

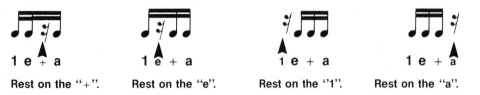

1 e + a 1 e + a 1 e + a 1 e + a

Rest on the "+". Rest on the "e". Rest on the "1". Rest on the "a".

The following drum beats incorporate the use of sixteenth note rests and dotted eighth and sixteenth notes.

EXERCISE 104 Examples of sixteenth note rests.

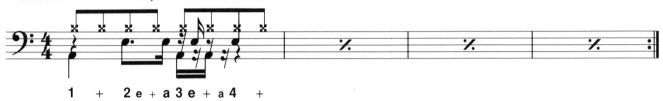

1 + 2 e + a 3 e + a 4 +

EXERCISE 105

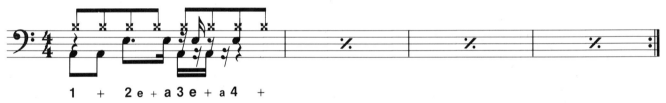

1 + 2 e + a 3 e + a 4 +

EXERCISE 106

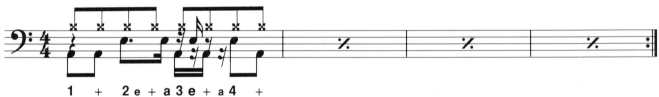

1 + 2 e + a 3 e + a 4 +

EXERCISE 107

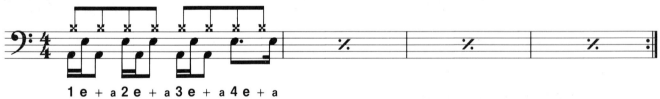

1 e + a 2 e + a 3 e + a 4 e + a

EXERCISE 108

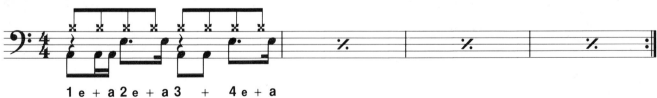

1 e + a 2 e + a 3 + 4 e + a

EXERCISE 109

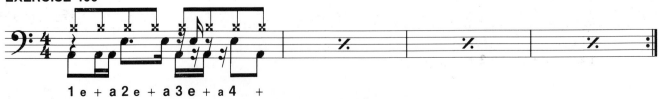

1 e + a 2 e + a 3 e + a 4 +

LESSON SIXTEEN

DOTTED EIGHTH AND SIXTEENTH NOTE ROCK BEATS

The following eighth and sixteenth note timing is very common in rock drumming.

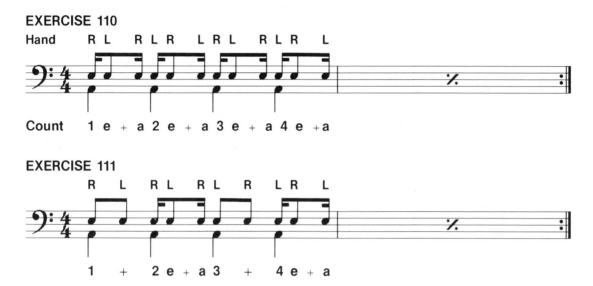

1 e + a

Hit on **1** and '**e**'. Rest on '**+**'. Hit on '**a**'.

EXERCISE 110

Hand R L R L R L R L R L R L

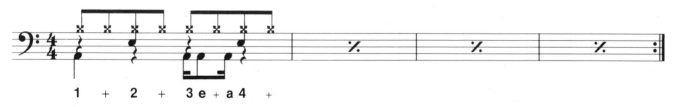

Count 1 e + a 2 e + a 3 e + a 4 e + a

EXERCISE 111

R L R L R L R L R L

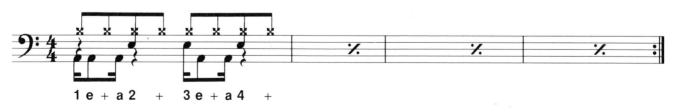

1 + 2 e + a 3 + 4 e + a

The following rock beats and fills incorporate the above timing.

ROCK BEATS:

EXERCISE 112

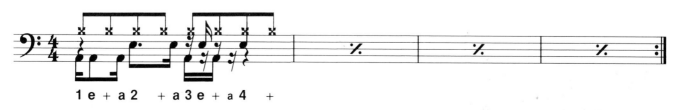

1 + 2 + 3 e + a 4 +

EXERCISE 113

1 e + a 2 + 3 e + a 4 +

EXERCISE 114

1 e + a 2 + a 3 e + a 4 +

40

FILLS: USING ABOVE TIMING

EXERCISE 115

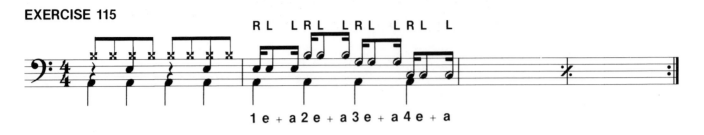

1 e + a 2 e + a 3 e + a 4 e + a

EXERCISE 116

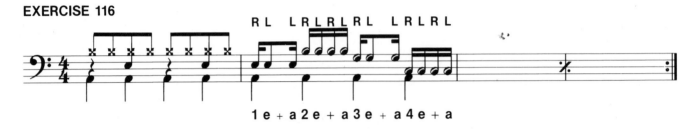

1 e + a 2 e + a 3 e + a 4 e + a

EXERCISE 117

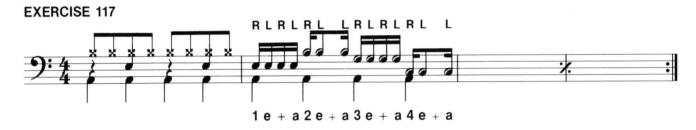

1 e + a 2 e + a 3 e + a 4 e + a

EXERCISE 118

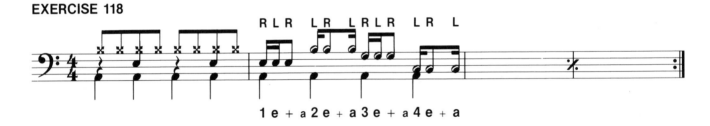

1 e + a 2 e + a 3 e + a 4 e + a

EXERCISE 119

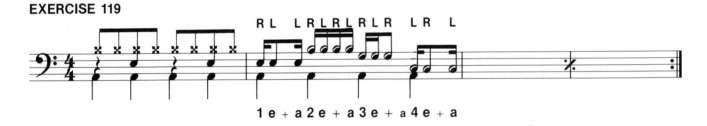

1 e + a 2 e + a 3 e + a 4 e + a

EXERCISE 120

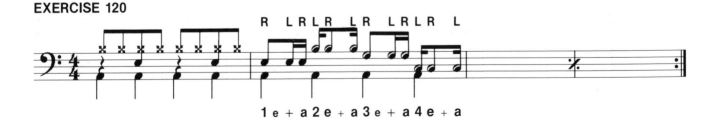

1 e + a 2 e + a 3 e + a 4 e + a

EXERCISE 121

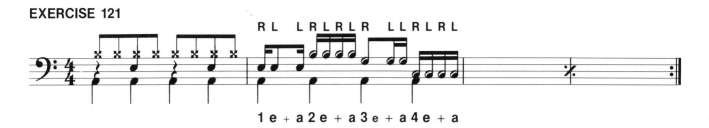

1 e + a 2 e + a 3 e + a 4 e + a

EXERCISE 122

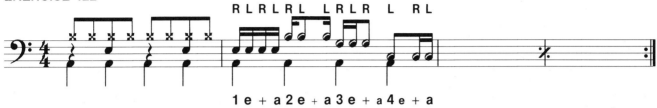

1 e + a 2 e + a 3 e + a 4 e + a

EXERCISE 123

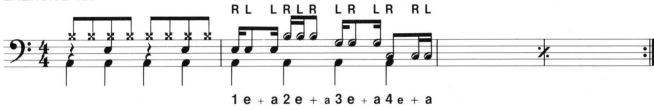

1 e + a 2 e + a 3 e + a 4 e + a

LESSON SEVENTEEN

RHYTHM REVIEW

The following rock beats incorporate the eighth and sixteenth note timing combinations you have been studying in the past three lessons.

EXERCISE 124

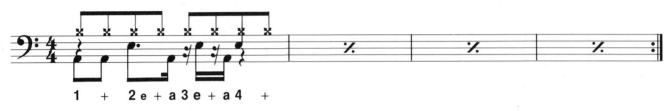

1 + 2 e + a 3 e + a 4 +

EXERCISE 125

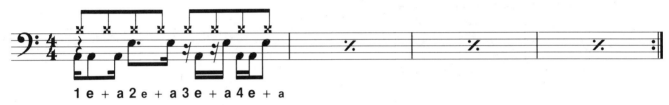

1 e + a 2 e + a 3 e + a 4 e + a

EXERCISE 126

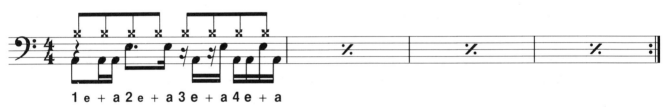

1 e + a 2 e + a 3 e + a 4 e + a

EXERCISE 127

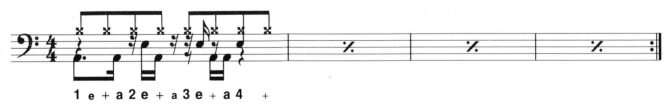

1 e + a 2 e + a 3 e + a 4 +

EXERCISE 128

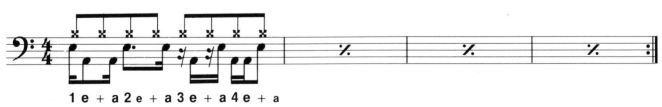

1 e + a 2 e + a 3 e + a 4 e + a

EXERCISE 129

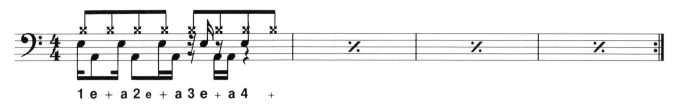

1 e + a 2 e + a 3 e + a 4 +

EXERCISE 130

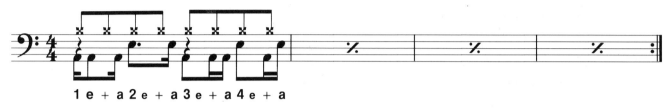

1 e + a 2 e + a 3 e + a 4 e + a

EXERCISE 131

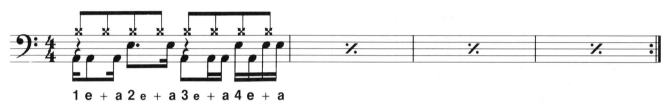

1 e + a 2 e + a 3 e + a 4 e + a

EXERCISE 132

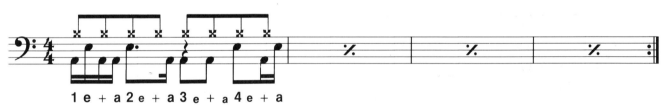

1 e + a 2 e + a 3 e + a 4 e + a

EXERCISE 133

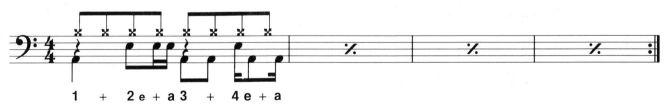

1 + 2 e + a 3 + 4 e + a

44

Here is a 12 bar exercise using dotted notes in rock beats.

EXERCISE 134

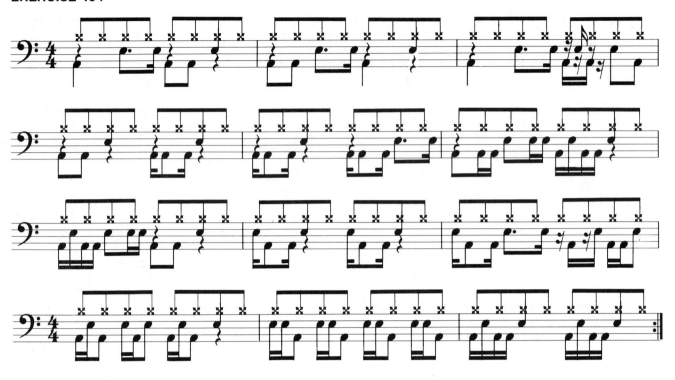

DRUM SOLO 3

EXERCISE 135

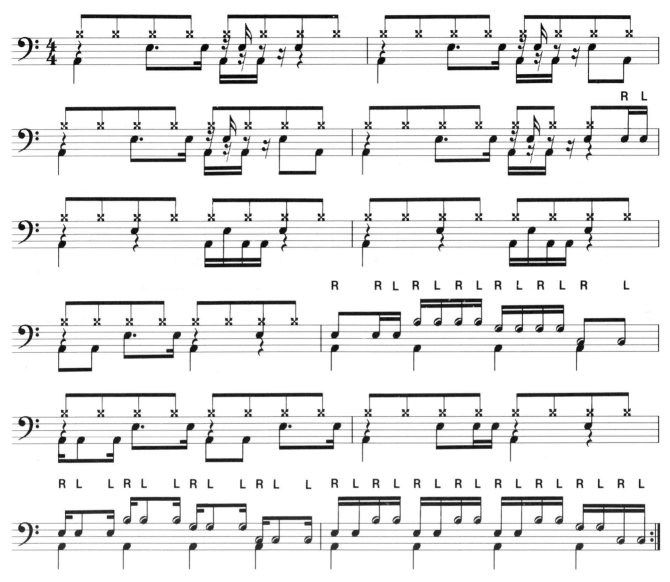

LESSON EIGHTEEN

QUARTER NOTE CYMBAL PATTERNS
Here are some rock beats using **QUARTER NOTE CYMBAL PATTERNS**.

EXERCISE 136

EXERCISE 137

EXERCISE 138

EXERCISE 139

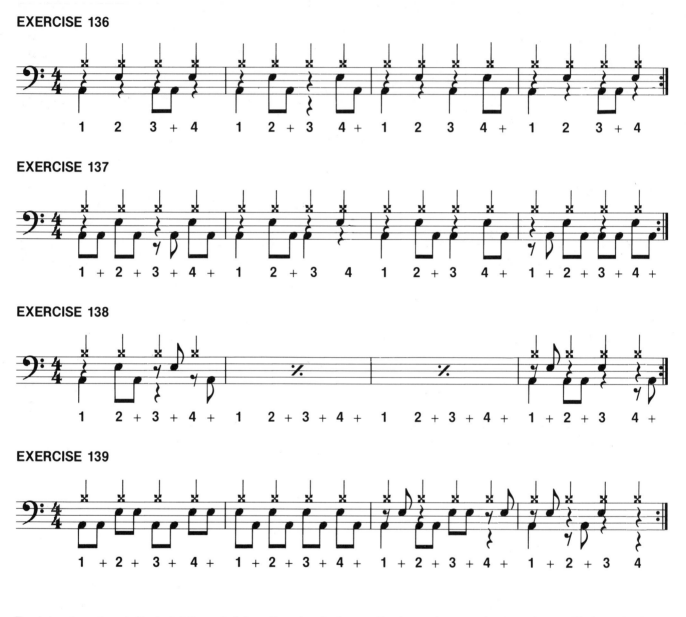

Rock beats using dotted eighth and sixteenth notes between the bass drum and snare drum will give a 'swinging' or 'bouncing' feel when playing quarter notes on the cymbal pattern.

EXERCISE 140

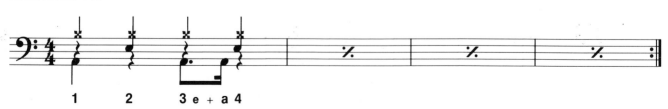

EXERCISE 141

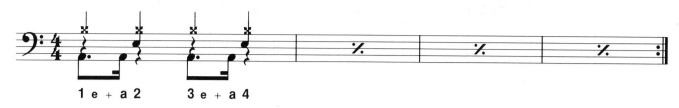

1 e + a 2 3 e + a 4

EXERCISE 142

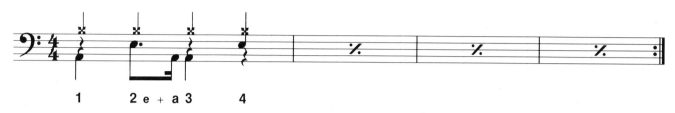

1 2 e + a 3 4

EXERCISE 143

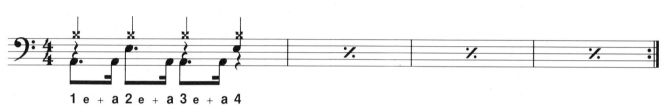

1 e + a 2 e + a 3 e + a 4

EXERCISE 144

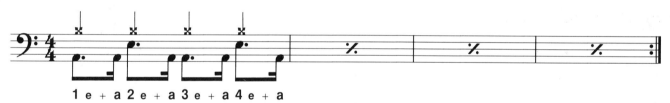

1 e + a 2 e + a 3 e + a 4 e + a

LESSON NINETEEN

THE SHUFFLE RHYTHM

The **SHUFFLE RHYTHM** is based on the cymbal pattern playing continuous dotted eighth and sixteenth notes giving the whole beat a 'swinging' or 'bouncing' feeling.

Normal eighth note patterns look like this:

Shuffle rhythm patterns look like this:

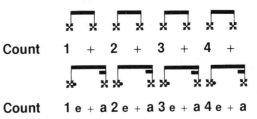

EXERCISE 145

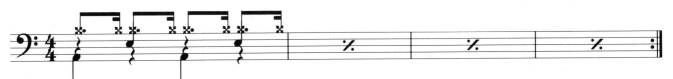

EXERCISE 146

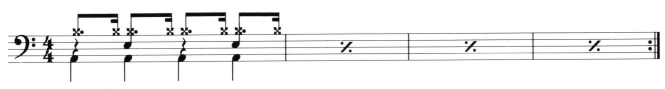

EXERCISE 147

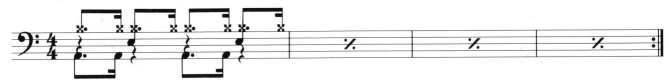

EXERCISE 148

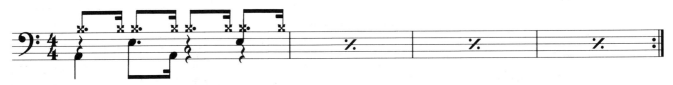

EXERCISE 149

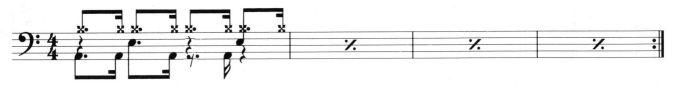

EXERCISE 150

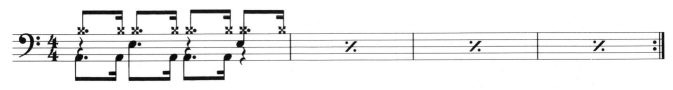

EXERCISE 151

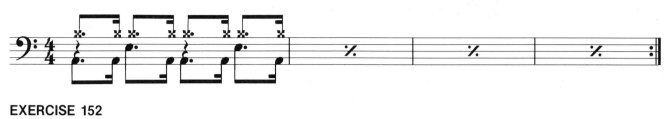

EXERCISE 152

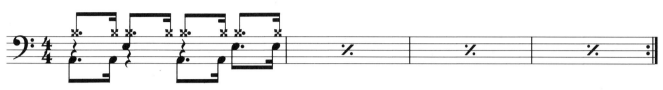

EXERCISE 153

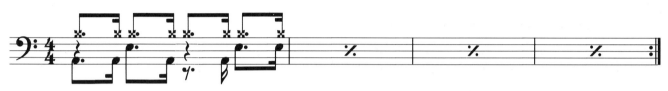

After practising each exercise individually try playing all the way through from **Ex. 145-153** without stopping.

DRUM SOLO 4

EXERCISE 154

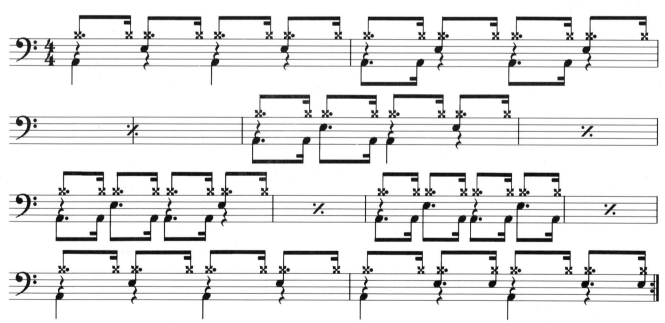

In Drum music (for simplification) the cymbal pattern is commonly **written** like this

However, if played as written, it would sound jerky and would not flow.
What is actually **played** by most drummers is this

This is done in order to produce a more even flowing feel. Hence, the shuffle beat may also be written using this triplet cymbal Pattern (see Triplets in the next lesson and Ex. 339 and 340).

LESSON TWENTY

THE TRIPLET

A **TRIPLET** is a group of three notes played in the same time as two notes of the same kind. The most common triplets are eighth note triplets, indicated by a curved line with the figure **3** above it.

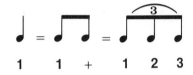

The triplet is used frequently in rock drumming and jazz drumming, whether it be played as a fill (using snare and tom-toms and rolling around them), or various combinations between your hands and feet on the bass drum, and hi-hat.

Just as eighth notes are played smoothly when joined together e.g. , triplets are played smoothly also e.g. .

Try these exercises going from eighth notes for 1 bar to triplet notes for the second bar, using the bass drum to help you keep time.

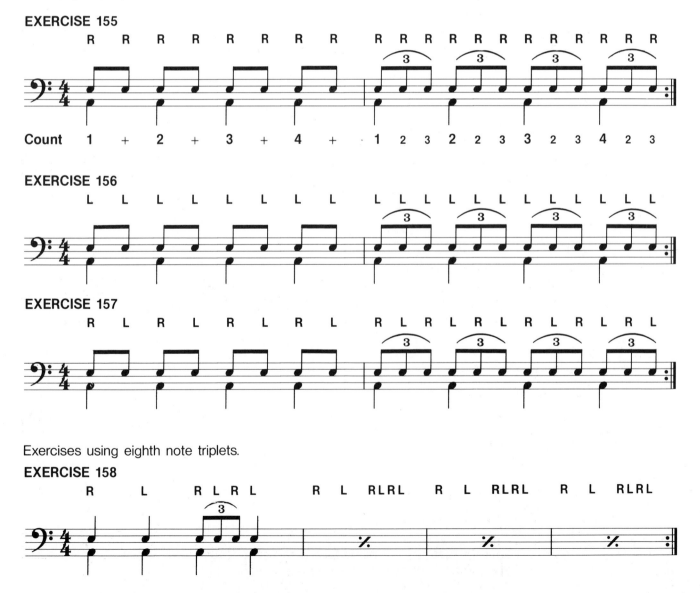

EXERCISE 155

EXERCISE 156

EXERCISE 157

Exercises using eighth note triplets.

EXERCISE 158

EXERCISE 159

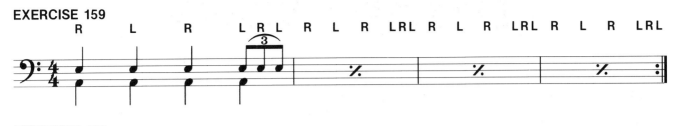

EXERCISE 160

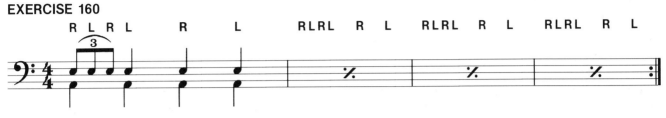

EXERCISE 161

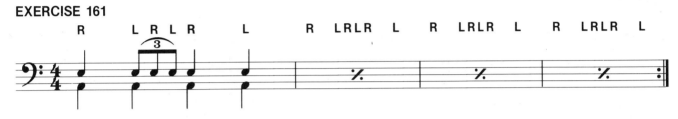

EXERCISE 162

EXERCISE 163

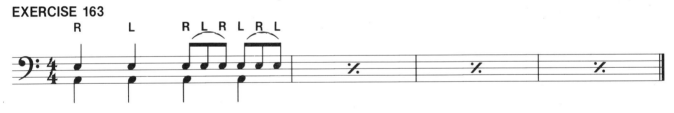

EXERCISE 164

EXERCISE 165

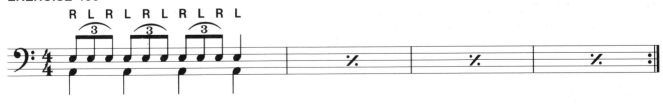

EXERCISE 166

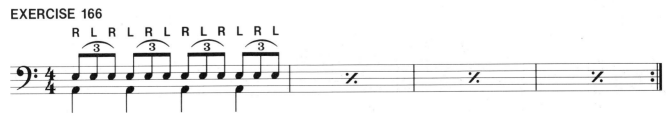

LESSON TWENTY-ONE

SIXTEENTH NOTE TRIPLETS

In **SIXTEENTH NOTE TRIPLETS** six evenly spaced notes are played on 1 beat, indicated thus:

The following exercises use sixteenth note triplets.

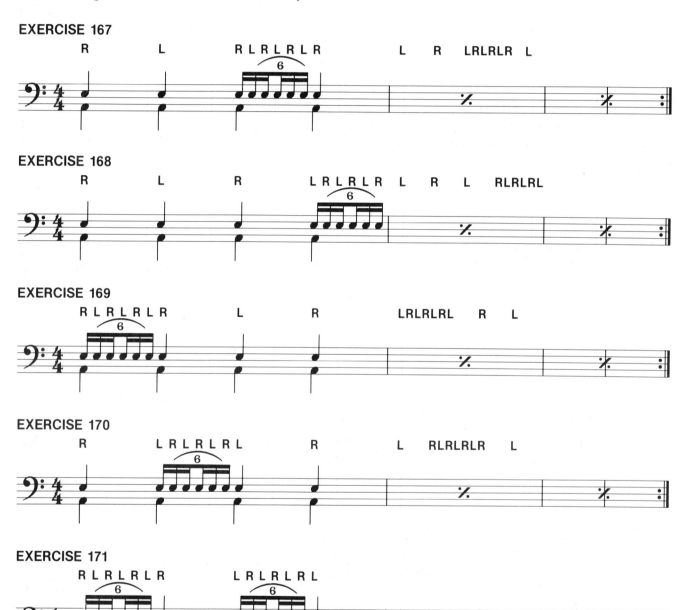

EXERCISE 167

EXERCISE 168

EXERCISE 169

EXERCISE 170

EXERCISE 171

EXERCISE 172

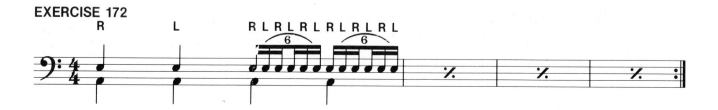

EXERCISE 173

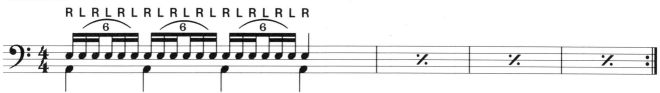

EXERCISE 174

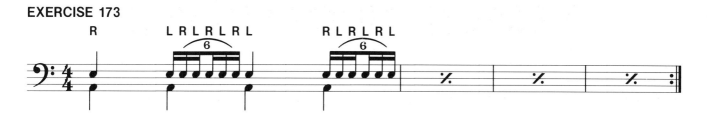

EXERCISE 175

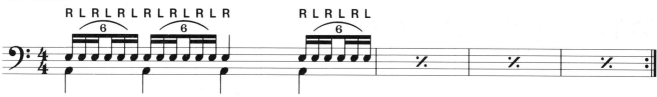

EXERCISE 176

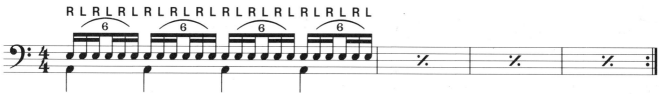

Exercises using eighth note triplets and sixteenth note triplets.

EXERCISE 177

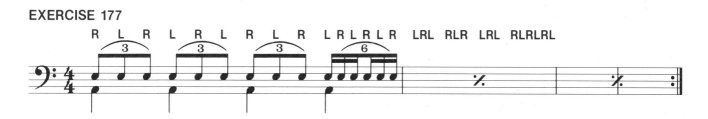

EXERCISE 178

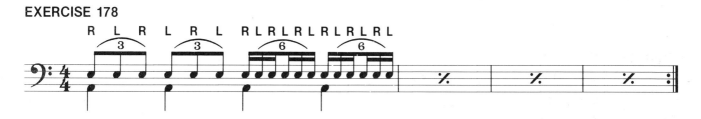

EXERCISE 179

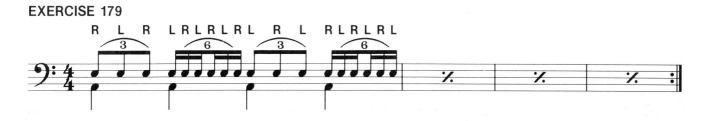

EXERCISE 180

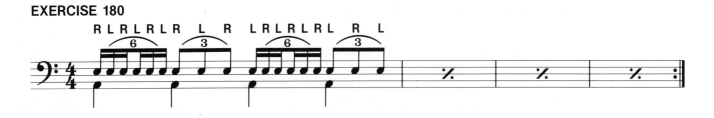

EXERCISE 181

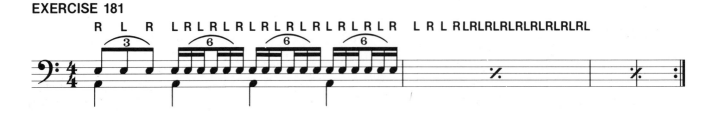

Here is a 12 bar exercise using triplets you have learnt so far.

EXERCISE 182

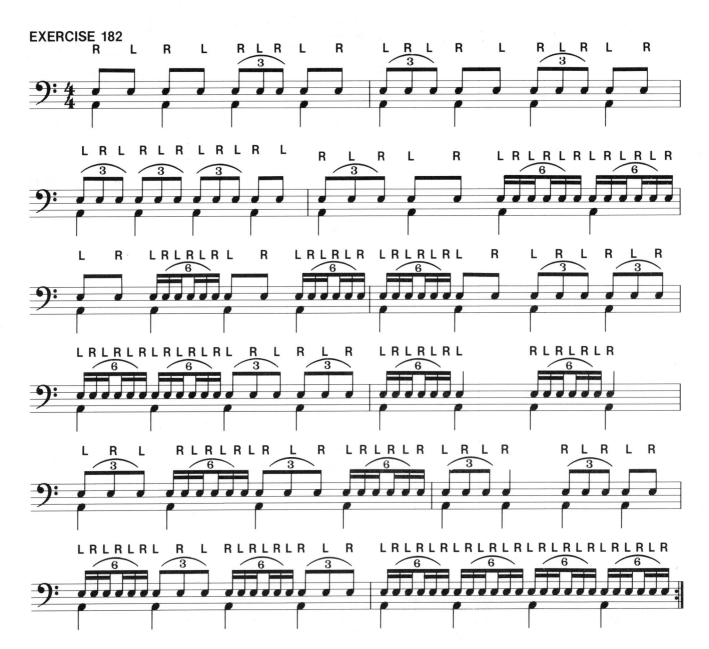

Here are four exercises using triplets around the drums.

EXERCISE 183

EXERCISE 184

EXERCISE 185

EXERCISE 186

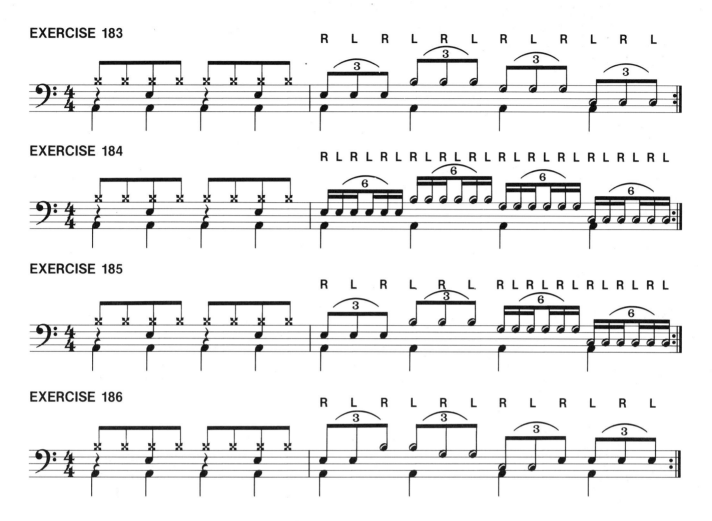

LESSON TWENTY-TWO

ACCENTS

ACCENTS indicate that a note is to be played louder. They are marked by an arrowhead > placed above or below the note e.g.

ACCENT STUDIES ON THE SNARE DRUM

First try all of these exercises on the snare drum only (**as written**). Once you can play them evenly and smoothly, experiment by playing the accented note on the tom-toms, cymbal, etc. (while still hitting the snare drum). e.g. right hand on the floor tom, left hand on the snare drum, or right hand on the bell of the ride cymbal, left hand on the hi-hat.

The possibilities are endless, so be creative and use your imagination.

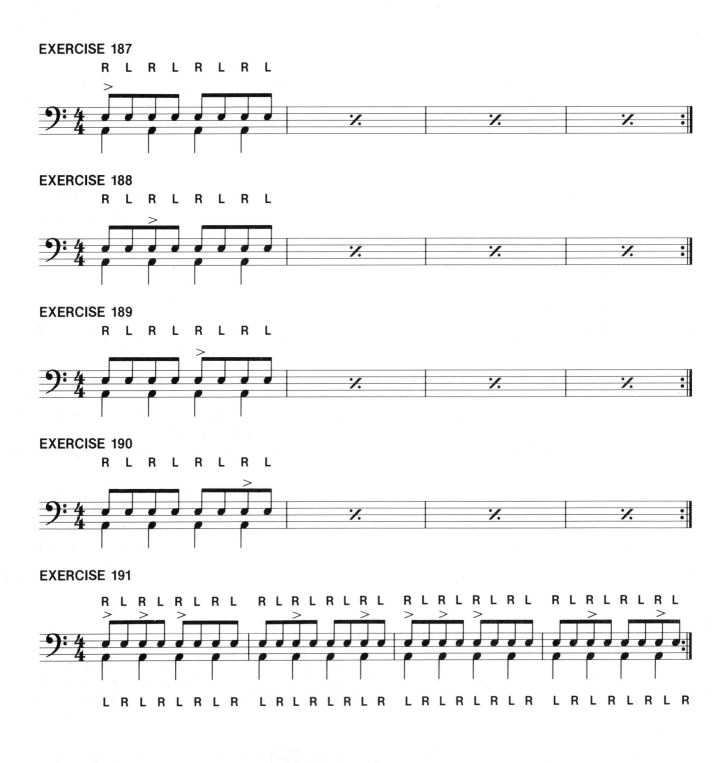

EXERCISE 192

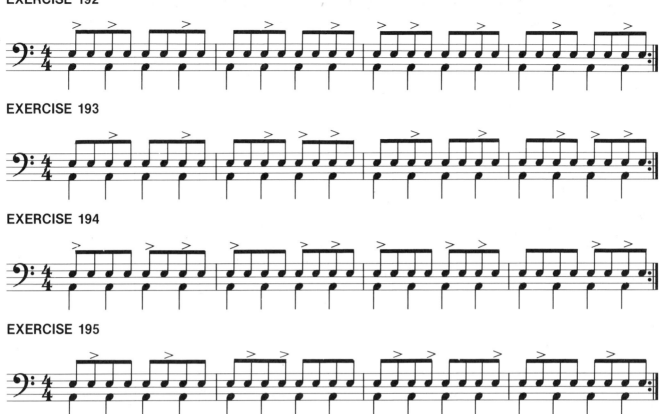

EXERCISE 193

EXERCISE 194

EXERCISE 195

EXERCISE 196

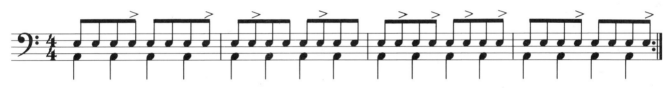

EXERCISE 197

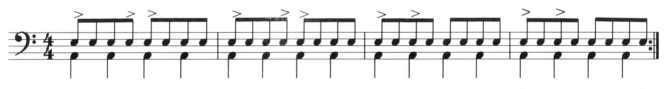

EXERCISE 198

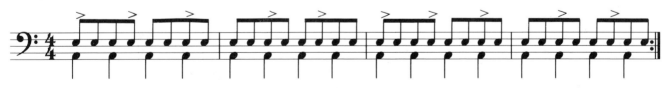

EXERCISE 199

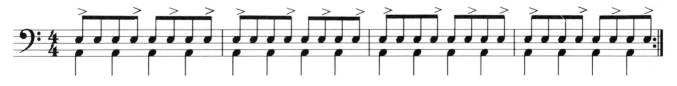

EXERCISE 200 Accented Triplets eighth notes.

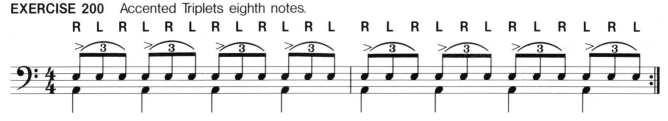

EXERCISE 201

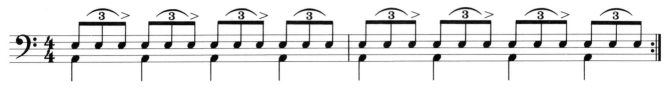

EXERCISE 202

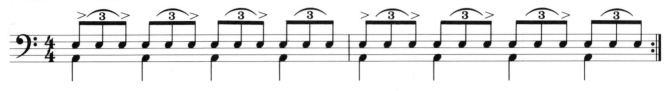

EXERCISE 203

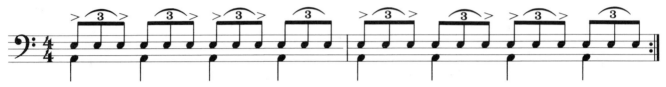

EXERCISE 204

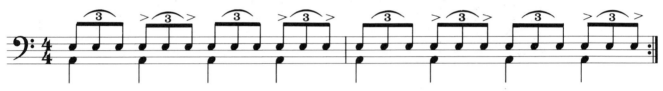

EXERCISE 205

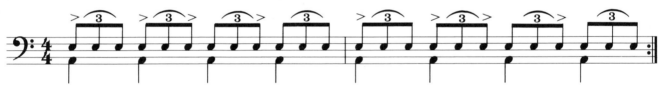

EXERCISE 206

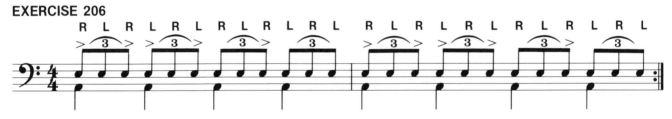

EXERCISE 207

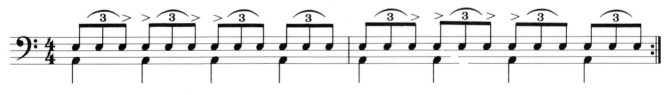

EXERCISE 208

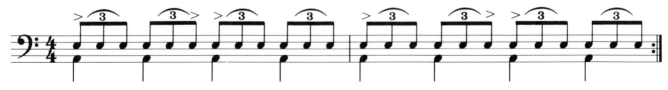

EXERCISE 209

SECTION TWO

LESSON TWENTY-THREE

DRUM RUDIMENTS

DRUM RUDIMENTS are basic drum techniques required to achieve greater stick control. These rudiments shall be introduced over the next twelve lessons and are essential for the development of drumming skills. In this book the exercises illustrating the rudiments are played on the whole drum kit and not just the snare drum. When playing these rudiments it is **ESSENTIAL** to observe the correct timing and correct 'sticking' (e.g. **RLRLLR**).

RUDIMENT NO. 1
THE LONG ROLL OR DOUBLE STROKE ROLL

The **LONG ROLL** is formed by playing two left taps or two right taps, followed by two right taps or two left taps respectively. e.g. **LLRRLLRRLLRR** or **RRLLRRLLRRLL**.

As you play this rudiment you will probably find that you can play it either slow or fast, but cannot play from slow going through to fast. It is this transition in the middle which gives students the most trouble. The reason for this is that when you are playing the roll slowly you are playing **ONE** tap with **ONE** wrist movement, but as your speed increases you begin playing **TWO** taps with **ONE** wrist movement. This is called **THE BOUNCE**. The bounce is achieved by playing the first beat as usual (with the wrist **AND** forearm), while the second beat is 'bounced' and controlled by the fingers. The wrist remains in the **DOWN** position.

The following exercise introduces thirty-second notes ♪. There are eight thirty-second notes in one quarter note, as illustrated below:

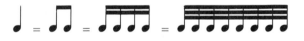

Because of the speed of thirty-second notes, you will play by 'feel' rather than counting each individual note.

Try bouncing each hand separately and then together to play **Ex. 210**. Make sure you relax and don't tense up and you will find the bounce will come after diligent practice.

EXERCISE 210

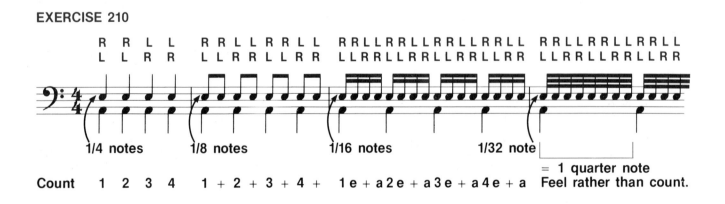

LESSON TWENTY-FOUR

RUDIMENT NO. 2
THE SINGLE STROKE ROLL

The **SINGLE STROKE ROLL**, together with the double stroke roll used in various ways are probably the two most used rudiments in rock drumming. They can be used in fills, introductions and endings of songs.

Practise starting the exercise with both your left and right hand. Unlike the double stroke roll the single stroke roll is played using single wrist movements for each tap and does not bounce in the same manner as the double stroke roll.
Start very slowly and gradually increase your speed making sure it is played smoothly, cleanly and evenly spaced.

EXERCISE 211

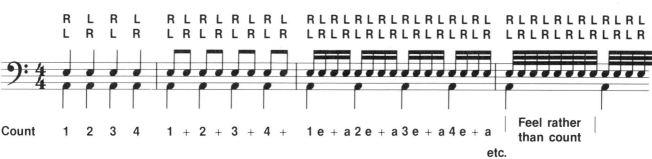

RUDIMENT NO. 3
THE FLAM

This rudiment is also common in rock drumming and consists of the main note with a 'Grace Note' played before it. Grace notes are indicated by a smaller note crossed with a diagonal line. They have no real time value.

i.e. grace note ▶ ◀ main note

Practise the flam by bringing both hands down together, but let the right hand strike the drum first, then immediately play the main note with your left hand. Repeat the procedure in reverse (i.e. let the left hand play the grace note and the right hand play the main note).

The slur line beneath each flam indicates that the notes should be played as smoothly as possible.

EXERCISE 212

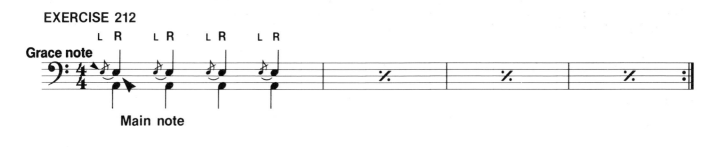

EXERCISE 213

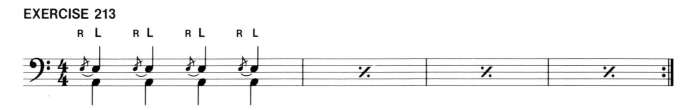

EXERCISE 214

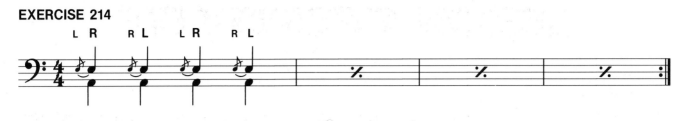

EXERCISE 215

EXERCISE 216

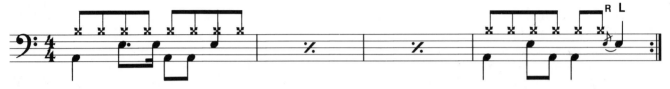

LESSON TWENTY-FIVE

RUDIMENT NO. 4
THE FLAM TAP

This rudiment is commonly used in marching bands but is also used in rock drumming. The majority of **MARCH-ING MUSIC** is written in either $\frac{2}{4}$ or $\frac{6}{8}$ time and can be adopted in rock music, most of which is played in $\frac{4}{4}$ time.

EXERCISE 217

EXERCISE 218

EXERCISE 219

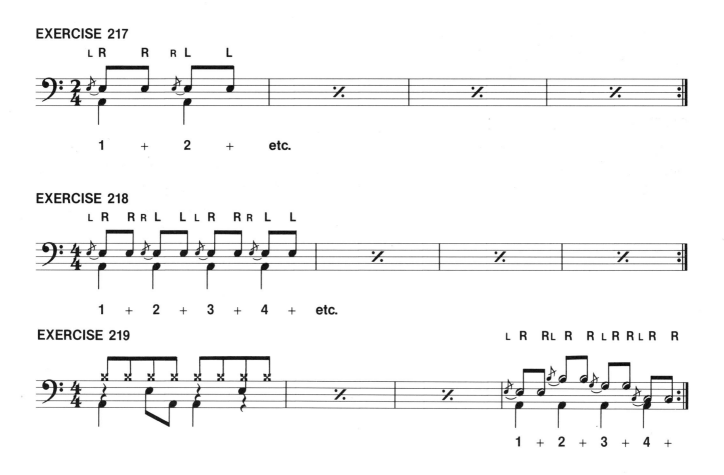

LESSON TWENTY-SIX

TIME SIGNATURES - SIMPLE AND COMPOUND TIME

A **TIME SIGNATURE** consists of two numbers. The top number tells how many beats per bar, while the bottom number shows the value of each beat. The bottom number in any time signature can only be a note. e.g. quarter note, eighth note etc.

4 - this represents 4/1, which indicates the number of beats per bar (4).

4 - this represents 1/4, which indicates that the beats are quarter notes (crotchets).

SIMPLE TIME

SIMPLE TIME occurs when the beat falls on undotted notes (quarter notes, half notes, eighth notes etc.) and thus every beat is divisible by two. In $\frac{4}{4}$ time the basic beat is a quarter note, which can be split into groups of two thus:

QUARTER NOTE	♩
EIGHTH NOTE	♫
SIXTEENTH NOTE	♬♬

Other common examples of simple time are $\frac{2}{4}$, $\frac{3}{4}$ and $\frac{3}{8}$. $\frac{2}{4}$ time indicates 2 quarter note beats per bar, $\frac{3}{4}$ time indicates 3 quarter note beats per bar, and $\frac{3}{8}$ time indicates 3 eighth note beats per bar (rhythmically similar to $\frac{3}{4}$ time).

COMPOUND TIME

A beat can also occur on a dotted note, making it divisible into groups of three. This is called **COMPOUND TIME.**

DOTTED QUARTER NOTE	♩.
EIGHTH NOTE	♪♪♪
SIXTEENTH NOTE	♬♬♬

The most common examples of compound time are $\frac{6}{8}$ and $\frac{12}{8}$. The interpretation of these time signatures is different from those of simple time. $\frac{6}{8}$ represents 6 eight note beats per bar. It can also represent 2 beats per bar i.e. 2 dotted quarter notes. This is calculated by dividing the top number by 3, to get the number of beats per bar (6 - 3 = 2); and dividing the bottom number by 2 (8 - 2 = 4) to get the type of dotted note receiving 1 beat. This results in a different rhythm feel for compound time. Compare $\frac{6}{8}$ to $\frac{3}{4}$ time, where they both can obtain 6 eighth notes in a bar.

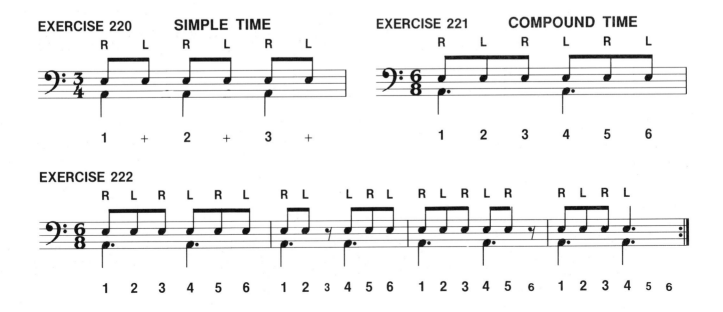

EXERCISE 220 **SIMPLE TIME**

EXERCISE 221 **COMPOUND TIME**

EXERCISE 222

EXERCISE 223

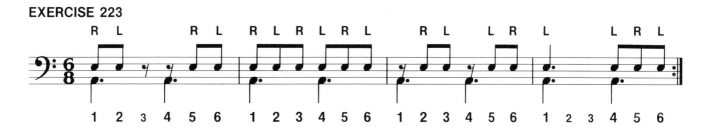

RUDIMENT NO. 5
THE FLAM ACCENT

This rudiment is generally played in $\frac{6}{8}$ time, but again can also be played in $\frac{2}{4}$ time or for rock in $\frac{4}{4}$ time. In $\frac{2}{4}$ and $\frac{4}{4}$ time it will be played as a triplet.

EXERCISE 224

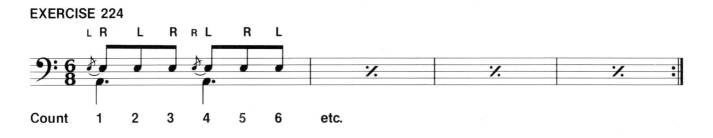

EXERCISE 225

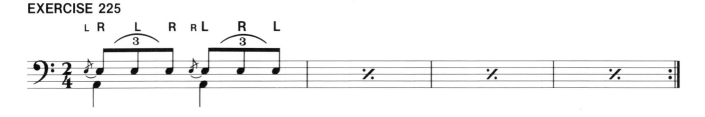

EXERCISE 226

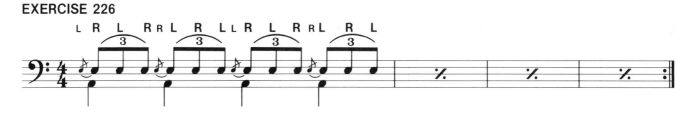

EXERCISE 227

RUDIMENT NO. 6
THE FLAMACUE

This rudiment combines both the flam technique and accents.

EXERCISE 228

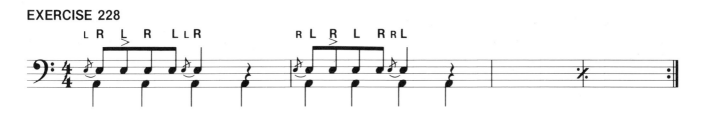

LESSON TWENTY-SEVEN

RUDIMENT NO. 7
THE SINGLE PARADIDDLE

The **SINGLE PARADIDDLE** consists of two groups of four notes (e.g. sixteenth notes) played either **RLRR LRLL** or **LRLL RLRR**. As the single paradiddle is not played strictly alternating (i.e. **RLRLRL** etc.) certain solos and fills can be played faster and more comfortably when moving around the kit.

EXERCISE 229

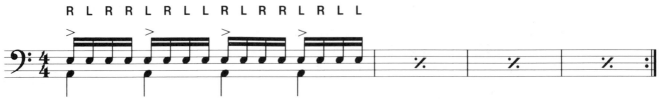

The following exercises are single paradiddles with the accent placed on different beats. Practise each exercise starting firstly with the right hand and then with the left hand.

EXERCISE 230

EXERCISE 231

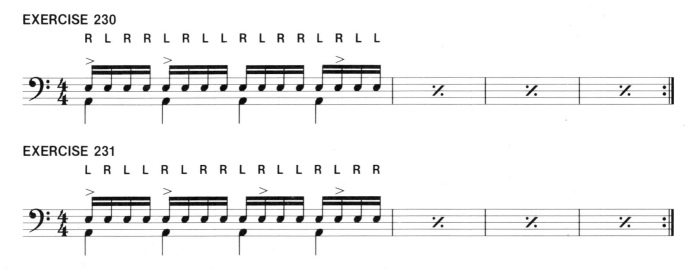

In the following exercises the accents are replaced by the tom toms.

EXERCISE 232

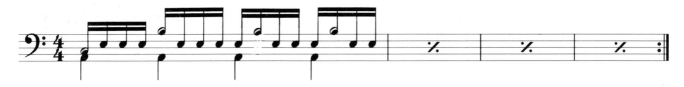

EXERCISE 233

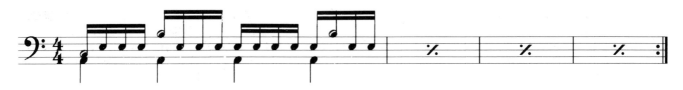

EXERCISE 234

L R L L R L R R L R L L R L R R

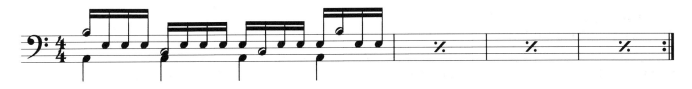

EXERCISE 235

L R L L R L R R L R L L R L R R

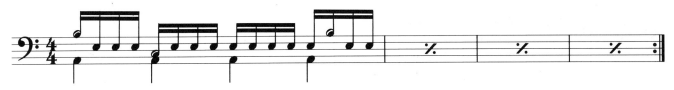

Here are some beats with paradiddle fills.

EXERCISE 236

R L R R L R L L R L R R L R L L

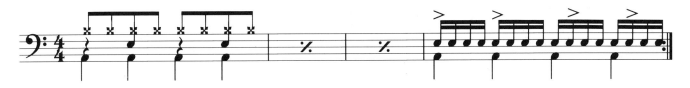

EXERCISE 237

R L R R L R L L R L R R L R L L

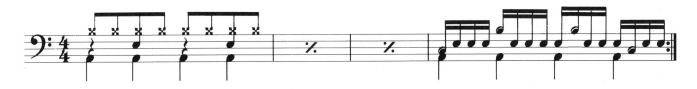

EXERCISE 238

L R L L R L R R L R L L R L R R

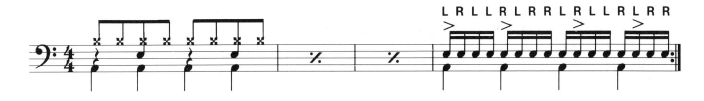

EXERCISE 239

L R L L R L R R L R L L R L R R

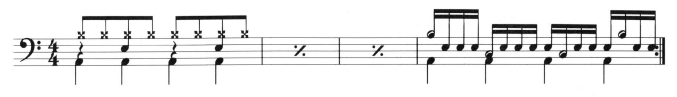

RUDIMENT NO. 8
THE FLAM PARADIDDLE

EXERCISE 240

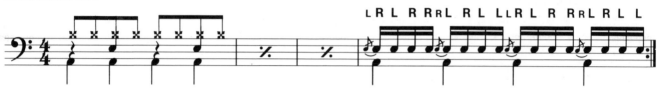

EXERCISE 241

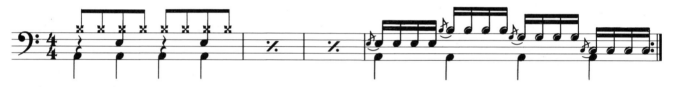

EXERCISE 242

LESSON TWENTY-EIGHT

ROLLS

ROLLS give you the ability to hold a note for a certain length of time on any drum or cymbal. They have their origin in military and traditional styles.

In each roll study an exercise in military and modern style will be given. The slur line beneath each abbreviated roll means that it should be played as smoothly as possible.

RUDIMENT NO. 9
THE FIVE STROKE ROLL
MODERN STYLE

EXERCISE 243

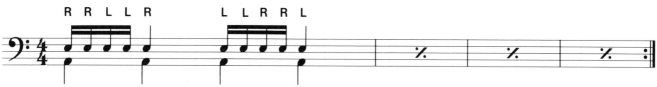

MILITARY STYLE

Most military music is written in $\frac{2}{4}$ time and you will find the five stroke roll very common. This exercise is in $\frac{2}{4}$ time with the last 2 bars being in abbreviated form. Abbreviations are used to condense the written form of rolls on the staff and hence simplify sight reading. The abbreviation of the five stroke roll is written thus:

EXERCISE 244

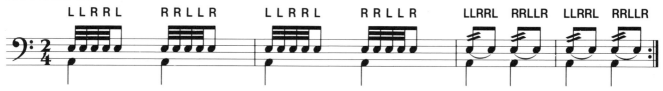

Rock beats using the **FIVE STROKE ROLL** in a two bar fill.

EXERCISE 245

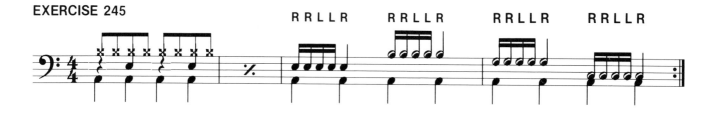

This exercise introduces the **CRASH CYMBAL** placing it at the end of the last five stroke roll in the last bar.

EXERCISE 246

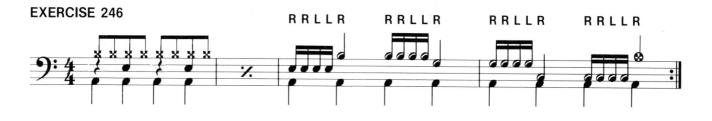

The five stroke roll can be used as a short fill. The last note of the five stroke roll is played on the cymbal when you return to the beginning of the first bar.

EXERCISE 247

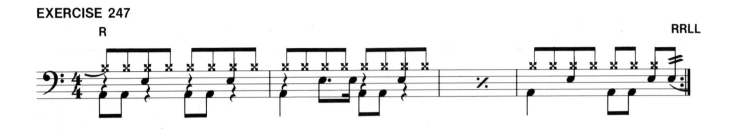

LESSON TWENTY-NINE

RUDIMENT NO. 10
THE SEVEN STROKE ROLL
Ex. 248 introduces the thirty-second note rest i.e.

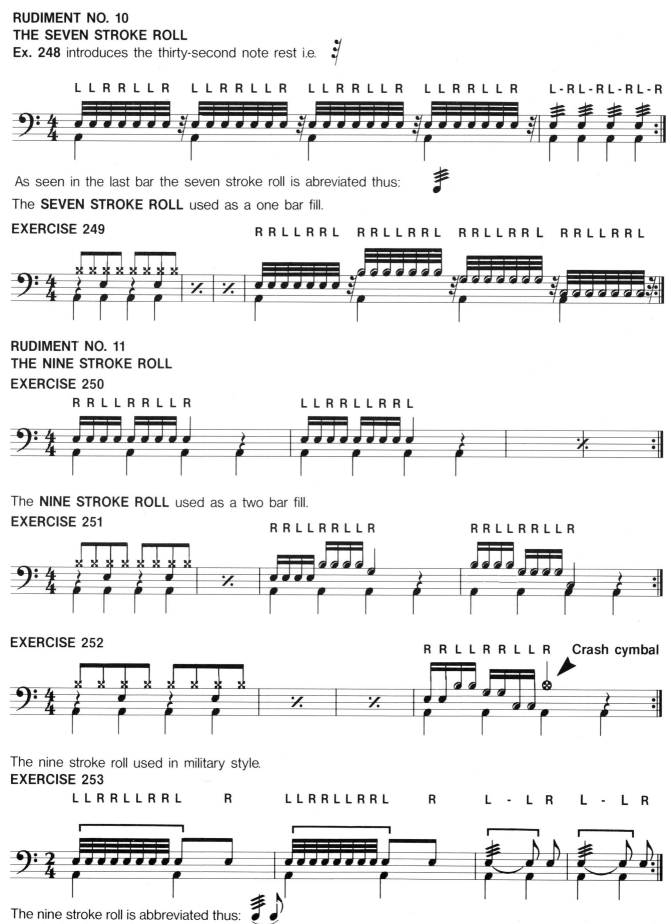

As seen in the last bar the seven stroke roll is abreviated thus:

The **SEVEN STROKE ROLL** used as a one bar fill.

EXERCISE 249

RUDIMENT NO. 11
THE NINE STROKE ROLL
EXERCISE 250

The **NINE STROKE ROLL** used as a two bar fill.
EXERCISE 251

EXERCISE 252

The nine stroke roll used in military style.
EXERCISE 253

The nine stroke roll is abbreviated thus:
The slur line joining the two notes indicates all notes are to be played smoothly.

LESSON THIRTY

RUDIMENT NO. 12
THE TEN STROKE ROLL

EXERCISE 254

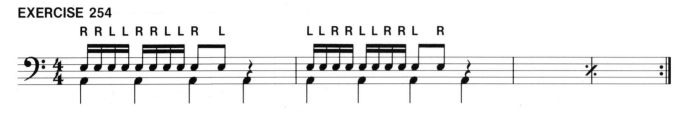

The ten stroke roll as a one bar fill.

EXERCISE 255

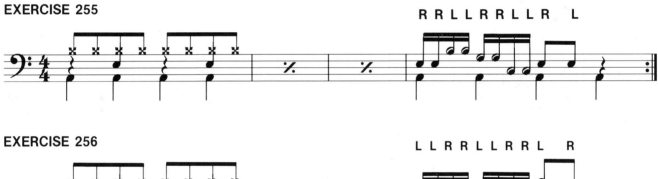

EXERCISE 256

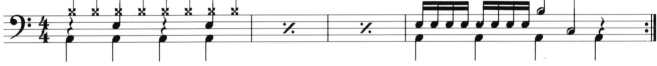

The ten stroke roll in abbreviated style is written thus:

EXERCISE 257

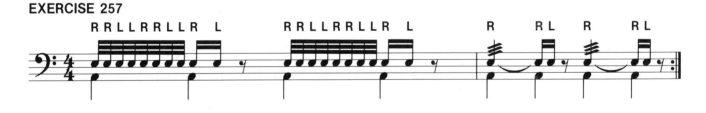

RUDIMENT NO. 13
THE ELEVEN STROKE ROLL

EXERCISE 258

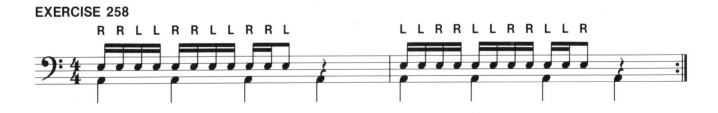

The eleven stroke roll used as a one bar fill.

EXERCISE 259

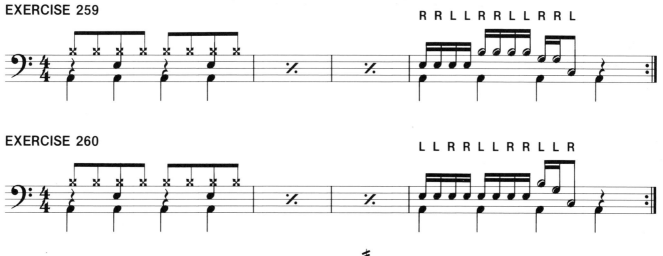

EXERCISE 260

The eleven stroke roll in abbreviated form is written thus:

EXERCISE 261

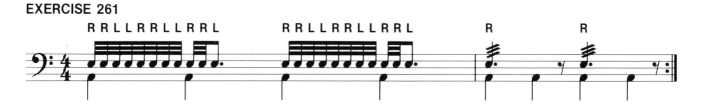

LESSON THIRTY-ONE

RUDIMENT NO. 14
THE THIRTEEN STROKE ROLL

EXERCISE 262

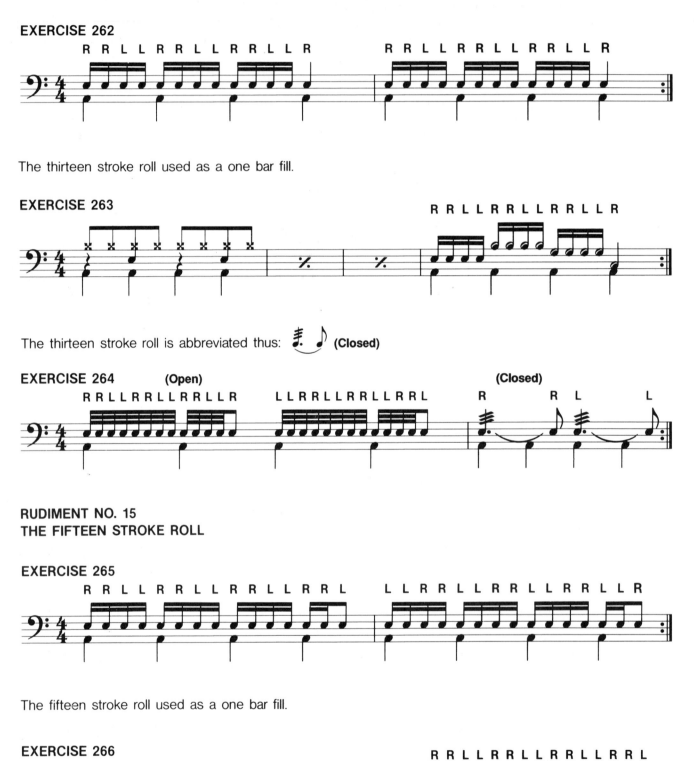

The thirteen stroke roll used as a one bar fill.

EXERCISE 263

The thirteen stroke roll is abbreviated thus: (Closed)

EXERCISE 264

RUDIMENT NO. 15
THE FIFTEEN STROKE ROLL

EXERCISE 265

The fifteen stroke roll used as a one bar fill.

EXERCISE 266

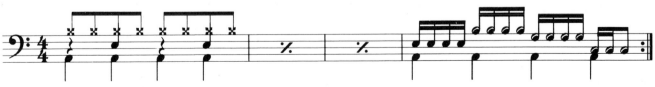

The fifteen stroke roll is abbreviated thus: 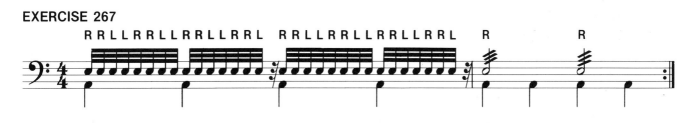 .This exercise introduces the **HALF NOTE** (or **MINIM**) ♩ which is worth two counts.

EXERCISE 267

SUMMARY OF ABBREVIATED ROLLS

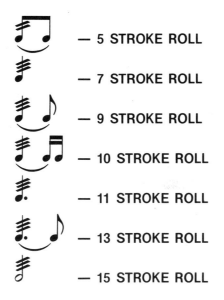

— 5 STROKE ROLL

— 7 STROKE ROLL

— 9 STROKE ROLL

— 10 STROKE ROLL

— 11 STROKE ROLL

— 13 STROKE ROLL

— 15 STROKE ROLL

Here is an 8 bar exercise using the rolls we have learnt so far.

EXERCISE 268

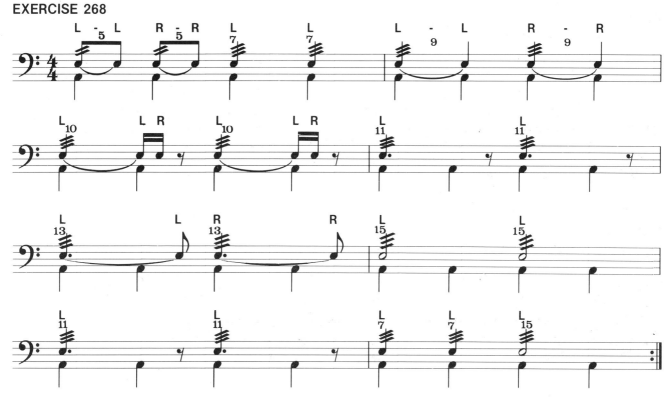

LESSON THIRTY-TWO

RUDIMENT NO. 16
THE DOUBLE PARADIDDLE

The **DOUBLE PARADIDDLE** consists of two groups of six notes (e.g. eighth notes) played either **LRLRLL RLRLRR** or **RLRLRR LRLRLL**.

The Double Paradiddle in $\frac{3}{4}$ time.

EXERCISE 269

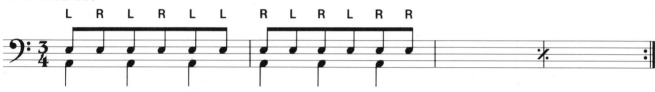

The double paradiddle in $\frac{6}{8}$ time.

EXERCISE 270

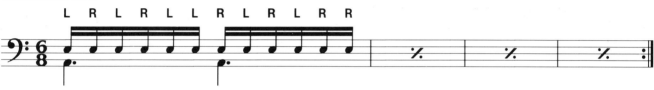

The Double Paradiddle in $\frac{4}{4}$ time using triplets.

EXERCISE 271

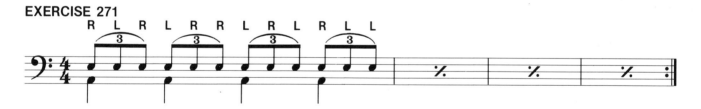

The Double Paradiddle used as a one bar Fill.

EXERCISE 272

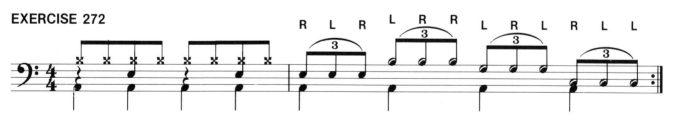

RUDIMENT NO. 17
THE FLAM PARADIDDLE-DIDDLE The Flam Paradiddle-diddle in $\frac{6}{8}$ time.

EXERCISE 273

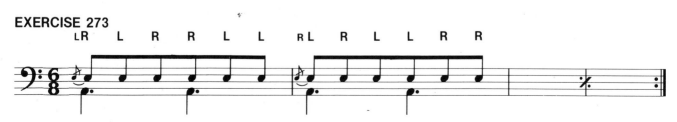

The flam paradiddle-diddle in $\frac{4}{4}$ time.

EXERCISE 274

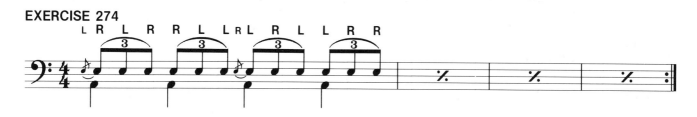

THE TRIPLE PARADIDDLE

EXERCISE 275

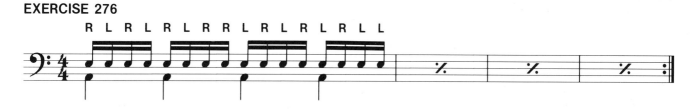

EXERCISE 276

LESSON THIRTY-THREE

RUDIMENT NO. 18
THE DRAG (OR RUFF)
The **DRAG** contains two 'grace notes' followed by one main note 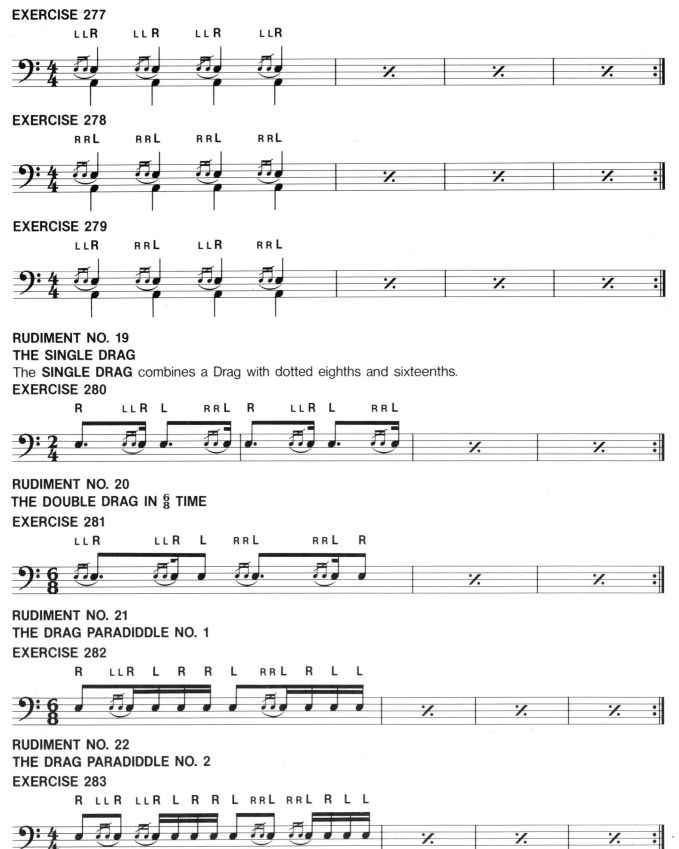. The two grace notes are played with the one hand e.g. L L R or R R L. Remember they are played as close a possible before the main beat, but have no real time value.

EXERCISE 277

EXERCISE 278

EXERCISE 279

RUDIMENT NO. 19
THE SINGLE DRAG
The **SINGLE DRAG** combines a Drag with dotted eighths and sixteenths.
EXERCISE 280

RUDIMENT NO. 20
THE DOUBLE DRAG IN $\frac{6}{8}$ TIME
EXERCISE 281

RUDIMENT NO. 21
THE DRAG PARADIDDLE NO. 1
EXERCISE 282

RUDIMENT NO. 22
THE DRAG PARADIDDLE NO. 2
EXERCISE 283

LESSON THIRTY-FOUR

RUDIMENT NO. 23
THE SINGLE RATAMACUE

EXERCISE 284

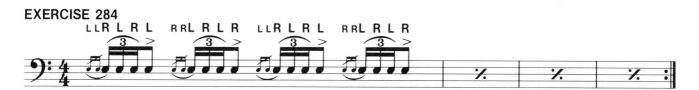

RUDIMENT NO. 24
THE DOUBLE RATAMACUE

EXERCISE 285

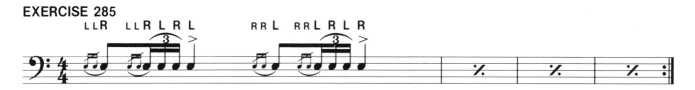

RUDIMENT NO. 25
THE TRIPLE RATAMACUE

EXERCISE 286

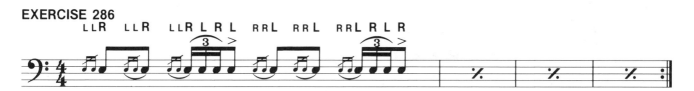

RUDIMENT NO. 26
This Rudiment is called **Lesson Twenty-Five**.

EXERCISE 287

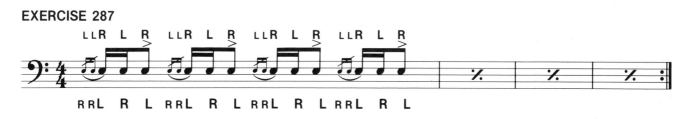

Lesson twenty-five inverted

EXERCISE 288

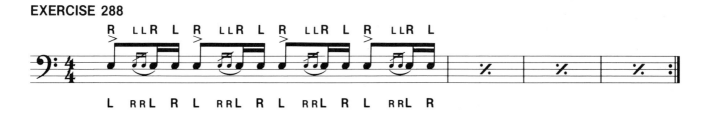

LESSON THIRTY-FIVE

THE FOUR STROKE RUFF.

This rudiment is an extension of the drag. It is played in exactly the same manner except there are three 'grace notes' preceding the main note instead of two.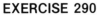

EXERCISE 289

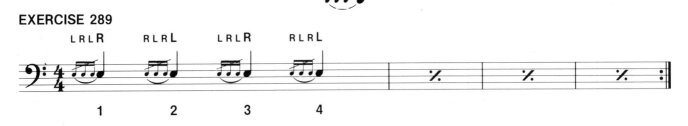

The **FOUR STROKE RUFF** used as a one bar fill.

EXERCISE 290

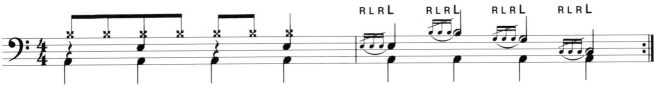

THE SIX STROKE ROLL

EXERCISE 291

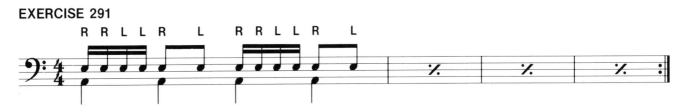

In abbreviated form the **SIX STROKE ROLL** is indicated thus

EXERCISE 292

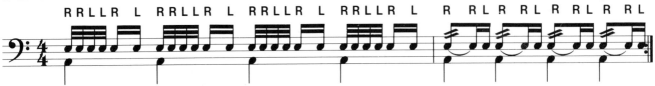

The following three exercises use the six stroke roll as a one bar fill.

EXERCISE 293

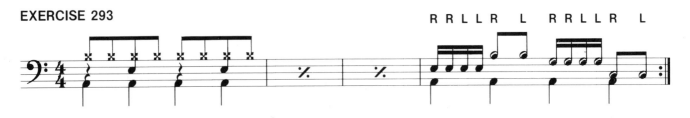

EXERCISE 294

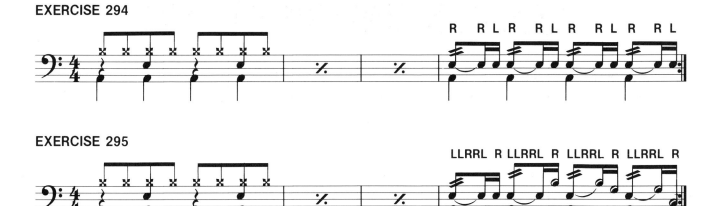

EXERCISE 295

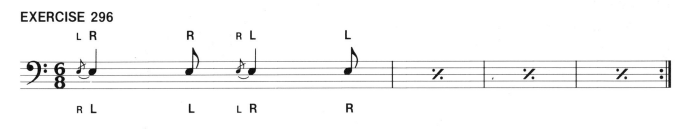

The flam accent no. 2 in $\frac{6}{8}$ time.

This exercise is an extension of **Rudiment 5**.

EXERCISE 296

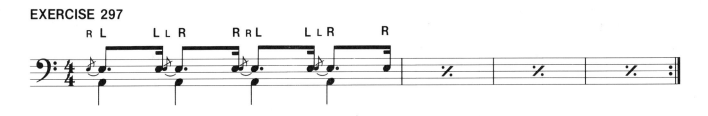

The flam accent no. 2 in $\frac{4}{4}$ time.

EXERCISE 297

SECTION THREE

LESSON THIRTY-SIX

12/8 TIME.

In Lesson Twenty-Five. you were introduced to compound time, where the basic beat is a dotted note and is thus divisable by 3. 12/8 time is another example of compound time, where there are 4 dotted quarter note beats per bar. e.g.

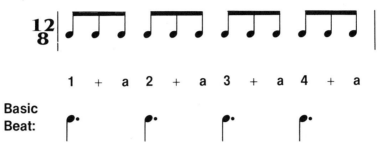

12/8 timing is commonly found in blues songs and very slow ballads.

EXERCISE 298

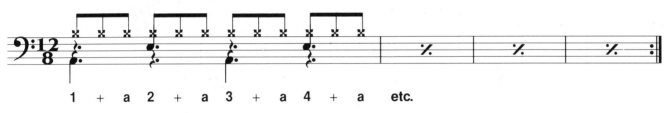

EXERCISE 299

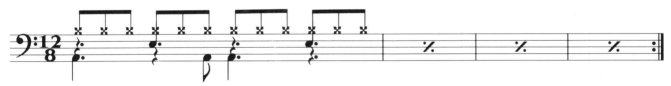

EXERCISE 300

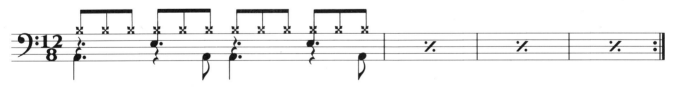

EXERCISE 301

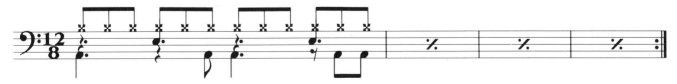

EXERCISE 302

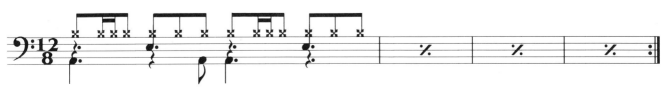

84

EXERCISE 303

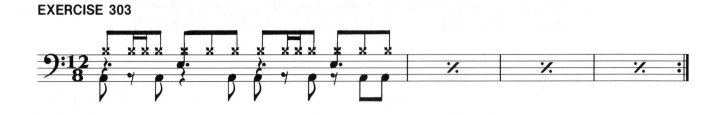

DRUM SOLO 5

EXERCISE 304

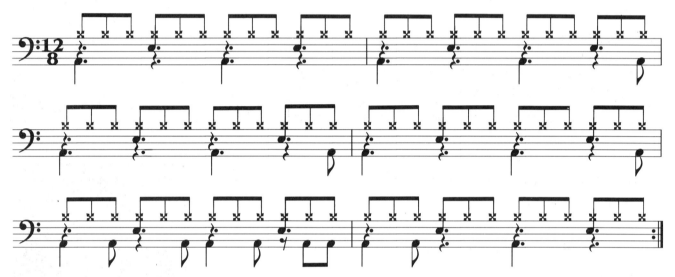

LESSON THIRTY-SEVEN

LATIN AMERICAN BEATS

LATIN AMERICAN BEATS are used widely in 60/40 bands playing at cabarets, dances and hotels.
60/40 bands are bands that play a selection of old pop standards (approximately 60%) and 'Top 40' tunes (40%).
There are many different interpretations of each beat, and it is up to you to experiment. Here are some beats that are the most popular and very useful.

THE CHA-CHA

Play this beat on the hi-hat with the left hand playing on the snare drum and the right hand playing on the small tom-tom on the '**4+**'. **Note:** all these beats can also be played with the butt of the left stick striking the rim of the snare drum.

EXERCISE 305a

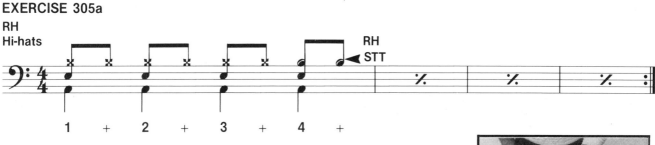

Often, in Latin American beats, the 'RIM' of the snare drum is hit (instead of the skin), indicated thus:

Generally the 'BUTT' of the stick is used **(See Photo. 4)**.

EXERCISE 305b

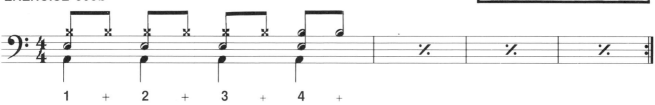

EXERCISE 306

Play this beat with the right hand on the ride cymbal and the left foot closing the hi-hat on each count (1,2,3,4). The left hand plays the tom-tom on the '**4+**' in the first bar, and the floor tom on the '**+3**' in the second bar.
Note: The ride cymbal pattern is continuous all the way through and should not stop when you strike the tom-toms.

Note right hand cymbal pattern and left hand tom-tom being played together on the "**4 +**" section of each bar.

EXERCISE 306

Approach this exercise in the same manner as **Exercise 306**.

EXERCISE 307

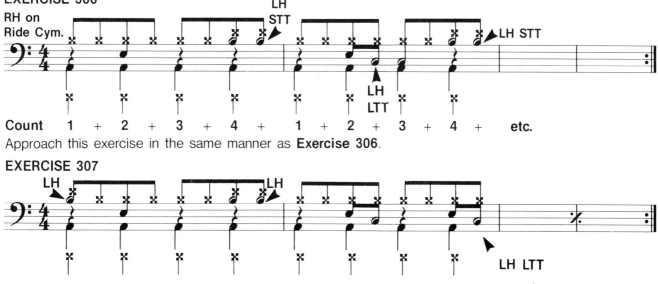

LESSON THIRTY-EIGHT

THE MAMBO

The **MAMBO** can sound very similar to the cha-cha except that the ride cymbal pattern is broken up around the snare drum and tom-toms. The hi-hat will be closing on the second and fourth beats.

EXERCISE 308

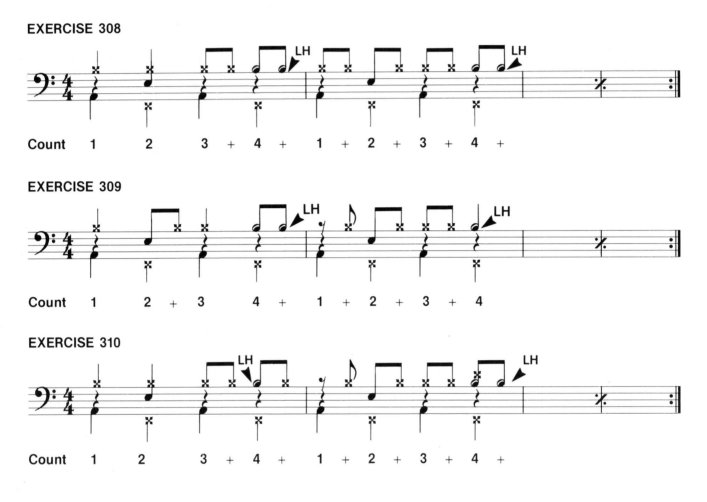

ROCK AND ROLL MAMBO

The **MAMBO** can be adapted to rock by simply changing the bass drum pattern. The hi-hat continues to close on the second and fourth beats with the main cymbal pattern being played on the ride cymbal.

EXERCISE 311

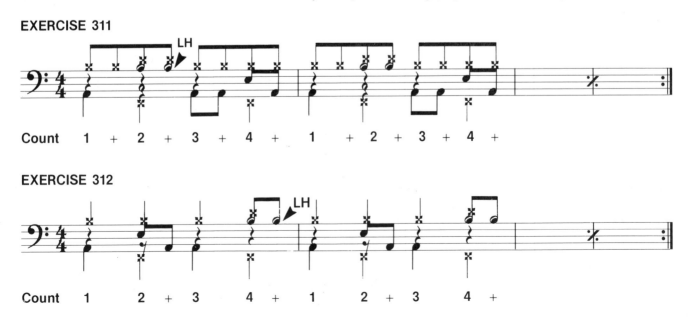

DRUM SOLO 6

EXERCISE 313

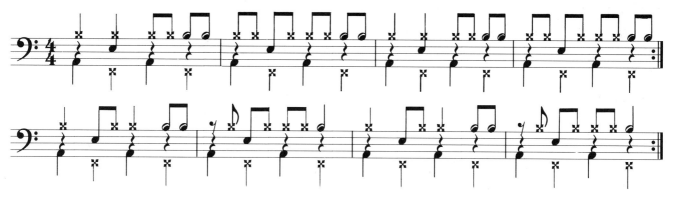

LESSON THIRTY-NINE

THE BOSSA NOVA

This rhythm would be one of the most difficult of the Latin American rhythms. This is due to the snare drum and bass drum playing syncopated notes in varying places, while the hi-hat pattern, closing with the left foot, is constant (being played on beats 2 & 4). First play the cymbal pattern and snare together and then, once you have the feel, add the bass drum; and then finally the hi-hat.

EXERCISE 314

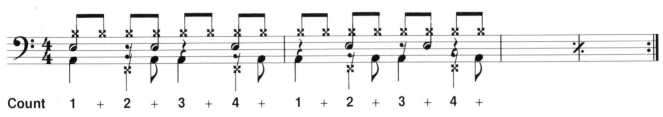

Count 1 + 2 + 3 + 4 + 1 + 2 + 3 + 4 +

THE FAST SAMBA

This rhythm is, as the name suggests, played fairly briskly. It covers two bars and the tom-tom notes are all played with the right hand.

EXERCISE 315

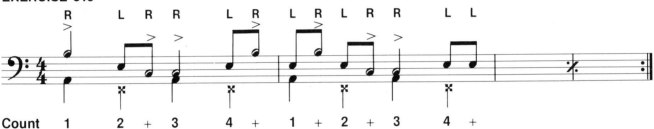

Count 1 2 + 3 4 + 1 + 2 + 3 4 +

THE SLOW RHUMBA

This rhythm is given its feel by the bass drum being played on the first, third and fourth beats only.

EXERCISE 316

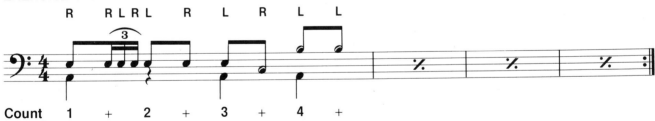

Count 1 + 2 + 3 + 4 +

CLAVE RHYTHM

This rhythm can be played on a cowbell, woodblock, muted snare (snare wires off) or any other percussion instrument, with the rhythm very often being played over the top of the other drums.

EXERCISE 317

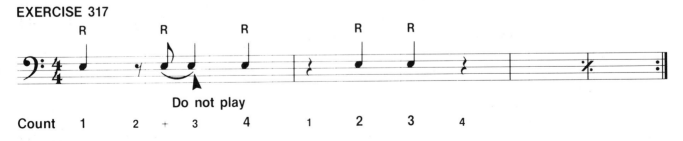

Do not play

Count 1 2 + 3 4 1 2 3 4

The curved line in the first bar of the above exercise is called a **TIE**. It indicates that the value of the second note is added to that of the first note. The second note is not played. Ties should not be confused with slur lines (**As Introduced In Lesson 24**) which indicate that a group of notes are to be played smoothly (e.g. in a roll).

LESSON FORTY

INTRODUCTION TO JAZZ AND INDEPENDENCE

INDEPENDENCE is the ability to play two or more disconnected actions at the same time, with the resulting aim being to free both hands and feet from dependence on each other, but without breaking the rhythm flow.

First start with the right hand, playing what is called a 'swing' pattern on the ride cymbal with dotted eighth and sixteenth notes. It is very similar to the shuffle rhythm **(See Lesson 19)** except it is played with the shuffle feel on the second and fourth beats only.

EXERCISE 318

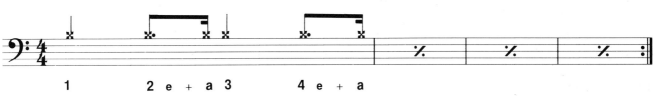

In all the following exercises the ride cymbal is played with a swing feel throughout. The snare pattern is different in each, helping to develop your right and left hand independence.

Then add the snare drum on the **2 & 4**.

EXERCISE 319

EXERCISE 320

EXERCISE 321

EXERCISE 322

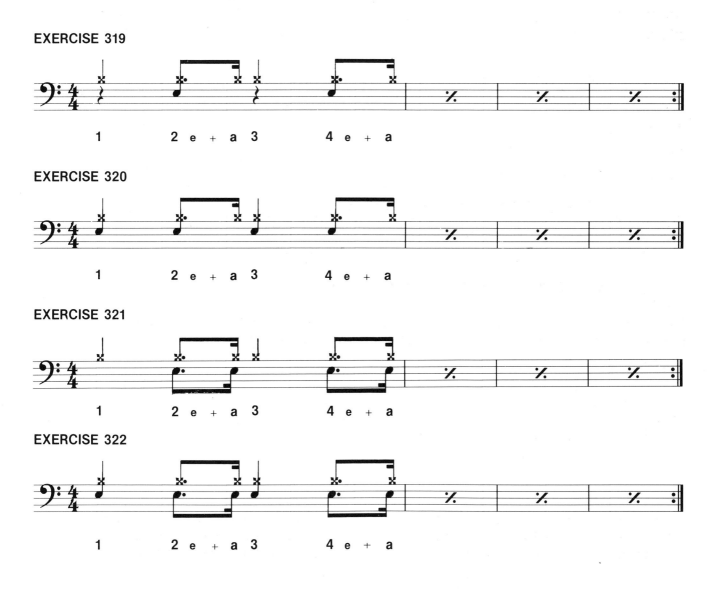

EXERCISE 323

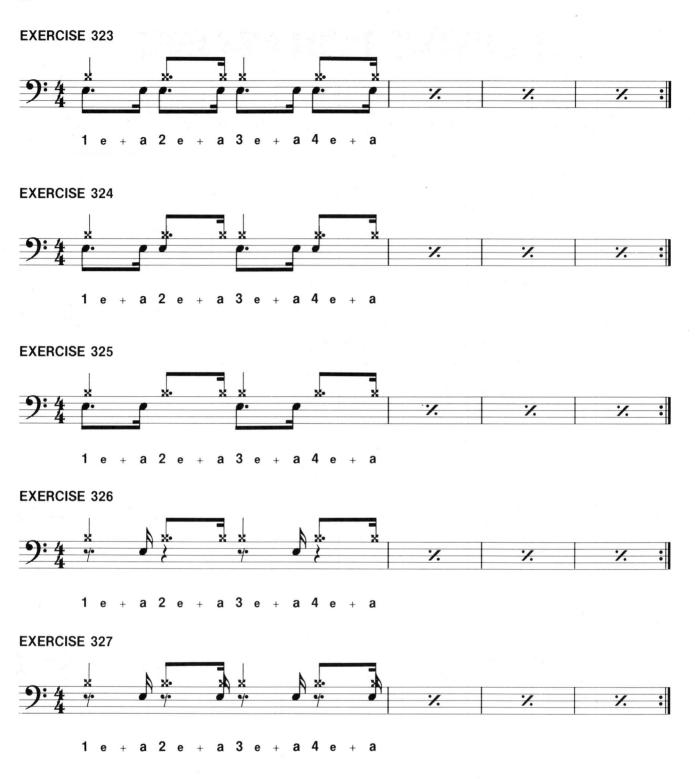

1 e + a 2 e + a 3 e + a 4 e + a

EXERCISE 324

1 e + a 2 e + a 3 e + a 4 e + a

EXERCISE 325

1 e + a 2 e + a 3 e + a 4 e + a

EXERCISE 326

1 e + a 2 e + a 3 e + a 4 e + a

EXERCISE 327

1 e + a 2 e + a 3 e + a 4 e + a

LESSON FORTY-ONE

ADVANCED INDEPENDENCE STUDIES

The following exercises introduce the bass drum and hi-hat on all 4 beats (closing on the **2 & 4**).

EXERCISE 328

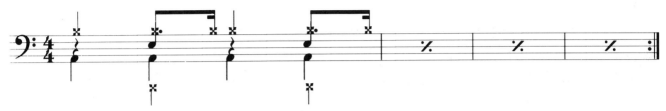

EXERCISE 329

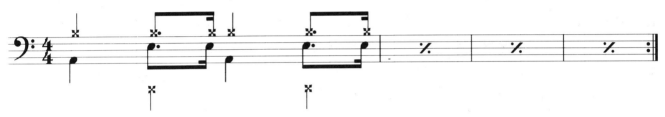

EXERCISE 330

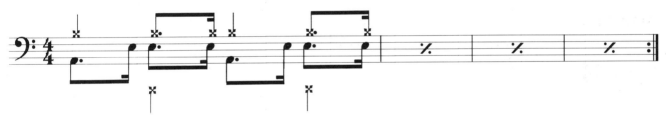

EXERCISE 331

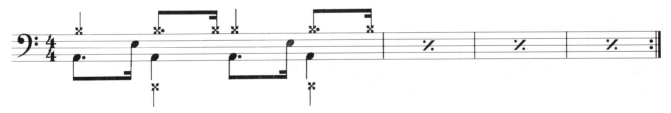

EXERCISE 332

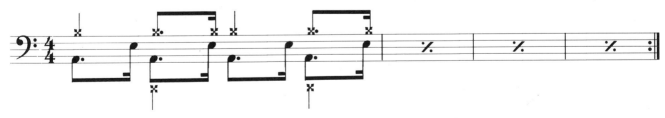

Here is an 8 bar exercise utilizing the independence studies given in this lesson.

EXERCISE 333

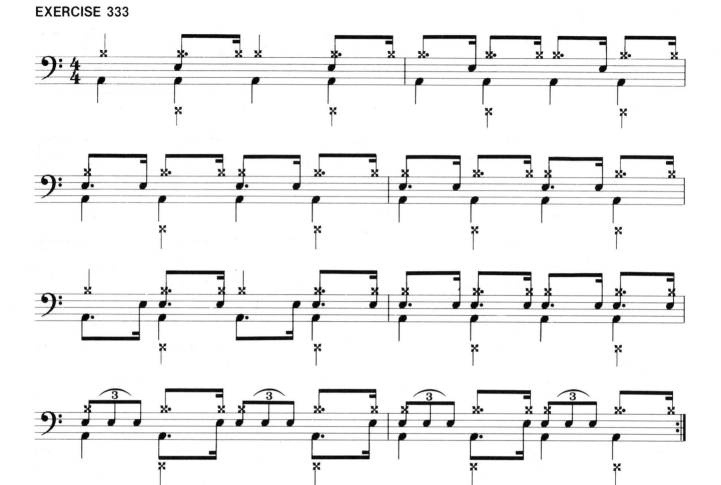

DRUM SOLO 7

EXERCISE 334

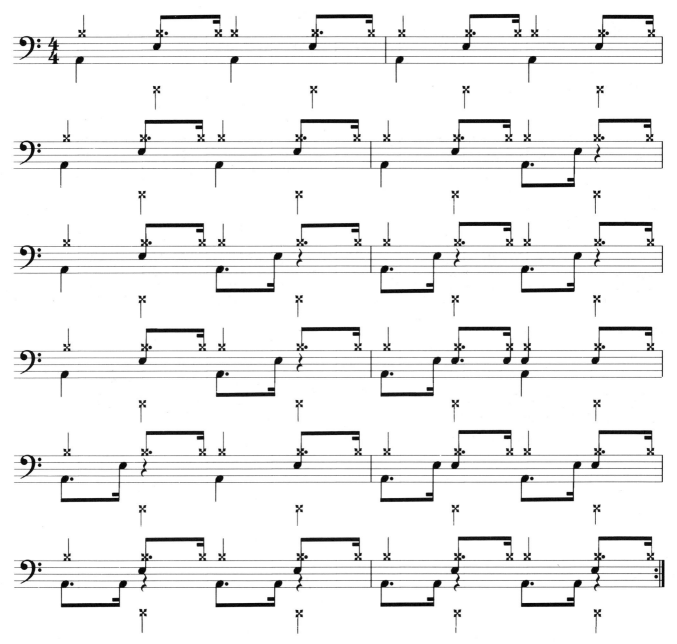

LESSON FORTY-TWO

JAZZ FILLS USING THE SWING BEAT

Triplets, when used with the swing beat create interesting fills. Here are a few examples:

EXERCISE 335

EXERCISE 336

EXERCISE 337

EXERCISE 338

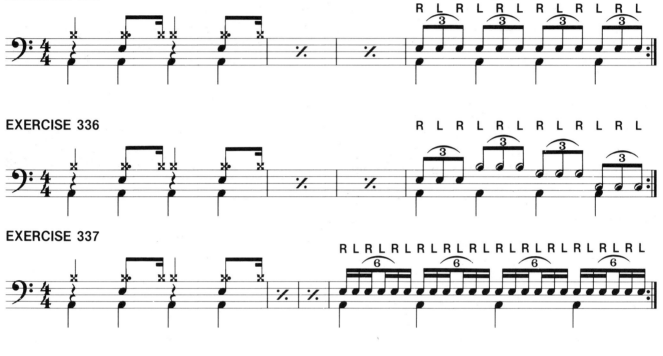

The swing beat may also be written using triplet cymbal patterns e.g. notice the eighth note rest in the middle of the triplet group. This creates the 'swing' feel.

EXERCISE 339

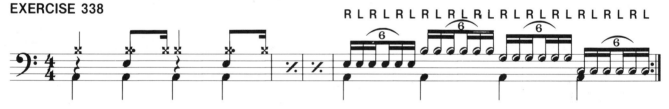

EXERCISE 340

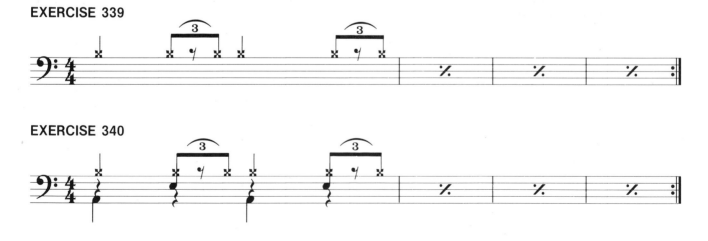

EXERCISE 341

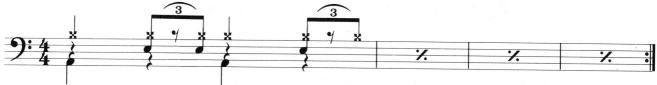

EXERCISE 342

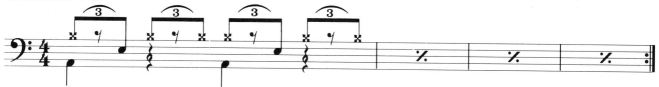

EXERCISE 343

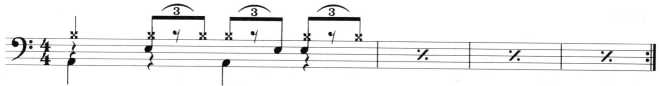

EXERCISE 344

EXERCISE 345

EXERCISE 346

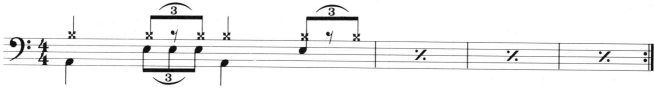

BRUSH RHYTHMS

The wire brushes are used when a quieter or more subtle rhythm is required. They would be used in a dance band for slow and medium tempo swing songs.

The right hand will be playing the same pattern as the swing beat in the jazz section, with the bass drum playing on the first and third beats, while the hi-hat is closing with the left foot on the second and fourth beats.

EXERCISE 347

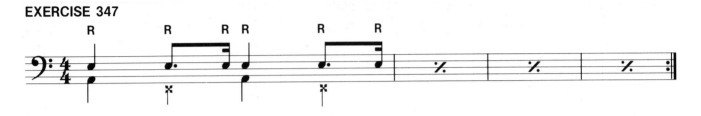

The left hand will be rotating the brush on the head of the snare drum in an oval shape, going from the outer edge to the centre and back continuously. The brush should be in the centre position with each beat.

EXERCISE 348

If you cannot keep up the pace of the rhythm with the left hand in faster tempos then just slow the left hand down so that you are rotating at half the speed before. The brush should now be in the centre for 1 beat and then at the edge for the second beat, back to the centre for the third beat and out to the edge for the fourth beat.

EXERCISE 349

LESSON FORTY-THREE

ROCK BEATS USING SIXTEENTH NOTES ON THE HI-HAT OR CYMBAL IN $\frac{4}{4}$ TIME

EXERCISE 350

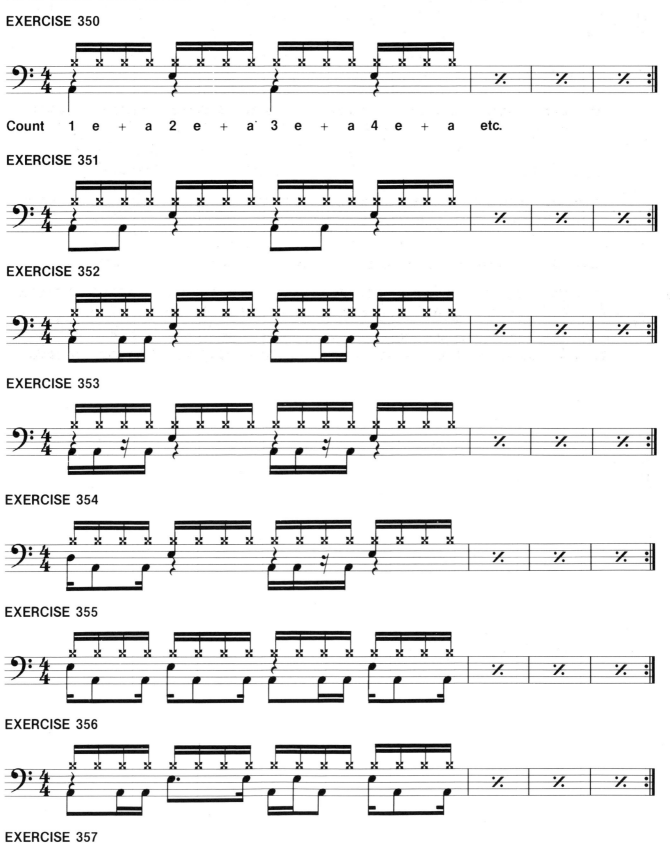

Count 1 e + a 2 e + a 3 e + a 4 e + a etc.

EXERCISE 351

EXERCISE 352

EXERCISE 353

EXERCISE 354

EXERCISE 355

EXERCISE 356

EXERCISE 357

98

Here is an 8 bar exercise using sixteenth notes on the cymbal.

EXERCISE 358

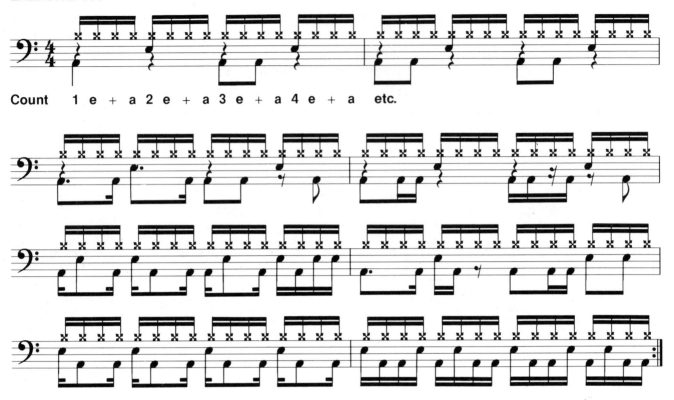

Count 1 e + a 2 e + a 3 e + a 4 e + a etc.

LESSON FORTY-FOUR

DISCO BEATS

DISCO BEATS are basically rock beats with emphasis being placed on the hi-hat playing eighth or sixteenth notes. Open the hi-hat with your foot on the '+' section of the count (off beat) and close it on the number section of the count (on the beat). As the hi-hat is opening it is hit with the stick. This is indicated by the O placed above the hi-hat.

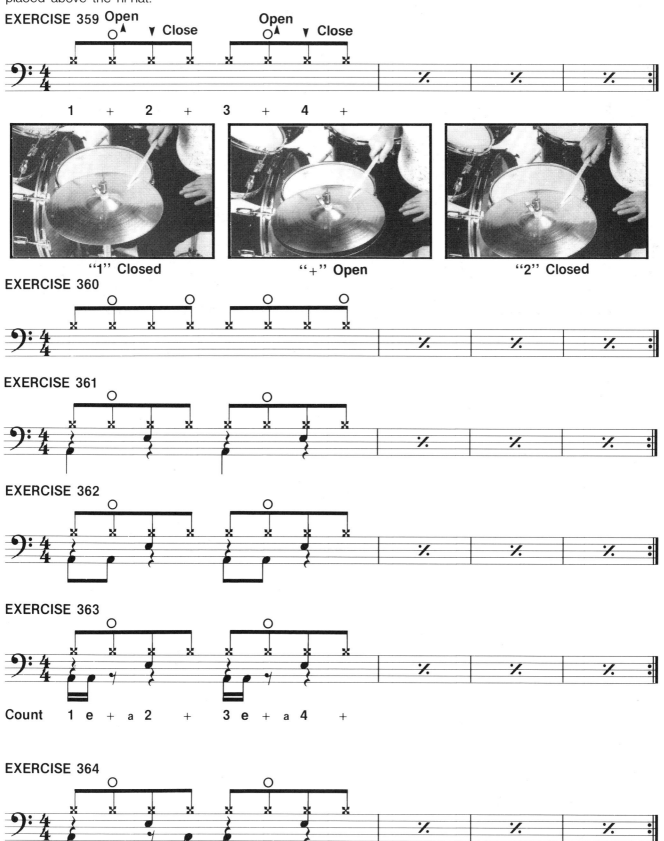

EXERCISE 359

"1" Closed "+" Open "2" Closed

EXERCISE 360

EXERCISE 361

EXERCISE 362

EXERCISE 363

Count 1 e + a 2 + 3 e + a 4 +

EXERCISE 364

Now by only playing the hi-hat on the '+' section of the count you can vary the disco rhythm accenting the offbeat even further. Although the following exercises are played with an open hi-hat (off the beat), it may be beneficial to first practise them with a closed hi-hat.

EXERCISE 365

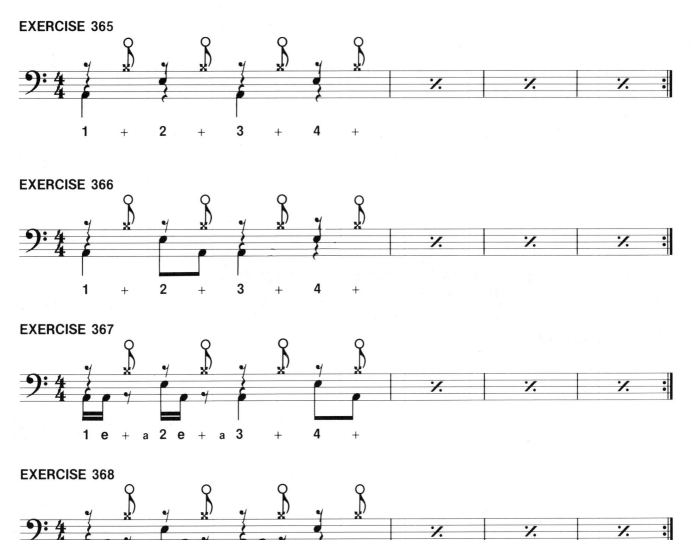

EXERCISE 366

EXERCISE 367

EXERCISE 368

LESSON FORTY-FIVE

DISCO BEAT VARIATIONS

The following exercises feature a **DISCO BEAT** using sixteenth notes on the hi-hat opening it in various places.

EXERCISE 369

EXERCISE 370

EXERCISE 371

EXERCISE 372

EXERCISE 373

EXERCISE 374

LESSON FORTY-SIX

Another variation of the disco beat used very frequently in rock is called 'alternate' sticking i.e. alternating both right and left hand on the hi-hat. (**RLRLRLRL etc.**). The snare is played with the right hand moving over to it **(see Photos)**.

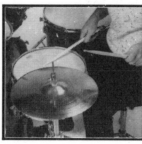

"+" "a" "2" "e"

EXERCISE 375

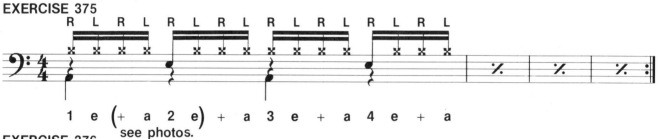

1 e (+ a 2 e) + a 3 e + a 4 e + a
see photos.

EXERCISE 376

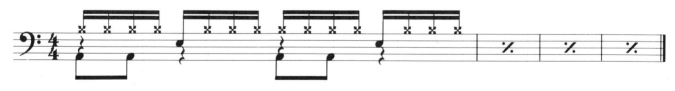

EXERCISE 377

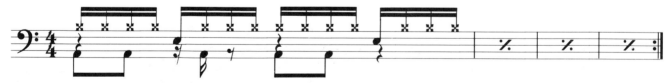

EXERCISE 378

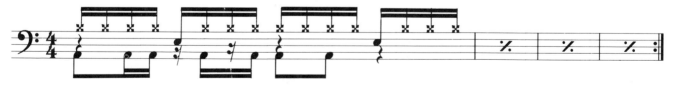

EXERCISE 379

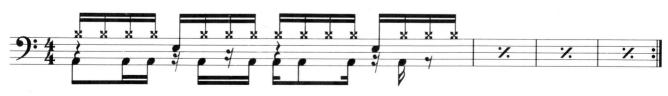

Now try alternate sticking on the hi-hat with it opening.

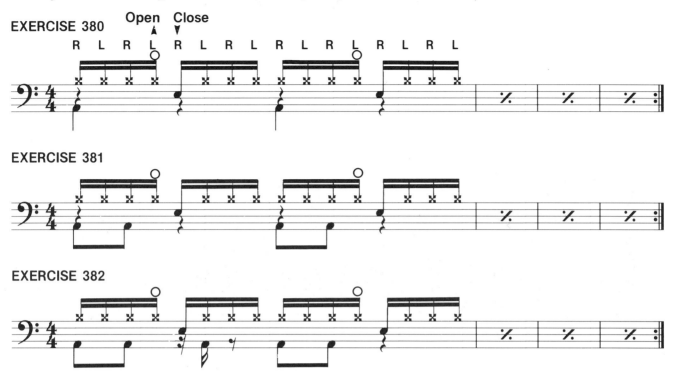

EXERCISE 380

EXERCISE 381

EXERCISE 382

EXERCISE 383

DRUM SOLO 8.

EXERCISE 384

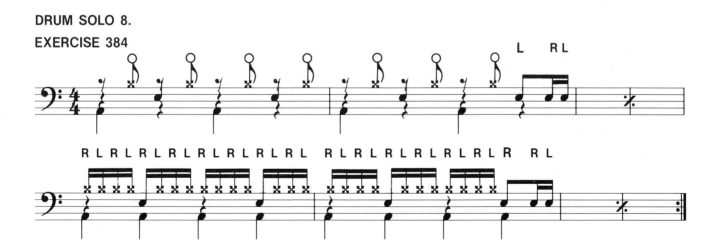

LESSON FORTY-SEVEN

ROCK BEATS USING SIXTEENTH NOTE TRIPLETS

SIXTEENTH NOTE TRIPLETS are commonplace in rock today, being used widely in 'funk-rock' style bands. They can be played effectively on either the snare drum or the bass drum. The important thing to remember is that the first sixteenth note in each group is usually left out as indicated by the rest ⅞

Triplets on the snare drum

EXERCISE 385

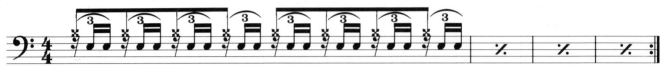

Triplets on the bass drum

EXERCISE 386

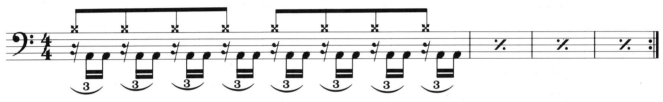

Note: The triplets must fit between the cymbal pattern being played.

EXERCISE 387

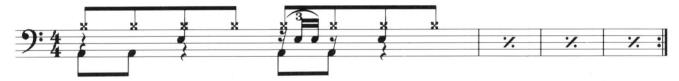

EXERCISE 388

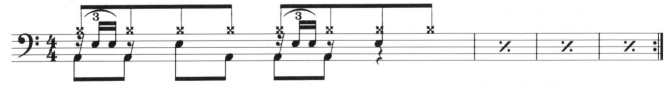

EXERCISE 389

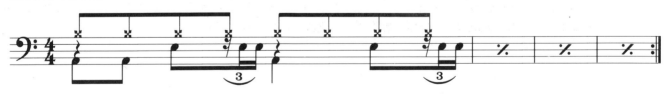

EXERCISE 390

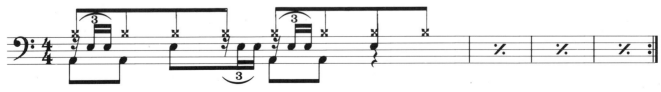

EXERCISE 391

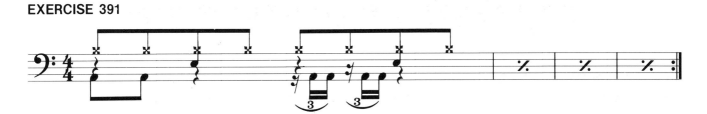

EXERCISE 392

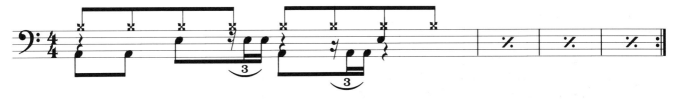

EXERCISE 393

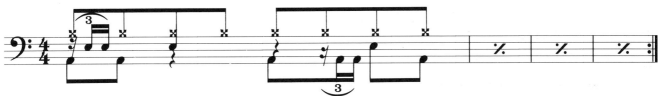

EXERCISE 394

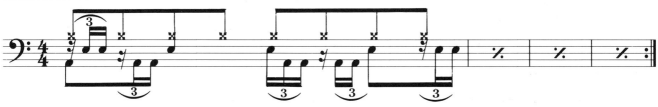

EXERCISE 395

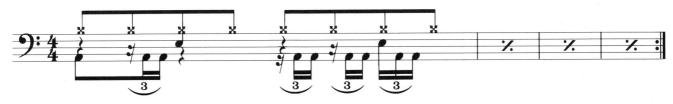

EXERCISE 396

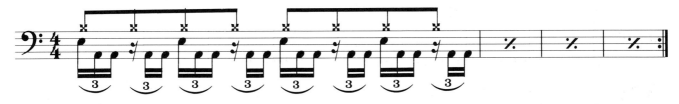

LESSON FORTY-EIGHT

SYNCOPATED ROCK BEATS

Syncopation was first introduced in **Lesson 6** and expanded upon in **Lessons 37** to **39** with Latin American beats.

The exercises below feature syncopated rock beats. Play each one four times.

SYNCOPATED BEATS

We have discussed syncopation earlier in its basic form and in a beat form (i.e. the bossa nova). Now we will try a few exercises in rock beat format, over 2 bars.

EXERCISE 397

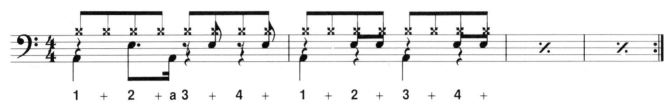

EXERCISE 398

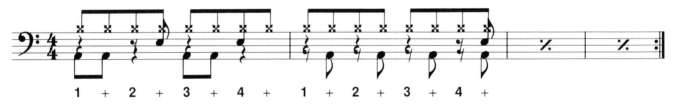

EXERCISE 399

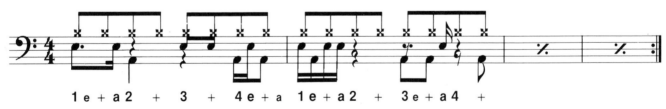

REGGAE BEATS

REGGAE BEATS are syncopated beats that generally involve the left hand playing with the stick across the rim of the snare drum. The bass drum plays on the second and fourth beats.

EXERCISE 400

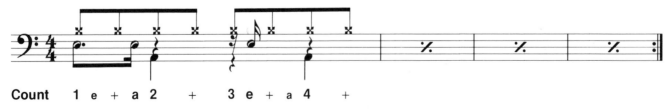

EXERCISE 401

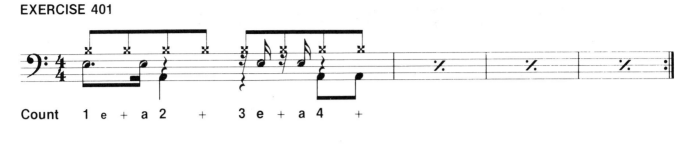

Count 1 e + a 2 + 3 e + a 4 +

EXERCISE 402

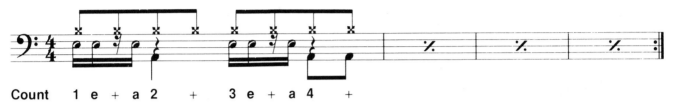

Count 1 e + a 2 + 3 e + a 4 +

To give the reggae rhythm a different effect you may wish to play certain snare drum notes on the skin and not the rim.

LESSON FORTY-NINE

ADDITIONAL BEAT STUDIES

EXERCISE 403

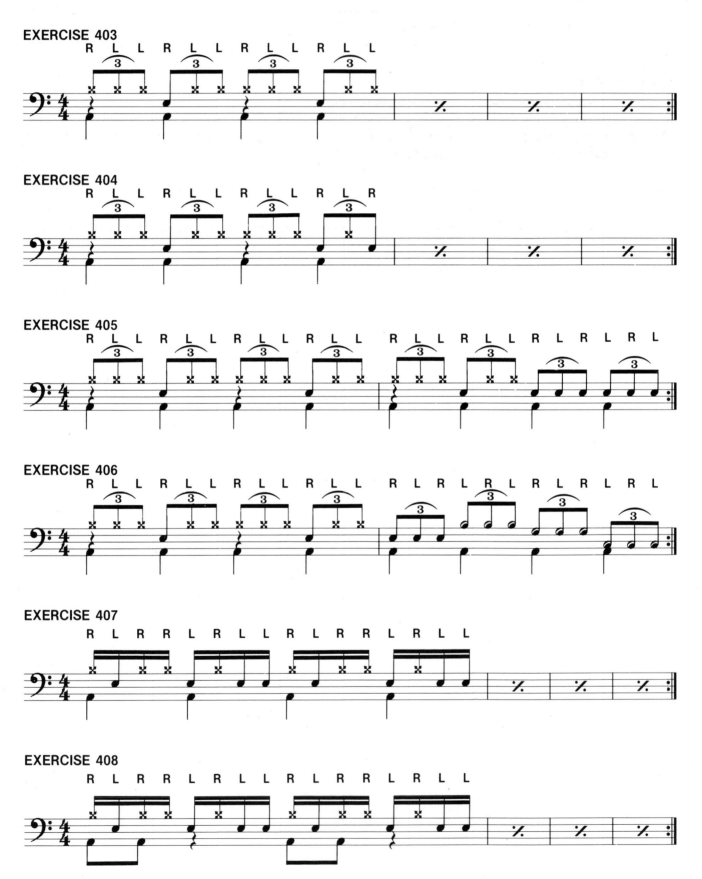

EXERCISE 404

EXERCISE 405

EXERCISE 406

EXERCISE 407

EXERCISE 408

EXERCISE 409

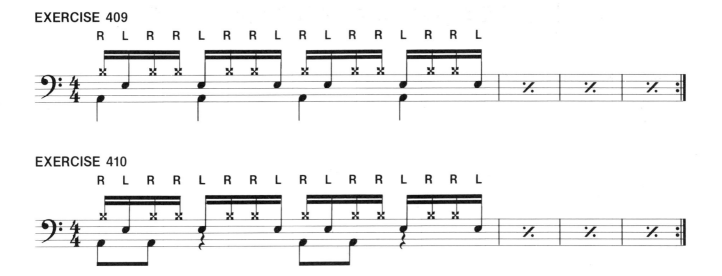

EXERCISE 410

LESSON FIFTY

INTRODUCTION FILLS

Here are some **INTRODUCTION FILLS** to start a song with.

EXERCISE 411

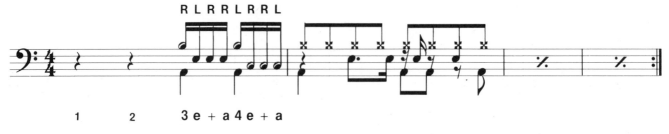

EXERCISE 412

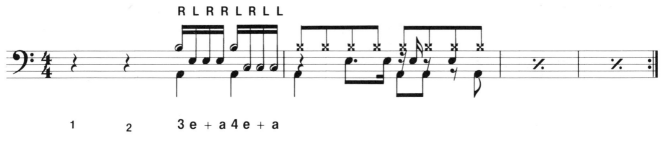

EXERCISE 413

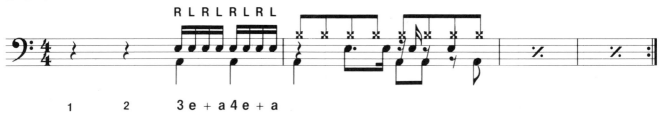

EXERCISE 414

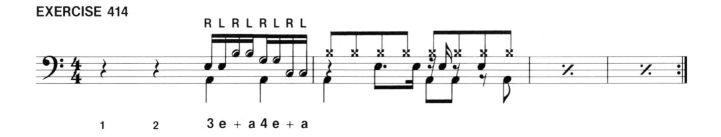

EXERCISE 415

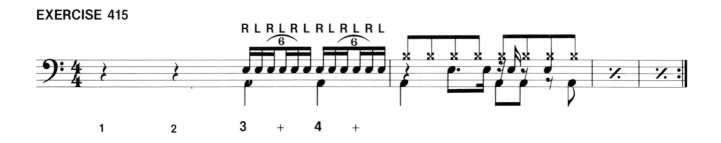

EXERCISE 416

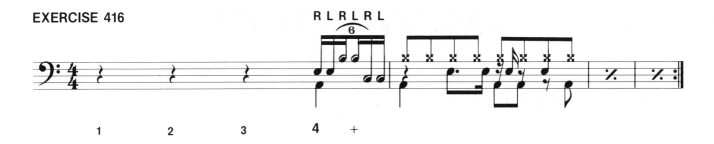

1 2 3 4 +

EXERCISE 417

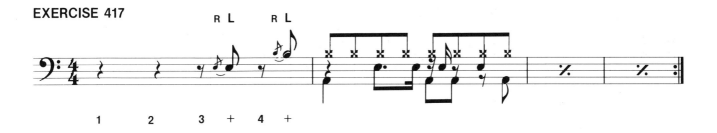

1 2 3 + 4 +

EXERCISE 418

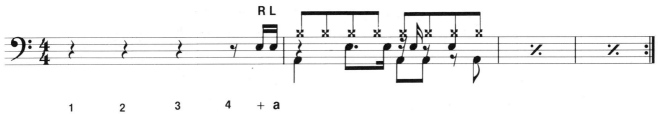

1 2 3 4 + a

APPENDIX ONE

TUNING

It is essential for your drums to be in tune, so that they will produce a good sound for either live or studio work. Each drum can be tuned to a specific note, but it is more important for each individual drum to be in tune with itself, and then in tune with the rest of the kit.

The main problem with tuning for most beginners is that the ear is not able to determine slight differences in pitch. For this reason you should seek the aid of a teacher or an experienced drummer.

The important thing to remember in tuning is that each drum is evenly in tune with itself. This means that if you strike the drum about 1" (2.5 cm.) from each tension rod **(See Photo.)** the note should sound the same. Use a **TEN LUG** snare drum as an example. Assuming the tension rods are all loose, start tightening from no. 1 tension rod through to no. 10 tension rod in that order (see Diagram) until finger tight. Then turn to no. 1 tension rod one turn (using a drum key), now strike the drum about 1" (2.5 cm.) from the tension rod listening very carefully to the note. Now tune tension rod no. 2 to exactly the same note as tension rod no. 1. Now repeat the procedure through to tension rod no. 10 using tension rod no. 1 as a reference point. Continue this process until you reach the required note, making sure that the note is the same at every tension rod. The bottom head of the snare should be tuned in exactly the same manner keeping it higher in pitch than the top (or batter head). This will give the snare a crisp an defined note cutting through the other deeper pitches of the drum kit. The pitch of the snare drum should be higher than the toms. It may be easier to tune the snare by releasing the snare wires.

The bass drum should have a deep, well defined flat sound if you are playing rock, with the skin being slightly looser. If you are playing in a jazz or big band the skins should be tuned higher to give a boomier, open sound. A piece of felt 2"-3" (5 cm.-7.5 cm.) wide running vertically down the striking side of the bass drum will help to muffle or flatten the sound.

When tuning the toms start with the floor tom and tune it to a deep, rich sound. If you have two toms on the bass drum tune the larger one slightly higher in pitch than the floor tom, and the smaller tom slightly higher in pitch than the larger tom.

If you want to dampen the toms (to make them sound flatter), you should dampen them from the outside, not the inside. Inside dampeners only choke the drum, restricting natural movement of the head.

You will get the best out of your drums if you practise tuning as much as possible. Experiment with different notes on each drum. If you can tune your drums successfully you will save the recording studio, or live sound engineer, a lot of headaches.

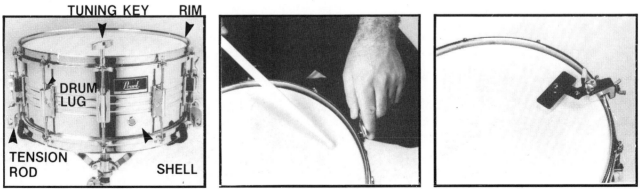

SNARE DRUM STRIKING DRUM DAMPENER

APPENDIX TWO

GROUPS

A successful group is not just a mixture of good musicians. You will need to be aware of the many other factors involved in order to avoid the pitfalls that cause many groups to disband within a very short time. The following ideas should increase your awareness of the problems facing a group, and how to avoid them.

1. **GROUP DIRECTION**

 Before forming a group, you should talk with prospective musicians about their aims for the group. You may decide to form what is called a '60/40' group; the type that plays at cabarets, dances and hotels. This type of group plays a selection of old pop standards (approx. 60%) and 'Top 40' tunes (40%). 60/40 groups can be assured of a steady income, although recognition will not go beyond the local scene.

 A different aim for the group may be to play mainly original material in the eventual hope of cutting a record and going on tours. Groups of this type generally do not make much money until they have become well known.

 If you are forming a new group you may find it more beneficial to play a 60/40 style to gain experience and money to invest in top quality equipment.

 Decide on the number of musicians, the type of instruments and the basic style of music before forming the group.

2. **MUSIC CHOICE**

 The style of music you play must be one that is enjoyed by all group members (not just a majority vote). Listen to other bands playing their various different styles and take particular note of the audience reaction in order to gauge the appeal of each style. Once you have decided on a style, aim specifically towards the section of people who enjoy that type of music. This will immediately decrease the number of possible venues for you to play at; but remember that you cannot please everyone and you should therefore aim to play to the type of people whom you will please.

3. **THE GROUP STRUCTURE**

 A group can be divided into two basic sections; a 'rhythm section' and a 'lead section'. The instruments of the rhythm section include drums, and bass (which lay down the basic beat), and rhythm guitar (which 'fills-out' the basic beat). These instruments must co-ordinate to provide the background rhythm; the 'tightness' of the group will depend on it. The lead section usually consists of lead guitar, vocals and keyboards (which may be used as either a lead or rhythm instrument). The lead instrument acts as a separate voice from the vocals and 'leads' in and out of each section or verse of a song (i.e. an introduction or a 'lead break').

 All instruments must work as a team, in order to provide a combined group sound.

4. **REHEARSALS**

 In a serious group you will spend more time rehearsing than doing anything else, so it is important to be properly organised. As far as possible, each session should have an objective which you should strive to achieve.

 Remember that the performance of a song involves not only the music, but also sound balance and stage presentation. These facets should be practised as part of the rehearsal. As well as group rehearsal, you should practise individually. Concentrate particularly on the harder sections of your songs, so that it will be easier to play them when working with the group. It is far more beneficial and time saving for each member to attend group rehearsal with full knowledge of his part.

 The underlying theme of all the above topics is one of group unity, both on and off stage. This is essential if the group is to survive together as an effective musical unit.

COPYING BEATS AND FILLS FROM RECORDINGS

As a drummer, you will sometimes be required to play a given beat from a recording (as compared to creating your own). Copying from recordings can be difficult at first, so here are a few suggestions:

1. Start with a simple beat. Record it so that you can play it many times over.

2. Listen carefully to the cymbal pattern and determine whether the notes being played on the hi-hat or ride cymbal are either quarter, eighth or sixteenth notes, and what time signature the song is in. The majority of rock songs are in $\frac{4}{4}$ time.

3. Then listen to the snare drum and determine where those notes fall. They generally fall on the **2 & 4** in each bar of most rock beats.

4. The bass drum is next, and again you will have to listen closely and count as you go through each bar so you can place the notes in the correct position.

5. The 'fills or breaks' are the hardest part of the song to pick out. If you break down each bar into the main quarter notes (e.g. $\frac{4}{4}$: four quarter notes, count 1,2,3,4) you can then dissect all of the other eighth and sixteenth notes and piece it all together.

6. Practice recording copying (often referred to as 'transcribing') regularly.

GLOSSARY OF MUSICAL TERMS

ACCENT — a sign, $>$, used to indicate a predominant beat.

AD LIB — to be played at the performer's own discretion.

BAR — A division of music occuring between two bar lines (also call a 'measure').

BAR LINE — a vertical line drawn across the staff which divides the music into equal sections called bars.

BASS — the lower regions of pitch.

BASS CLEF — a sign placed at the beginning of the staff to fix the pitch of notes placed on it.

CHORD — a combination of three or more different notes played together.

COMMON TIME — an indication of $\frac{4}{4}$ time - four quarter note beats per bar. Also written **C**

COMPOUND TIME — occurs when the beat falls on a dotted note, which is a divisable by three: e.g. $\frac{6}{8}$ $\frac{9}{8}$ $\frac{12}{8}$.

DOT — a sign placed after a note indicating that its time value is extended by a half. e.g. in $\frac{4}{4}$ time.

$$\mathbf{\text{♩} = \text{♩}\,\text{♩}}$$ **2 Beats** $$\mathbf{\text{♩.} = \text{♩}\,\text{♩}\,\text{♩}}$$ **3 Beats**

DOUBLE BAR LINE — two vertical lines close together, indicating the end of a piece, or section thereof.

DYNAMICS — the varying degrees of softness and loudness in music.

EIGHTH NOTE — a note with the value of half a beat in $\frac{4}{4}$ time, indicated thus ♪ (also called a quaver).

The eight note rest indicating half a beat of silence, is written: ♪

FILLS — any variation of stick movement from the basic beat and used to fill out or color the music.

HALF NOTE — a note with the value of two beats in $\frac{4}{4}$ time, indicated thus: ♩ (also called a minim).

The half note rest, indicating two beats of silence, is written: ▬ third staff line.

IMPROVISE — to perform spontaneously; i.e. not from memory or from a written copy.

INTRO — introduction to a song (e.g. using fills).

METRONOME — a device which indicates the number of beats per minute, and which can be adjusted in accordance to the desired tempo. e.g. **MM** (Maelzel Metronome) ♩ = 60 indicates 60 quarter note beats per minute.

NOTATION — the written representation of music, by means of symbols (music on a staff).

NOTE — a single sound with a given pitch and duration.

QUARTER NOTE — a note with the value of one beat in $\frac{4}{4}$ time, indicated thus ♩ (also called a crotchet). The quarter note rest, indicating one beat of silence, is written: 𝄽

REGGAE — a Jamaican rhythm featuring an accent on the second and fourth beats (in $\frac{4}{4}$ time).

REPEAT SIGNS — in music, used to indicate a repeat of a section of music, by means of two dots placed before a double bar line:

A repeat sign ✕. , indicates an exact repeat of the previous bar.

REST — the notation of an absence of sound in music.

RHYTHM — the aspect of music concerned with tempo, duration and accents of notes. Tempo indicates the speed of a piece (fast or slow); duration indicates the time value of each note (quarter note, eighth note, sixteenth note, etc.): and accents indicate which beat is more prominent (in rock the first and third beats; in reggae the second and fourth beats).

SIMPLE TIME — occurs when the beat falls on an undotted note, which is thus divisable by two.

SIXTEENTH NOTE — a note with the value of a quarter of a beat in $\frac{4}{4}$ time, indicated thus ♬ (also called a semiquaver). The sixteenth note rest, indicating a quarter beat of silence, is written ꝑ.

SLUR LINE — notes with slur line are to be played smoothly -

STAFF — five parallel lines together with four spaces, upon which music is written.

SYNCOPATION — the placing of an accent on a normally unaccented beat. e.g.:

$$\overset{>}{1}\ \overset{>}{2}\ 3\ \overset{>}{4} \qquad 1 + 2 \overset{>}{+} 3 + 4 \overset{>}{+}$$

TEMPO — the speed of a piece.

TIE — a curved line joining two or more notes of the same pitch, where the second note(s) is not played, but its time value is added to that of the first note.

1 + 1 = **2 counts**

TIME SIGNATURE — a sign at the beginning of a piece which indicates, by means of figures, the number of beats per bar (top figure), and the type of note receiving one beat (bottom figure).

TRIPLET — a group of three notes played in the same time as two notes of the same kind. Eighth note triplet:

WHOLE NOTE — a note with the value of four beats in $\frac{4}{4}$ time, indicated thus 𝅝 (also called a semibreve). Whole note rest, indicating four beats of silence, is written: ▬ fourth staff line.